Remarkable Yukon Women

Profiles by Claire Festel. Portraits by Valerie Hodgson

Remarkable *Yukon* Women

Lost Moose is an imprint of Harbour Publishing Co. Ltd.

Harbour Publishing
P.O. Box 219
Madeira Park, BC VON 2H0
www.harbourpublishing.com

Photography of the portraits by Robin Armour Photography
Edited by Amelia Gilliland and Dona Sturmanis
Page design by Robert MacDonald, typeset by Mary White
Printed on chlorine free paper made with 10% post-consumer waste
Printed and bound in Canada

The exhibit, *Yukon Women, 50 Over 50*, featuring the portraits in *Remarkable Yukon Women* by Valerie Hodgson premiered at the Yukon Arts Centre Public Art Gallery June 2–August 27, 2011.

Harbour Publishing acknowledges financial support from the Government of Canada through the Canada Book Fund and the Canada Council for the Arts, and from the Province of British Columbia through the BC Arts Council and the Book Publishing Tax Credit.

Library and Archives Canada Cataloguing in Publication

Festel, Claire, 1957–
 Remarkable Yukon women / profiles by Claire Festel ; portraits by Valerie Hodgson.

ISBN 978-1-55017-523-3

 1. Women—Yukon—Biography. 2. Yukon—Biography. I. Hodgson, Valerie, 1951- II. Title.
HQ1455.A3F48 2011 920.7209719'1 C2011-901253-7

Dedicated to my husband Ed, who encouraged me and insisted I follow my passion.
You are my best friend and inspiration.

A special thanks to Yukon women for sharing their stories so openly and honestly
and to Val for her graciousness.

Remarkable Yukon Women has captured the essence and spirit that Yukon women cultivate
in our northern communities. We honour and congratulate the women in this book
and extend it to each and every woman who has made the Yukon their home.
Their genuine and continuous contributions to families, businesses, education,
culture, sport and daily life keep the Yukon strong and unique.

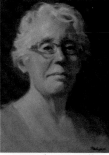
Truska Gorrell

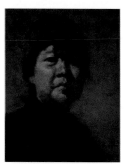
Norma Shorty

Carol Murphy

Wendy Fournier

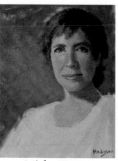
Miche Genest

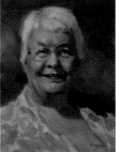
Phyllis Simpson

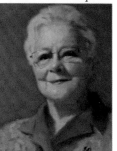
Ione Christensen

May Blysak

Marlene Dunstan

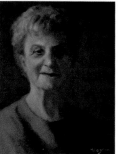
Poldi Fuerstner

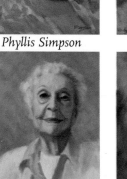
Fran Wellar

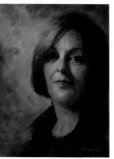
Roberta Prilusky

Rusty Reid

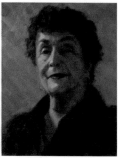
Florence Wright

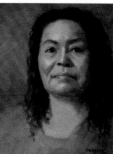
Arleen Kovac

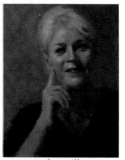
Judy Miller

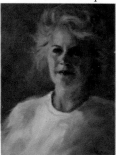
Joyce Andersen

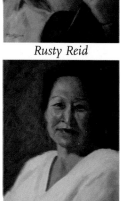
Sarah Lennie

Evelyn Loreen

Clara Dionne

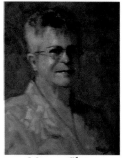
Maura Glenn

Millie Jones

Barb Zaccarelli

Mary Mickey

Jenny Skelton

Patricia Robertson

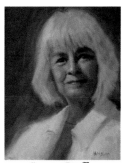

Susan Staffen

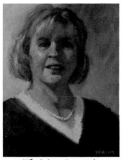

Thérèse Lacroix

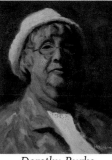

Dorothy Burke

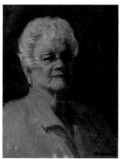

Velma Hull

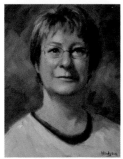

Karen Lang

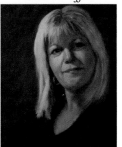

Birgitte Hunter

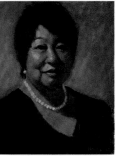

Joy Kajiwara

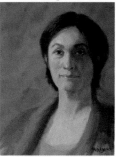

Louise Hardy

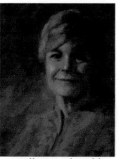

Sally Macdonald

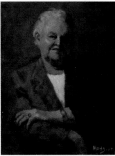

Goody Sparling

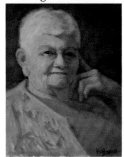

Babe Richards

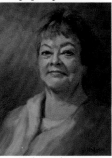

Cecil-Gayle Terris

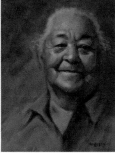

Pearl Keenan

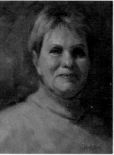

Carel Alexander

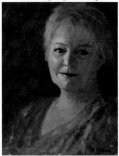

Donna Isaak

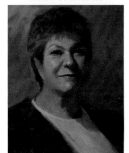

Nancy Huston

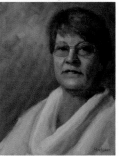

Dale Stokes

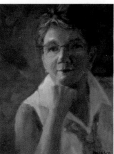

Penny Kosmenko

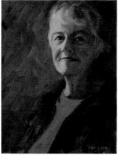

Pam Makarewich

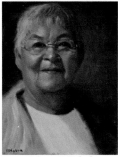

Nora Mirkel

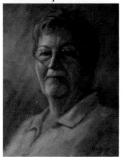

Minnie O'Conner

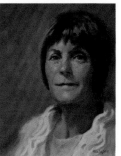

Maggie Holt

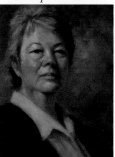

Carol Pettigrew

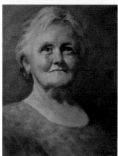

Ellen Davignon

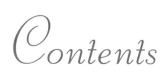

Contents

Preface
Why the Book?

On hunter change days, there would be a fair crew of incoming and outgoing hunters at our fly-in camp at the farthest point of Little Arm on Kluane Lake. We'd gather in the cookshack while our daughter cooked up a big feast and, in my mind, I'd be conducting this wilderness salon. I would introduce the new hunters to the old ones and make sure that the old ones got to the best stories quickly and that the new ones were listening at the appropriate time and then I'd throw some colourful notes into the mix and the whole time in the background the turkey would be cooking. The horses would be grazing in the camp clearing and the sound of their bells would mingle with the lapping of the lake. It was so busy and it was so beautiful to be there and it was so good with the family presence and all the comforts of home and I'd feel the presence of the generations of outfitters and First Nations hunting parties who had used this campsite down through time. It was like some mythic kind of place.

— Carol Pettigrew

The Yukon is a mythic place—the land is vast and wild, the climate harsh and uncompromising, the people resourceful and resilient. Say the word "Yukon" and southerners still conjure up images of the rough and ready frontier: whiskered men in plaid shirts or parka-clad women wielding axes in the struggle for survival in a silent, isolated land. The truth is you can find them here.

But the Yukon holds more than one truth. Writer Patricia Robertson says, "The fact that it's young seems to attract really interesting, adventurous people who want something different and who are willing to take a risk." The stories in this book, shared by fifty women—"born here or came here"—attest to the enduring nature of the North and the evolving character of a dynamic community. The changes over time and the things that stay the same give a unique insight into the circumstances that make their lives different.

Yukon women live lives similar to their counterparts down south: they are homemakers, doctors and teachers and they run businesses and work in government. But how they live their lives in the Yukon is unique. As Robertson says, "You are pulled back to the elemental aspects of life. You can pretend in a city that you're in control but you know if your car breaks down between Whitehorse and Carcross at 40 below, you better hope somebody turns up or you're well prepared because you could die. The natural world is in charge and you are not."

Whether born in a wood camp along the Yukon River like Phyllis Simpson or anywhere Outside, from New Zealand to Fort Nelson, all of these women have had extraordinary experiences. Sarah Lennie was delivered by her father with remembered advice from his mother-in-law in a hunting camp in the Arctic. Fran Wellar and Pearl Keenan were born where their ex-Northwest Mounted Police fathers and native mothers homesteaded. Ellen Davignon and Ione Christensen's mothers travelled to the nearest nursing station and hospital when their time came. Even today, women from all Yukon communities travel to Whitehorse to deliver their babies.

For those who came to the Yukon, the isolation and distance from their biological families bind Yukon mothers in a very special way. Grandparents are too far away to come over while mothers go shopping, take a fitness class or just get out of the house. So mothers form support systems and rely on each other. Susan Staffen and Birgitte Hunter talk with great fondness of their "Yukon families." Dale Stokes was involved in the YMCA Take a Break Club; Jenny Skelton set up the Watson Lake Play Group and it's still going strong today.

Whether "born here or came here," what keeps women in the Yukon is intriguing—most participate fully in the Northern lifestyle and form a deeply personal attachment to the place. Florence Wright took up hunting with her husband after the children were grown. Goody Sparling never missed a Yukon Christmas in her twenty-odd years living Outside. Penny Kosmenko loaded up the kids and gear to spend summers out on the gold claim. Carol Murphy followed her dream to be an air-brakes operator and a camp medic. In her youth, Norma Shorty raged at government and wore it deep inside, devastated by the colonial treatment of her family. She shares how she has transformed that anger into her life purpose. Ione Christensen's childhood reminiscences bring life back to Fort Selkirk, a ghost town since the advent of permanent roads in the 1950s. Raised in the bush and educated in private schools, she converted her liabilities into leadership skills that took her all the way to the senate in Ottawa.

These stories paint a picture of what life was—and is—really like for Yukon women. It is an untold story that will deepen your understanding of how and why this remote frontier adds not only colour, but also depth, sensitivity and strength to the Canadian story.

Introduction
Why Val and I?

Yukoners' stories, like the land they inhabit, grip me. It has been that way since I first arrived in 1977. There is a very small core group of people who live in the Yukon long term. The median length of residency for all Yukoners, regardless of where they were born or their ethnicity, is a short seven years. In the Yukon, leaving is always an option; many do, then yearn to come back but never do. Some return to stay while others find a balance by living part-time Outside. Over the years, this migration and attachment has come to define the Yukon for me, and it has long been my ambition to capture, through Yukoners' stories, what makes this place—and its people—so remarkable.

Although I've written professionally in many ways during my career—including a stint with CBC radio—it was only when I approached fifty that I decided to fully follow my passion for sharing Yukoners' stories. Within months, I was presented with the opportunity to work with visual artist Val Hodgson, who was putting together an ambitious art exhibit titled *Yukon Women, 50 Over 50*.

Val explains what motivated her:

The seed of interest in this women's portrait project developed from several concurrent thoughts and desires. Discouraged with painting from photographs, I wanted a project that would allow me the experience of painting people from life. I desired to complete a significant body of work celebrating the Yukon and ordinary Yukoners. It seemed an obvious choice for me to focus on Yukon women over the age of fifty, a cohort I understood well!

The selection method was flexible, inclusive and reflective of Yukon women's social connections: I invited two friends and asked them to invite two additional participants, asking each subsequent participant to invite two more women until fifty women were chosen. The intent behind this approach was for the process to take on a life of its own instead of being directed or influenced by arbitrary criteria.

After dinner at a friend's, Val and I decided to collaborate with the goal of developing a multi-media art exhibit presenting the women's voices along with the portraits. We agreed to post only basic information about the women next to the portraits. But when I began interviewing the women, a consistent question was, "And what about a book?" Without their trust and encouragement—and Val's inclusive attitude—it would not have happened.

Following is Val's description of her creative process:

All of the portraits were started from a sitting in my studio. The two- to three-hour sitting gave me time to do a rough sketch and block in the major areas and I took photographs to finish from. Most of the women who participated had never had their portrait painted before so it was a new experience for them. It was a surprise and a delight to me how involved and interested they became.

I allowed myself only one day to complete each portrait. For the most part I achieved this goal. Just as the portraits reveal the women they also reveal me, the artist, and my struggle to improve, develop and refine my skills. Completed over a period of two years, they don't pretend to be perfect. They strive to be accurate and honest and always respectful of the generous women who allowed themselves to be painted.

My process was similar: I conducted a face-to-face interview with each woman of up to two hours and made follow-up calls to check facts. This became the material from which I shaped each profile. Some of the women are polished public figures but others had never been before a microphone talking about themselves. Thérèse Lacroix said, "It makes me feel like a châtelaine. Oh, la, la. Imagine!"

Val and I shaped the material in this book. Just as the portraits are a visual interpretation by an artist, so are the profiles a written construct of the stories each relayed to me. Our task was to get to the essence of the person in the short time we had.

Sadly, two of the women, Thérèse Lacroix and Fran Wellar, are no longer with us. I am honoured to play a small part in ensuring their stories will carry on.

It has been my fervent intention to be true to these women who placed their trust in me and to share their remarkable stories with a broader audience.

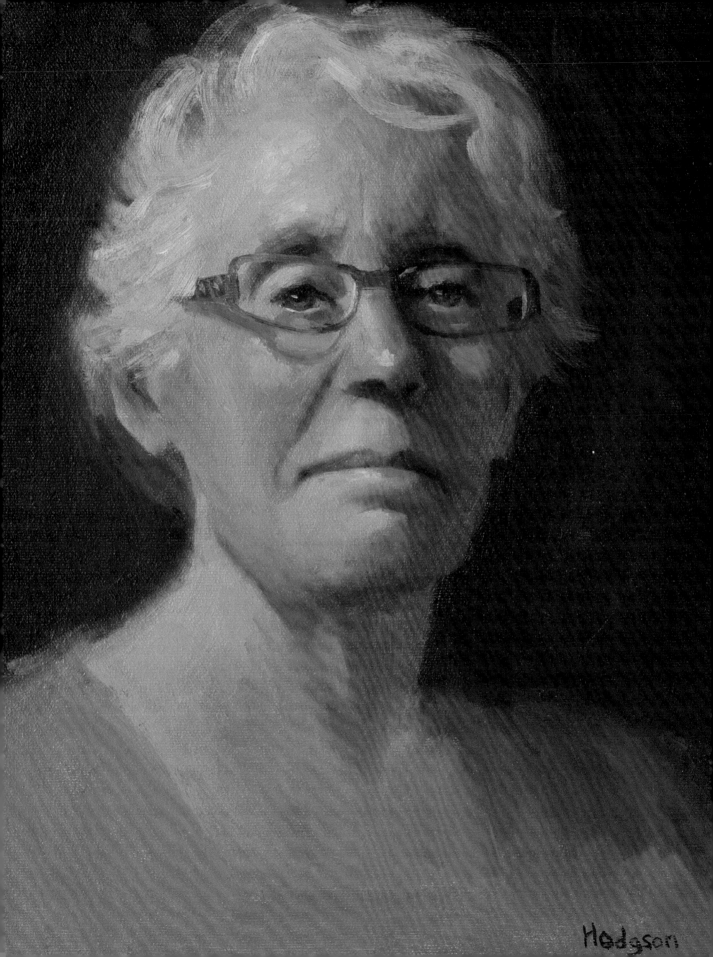

Truska (Patricia) *Gorrell* (Riley)

Levelling the Playing Field

Born February 1, 1943, in Manchester, England

Doing what you believe is the right thing is the biggest reward. Regardless whether it changes anything or anybody notices.

—Truska

"Come in!" Truska calls over the barking dog and ringing phone. The natural cork floor cushions my feet as I walk through the wide-open, light-filled kitchen to the adjoining living room. Truska brings coffee and cookies. I sink into the deep leather couch under the window and the dog, Buddy, jumps on to the back of the couch, keeping watch inside and out. Truska pours the coffee, saying, "The house is so handy for the grandchildren; they love all this open space, especially in winter." Family is central to Truska—the foundation from which she has built a life of encouragement and service to others.

Truska was born in England during World War II and when she was five years old, her father died, leaving her mom a single parent with two kids. The family struggled financially and lived in a tough neighbourhood. Her dad's brother watched out for them, and she says, "He was a little bit of magic in our lives." Truska stood up for the underdog, which got her in trouble at school. She says, "As a child, I believed life was fair and then I learned that for some, life is totally not fair." It is something she has never forgotten or turned her back on.

Truska struggled academically until she was put into an intense learning group. "I went to people who had faith in me and life did turn around for me." She went on to become a teacher, always with a concern for the less fortunate. "I've devoted a lot of my time as an adult to help level the playing field. What little that one can do, you just do it." Many years later, Norma Shorty, one of Truska's struggling Yukon students said, "She grabbed inside of me and honoured and supported my desire to do academic work. She really helped me." Norma is currently a PhD candidate.

Truska came to Saskatchewan in 1965 as a teacher. The salary was four times higher than in England and her way was paid if she taught for two years. She knew after her first night she would never go back. She smiles. "It's silly things that make a difference." Money had been so tight in England that they had to ration hot water, but for her first bath in Canada her landlady said, "You can fill it to the top if you want." Waking up the next morning to the smell of freshly baked bread clinched it—Truska was in Canada to stay. After fulfilling her contract in Saskatchewan, she applied for and got a teaching job in Whitehorse. That year, she met her husband Ron, an optometrist. They have never left and their two children are now raising their children in Whitehorse.

Truska's daughter was born on her thirtieth birthday and about the same time, her mom's last relatives passed on. She and Ron invited her mom to live with them and she accepted. Truska says, "I lived at home with Mom until I was twenty-two and when I was thirty she moved in with us." Connie Riley played a key role in their family life and worked at Murdoch's Gem Shop until she was seventy-five where, Truska says, she was "kind of a drill sergeant." Truska takes comfort in knowing that the end of her mom's life somewhat made up for the tough early years.

Throughout her life, Truska has stood up for underprivileged youth. In troubling situations, she works to make a difference. "I think the human spirit can survive some of the most awful things; people can live through unimaginable things but it is difficult. I try to do for some kids what my uncle did for us when we were young—to bring that little bit of magic to their lives." Truska has received quite a number of awards but they're not on display. Even the one that means the most to her, the Governor General's Caring Canadian award, hangs in her bedroom.

Norma Yeskéich Aan.tookwasaax *Shorty*

We Are Stronger

M.Ed, B.Ed, C.T.
Born April 15, 1956, in
Whitehorse, Yukon

I can't put my belonging-
ness into words, it is a
feeling. I am connected to
this land. I belong here. I
have roots here.

—Norma

During her half-hour lunch break, I find Norma at her desk deep in the bowels of Yukon College, tucked in the far corner of the First Nations Initiatives program. She wraps up a phone call, grabs her lunch and leads me briskly to a board table in an adjoining cubicle. She introduces herself in the traditional Tlingit way. "My name is Norma Yeskéich Aan.tookwasaax Shorty. I am of the Gunach.udi clan on my mother's side and my father is descended from the Northern Tutchone people. I belong to the Kukhittaan House from Teslin."

Being the eldest, Norma's main job was to attend to her daily household chores, which included helping out with the cooking and looking after her four younger siblings as they were growing up. Her parents struggled to find work and gave up their Indian status so that their children would not have to go to residential school. There were a few outstanding teachers and prominent elders along the way who were supportive, and around grade 10 she knew she wanted to be a teacher but "some of my teachers and others said I didn't have the academic stamina." One teacher in particular, Truska Gorrell, was there at the right moment and she really believed in her. "She grabbed inside of me and honoured and supported my desire. She really helped me."

Even so, Norma recalls how she bumped along for years before coming to a massive crash. "I was feeling so . . . troubled is not even the word. I felt like the world just wasn't there. I wanted to die. That's when I called therapy." She says that crash was the worst and best thing in her life because from that point on, she began to "put some emotional intelligence to the rage inside of me for the way government ruined my family, they took away my language, they ruined my understanding of the history of who I am—I felt all of that at one thousand percent."

She learned, through therapy, that "I was wearing the effects of contact and colonization personally, inside myself, and I was devastated. During the early period of my life I was into drugs and alcohol. I used sex inappropriately. Yeah, I wore all those things. I'm not ashamed

of it. It's a long journey and maybe my story will help others find relief. The help I needed was to understand that all of those things were happening outside of me; it was to understand about my family's history and the pain and turmoil that my parents must've gone through. To see a very proud First Nation man like my dad not having work because of his skin colour—in his homelands. Being ousted in your homelands, how devastating. That ruined me, almost."

But it didn't.

Although Norma admits to a few dips, she holds this certainty close: "We are here, we are not going away and we are stronger." And she has transformed that rage into a driving force. Her life purpose, she says, "is to engage in the cultural and language revitalization of the Tlingit ways of knowing and doing—learning about my family history and origins is a process of validating our proud heritage and complex social order and structure as indigenous peoples. It's a process of validation." Part of the process was regaining her status through Bill C-31, which brought the Indian Act in line with the Canadian Charter of Rights. She says, "It is ironic that I lost my status so that I could go to public school and that I regained my status because of my desire to go to university."

She fulfilled that long-held desire by first obtaining a bachelor's degree of education and most recently a master's degree of education from the University of Hawaii at Manoa. Norma received her public teacher's certification from the Ministry of Education in 2002. She is currently working toward her doctorate at the University of Alaska, Fairbanks, in the school of languages. Her PhD will have her proficient in Tlingit language upon completion.

Norma values the First Nation ways of knowing as much as western education. Last year, she travelled to Alaska with her mother to learn her language. In explaining how important it was, she says, "When my daughter was born it was a moment of complete and pure joy. The next moment of complete and pure joy was when my mother said something to me in Tlingit and I could understand it. I realize this is the journey I want to go on now."

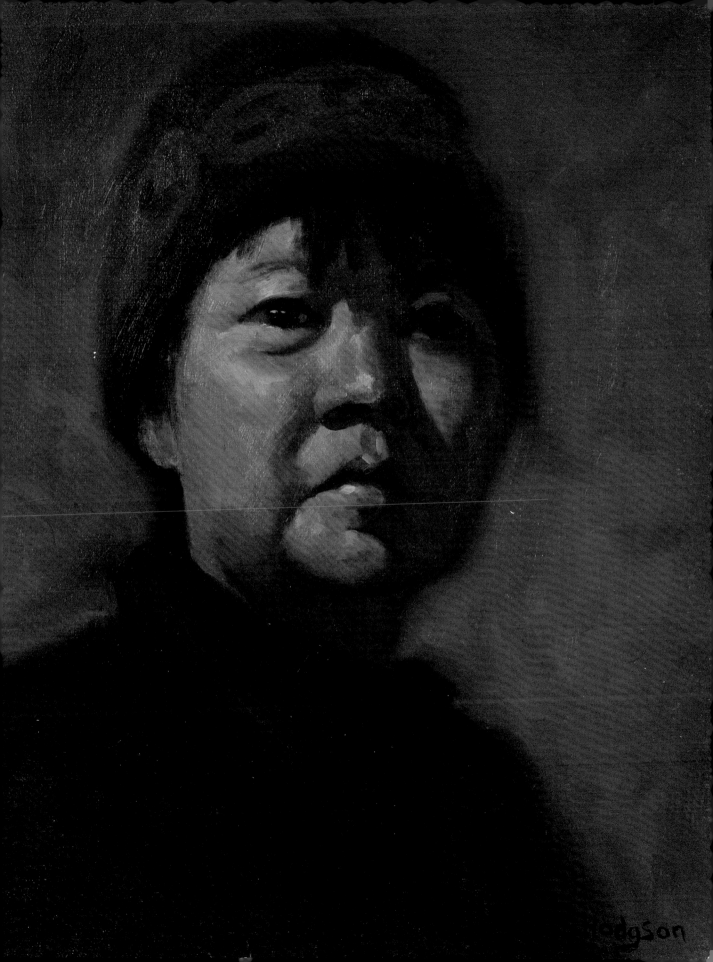

Carol Murphy

Lucky to Be Alive

Born October 17, 1955, in London, England

When you walk outside, it's beautiful. Even when the snow is coming down, it's beautiful. Even at 45 below, it's beautiful, as long as you have a good brand of coffee sitting on the wood stove and a few books. That's life here. It's good.

—Carol

Carol drives up to my house in a red pickup truck. She opens the door and uses her arms to lift and swing her legs out. She slowly stands, keeping her hand against the truck for support. She gives me a wide smile and a friendly nod and turns her concentration inwards. Each step is an effort: she consciously lifts a leg, swings it forward, pauses, transfers her weight, lifts and swings. When she notices me watching, she smiles briefly, then grimaces with the effort and continues. I hold the door, look toward Marsh Lake and wait until she has mounted the steps beside me. We go wordlessly into the house.

Carol was born into a military family. Her parents met in England, where she was born. Her father was posted to Whitehorse in 1957 where her younger brother and sister were born, but Carol says, "We bounced around like the military does." Carol grew up mostly between Whitehorse and Chilliwack, BC.

Carol says she was not a very good student. "I guess I was troubled when I was younger." She spent a lot of time with Sylvia Williams' (a frontier bush woman) family in Sleepy Hollow where she learned how to dumpster dive for food, shoe horses and work for big game outfitters. She got as far as grade 10 and quit to work full-time. "Anything you could do outside, that was the key." She ran equipment in mining camps and a buggy and a D8 Cat at a placer gold mine. "Then, I bounced down to Atlin, BC and ran a scraper for quite a few years." She saved money to travel in winter, mostly to southern BC.

In one camp, she sorted and screened nuggets in the gold room. She worked the mercury plates, the jigs and the tables. "We were allowed to buy an ounce of gold a month from the company." She laughs, "I'd set aside the nuggets I liked, and at the end of the month, I'd sort through and pick out the ones I really liked and buy them." That cache of nuggets prompted her to explore her creative side.

Carol took a goldsmith course and later got into carving. She wears her own ivory pendant.

"My friend Norma Shorty prayed over it for me and so did a Buddhist monk. I wear it quite frequently; it's like a little goddess." I say its flowing lines remind me of fish, and her face brightens. "Ah, salmon. I worship at the shrine of Coho; I go to Haines, Alaska, all the time. I love watching them come up the river with the tide—these silver darts shooting up the current. They're a beautiful silver colour when you catch them and they feed you so, so well and you thank them." She comes back to the present with a shake of her head.

In 1984 she qualified as a medic and worked on the oil rigs in northern BC. "They want a woman out there if they're good. The girls who went in there with the makeup and looking pretty had the problems. If you kept in mind the men had families then you never had problems. You had to go in there and be the buddy. Then they trusted us essentially. You learned that with age."

Finally Carol tells me about her physical state. "I turned fifty and I think my warranty ran out. I had cervical cancer and they got it all out." But her real struggle is the neck injury. It's been two years since a rock hit the truck she was operating. "My head went back and forth, from side to side, inside the cab. It took me almost eight months to convince my doctor something was really wrong. Turns out I was walking around with a totally collapsed disk and my spinal cord is flattened against my backbone." She will be in operation after operation for the foreseeable future.

She wipes away a silent tear. "I'm living in medical limbo, waiting and waiting. Pretty much everything that I did in my life is closed to me. I've been playing with my carving. I have to think about what I can do if I end up in a wheelchair." Then she puts her hands flat on the table and breathes deeply. "But my spine surgeon is going to bat for me and he's one of the top spine surgeons in the world. Actually, I'm lucky to be alive."

Wendy Fournier (Heikkila)

Coming Back to the Wilderness

Born May 20, 1952, in New Westminster, British Columbia

I keep coming back to my animals and the wilderness. Everything else in my life is conditional.
—Wendy

Wendy wears her soft brown hair below her shoulders. Her blue-checkered shirt is tucked into belted jeans over top of well-worn boots. She sits upright and pushes her bangs back with a calloused hand.

Our eyes connect and I feel that thrill of encountering a shy wild creature, ready for flight but willing to engage—for now. I smile, her shoulders relax and one corner of her mouth turns up. "I spent the morning going through my mom's old letters; they brought back a lot of memories."

Her mom, Sylvia Williams, was a fiercely independent woman who "believed the outdoors is where children belong and figured it was better to make a living than do school." Sylvia thrust her philosophy on her children, but Wendy says, "she had another side; she took in people of all ages who didn't fit in or lived on the rougher edge of life."

Wendy was born in New Westminster Hospital when her parents were en route to the Yukon. Although Sylvia "was bit by the Yukon bug," they returned to BC. When Wendy was seven, their father disappeared from their lives. Wendy says, "In total, Mom had seven kids with four fathers; she was different." Determined to lead a frontier life, Sylvia began moving north, first to a trapline outside of Anahim Lake, BC.

Then, in 1959, with her three young ones and two extra kids, Sylvia loaded a horse-drawn wagon and headed for the Yukon.

It was an epic journey filled with adventure—and tragedy. Outside Dawson Creek a drunk driver hit the wagon. Wendy closes her eyes, "There was glass everywhere and my horse jumped and landed on the roof of the car and his whole leg was just a big mash. They got him loose and he came up to me and put his forehead on my chest. Then the RCMP took him away and shot him. It was a rough go." Two horses were killed, the wagons were wrecked, but the family was unhurt.

After a year rebuilding her grubstake, Sylvia loaded up two wagons and three extra people and continued north. When she hit Marsh Lake, about 45 kilometres west of Whitehorse, they settled.

Sylvia occasionally took on jobs in town, charging Wendy with looking after the young ones. "I was on call 24/7, 365 days a year," Wendy says. "I would take the kids five miles up M'Clintock Road to this little shack to run the trapline. We didn't have any boots; we'd wear four pairs of socks, a plastic bag and another pair of socks over top so it didn't get slippery. We used to run around at 40 below." She laughs, "They were probably warmer than what we called those white-man boots."

Later, Sylvia moved the family to infamous Sleepy Hollow in Whitehorse and Wendy shudders. "That was Sodom and Gomorrah. Mom would not allow anyone to do anything weird in her own place but it was all around us. I had to leave at fifteen. I just had to get away from there."

With an incomplete grade 7, Wendy enrolled in vocational school and then took auto mechanics. She got work in a garage and says proudly, "Yeah, I had to prove myself but that's how I worked anyways; I worked hard. I fit right in." She was paid equal to the men.

Three days after her eighteenth birthday, she married and "that was a bad marriage. Back then, I had lots of guts but only when I was in the bush or with my animals." After her two kids, Kevin and Kerry, were born, she knew she had to get out.

Wendy moved a couple of kilometres down the valley from Sylvia's Fish Lake ranch and built a cabin. It was not easy but she says, "I stood on my own two feet and looked after my boys. I got a job over at the hospital working shifts and swing shifts. That was tough, but I was making it." When they grew up, her boys left the Yukon but she says, "one finally moved back home; he's out at the ranch."

Wendy smiles wryly. "I continued Mom's legacy with men." In her second marriage, now with Pierre, their relationship has been on-again, off-again for fifteen years. One relationship she grieves to this day was with Iron Man Bauman. "I ended up with him for two and a half years. He was a champion dog musher. He died of exposure out on the trapline. I'm still not over that."

Wendy shrugs. "I keep coming back to my animals and the wilderness. Everything else in my life is conditional."

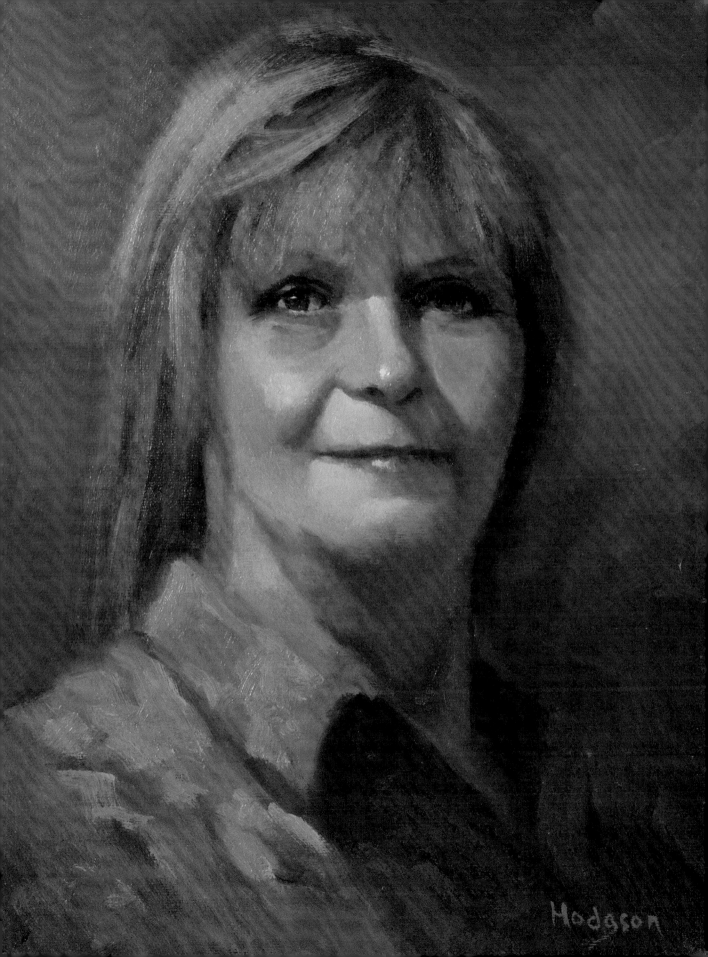

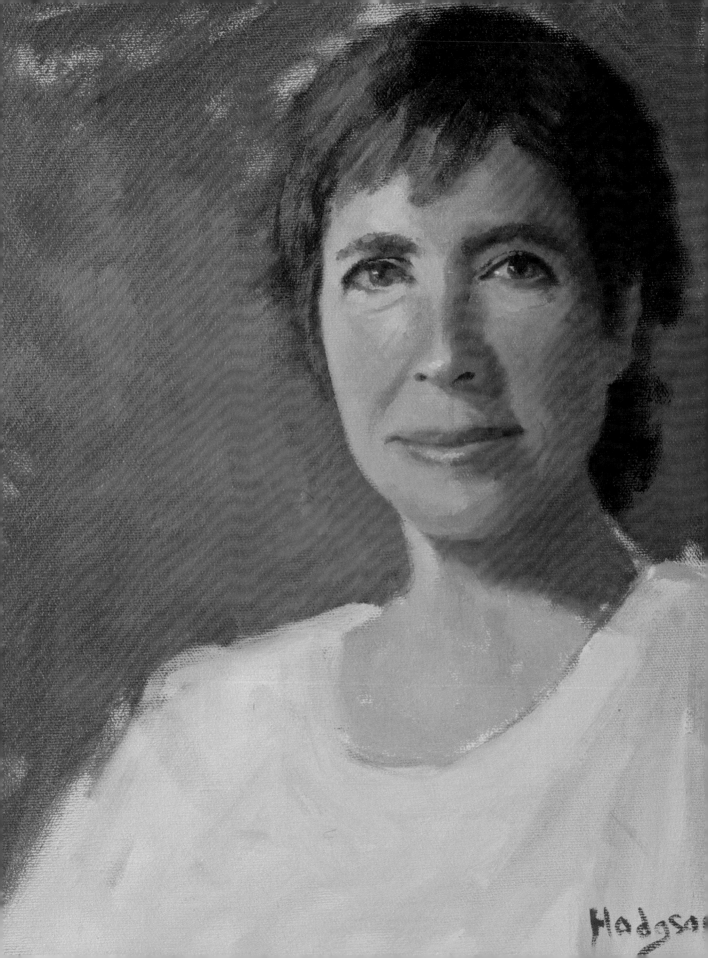

Miche (Michele) *Genest*

Woman of Passion

Born January 7, 1956, in Toronto, Ontario

The Yukon gave me the sense of anything being possible. If you want to do something, you can do it. It continues to feed that sense of possibility, exploration, adventure, discovering new things and new ways of being.
—Miche

Although Miche and her husband Hector live in downtown Whitehorse, their property has a country feel. The three-level light-filled home is spacious yet warm and set back from the street on a lot tucked close to the clay cliffs. Inside, the air is redolent with the sounds and smells of cooking: a caribou roast sizzles in the oven and a pot of caribou stock simmers on the stove. Their lab-husky cross, Bella, jumps and barks as Hector grabs her leash. When they head out for a walk, we begin.

Before coming to the Yukon in 1994 to visit her sister Anne Louise, "to take a break and make some money," Miche had been editing and writing for magazines in Toronto. She smiles. "I never left. A year later I went back to pack up my apartment and ship everything up here."

She first lived at Gruberville on the Mayo Road. "They rent cabins for very little money. Mine had electricity, but no plumbing, no running water and I heated by wood. I stayed out there for three years. I moved because I didn't have a vehicle and I was tired of hitchhiking." In 1997, she rented this property and a few years later, she and Hector bought it.

Meeting and marrying Hector, she says, "knowing we're in this for the long haul, is the happiest thing that has happened for me in the Yukon." Reconnecting in a deep way with her sister Anne Louise, seven years her junior, is another.

During those first years, Miche combined cooking three days a week with writing freelance, which, she says, "was great, but I was poor. Now, my day job is working for the federal government. I like the job and it enables me to follow my passions: writing is my number one passion and right after that, cooking."

She pens "The Boreal Chef," a magazine column featuring northern-style recipes, and has recently compiled her favourite recipes into a cookbook entitled *The Boreal Gourmet*. Cookbook writing is a long process. "It's fun and scary and challenging. Some days I wish that I had never seen an egg or had to measure out a cup of flour, but then friends sample a recipe and I get all excited and rejuvenated."

Miche is a woman of many passions. Running and hiking are two more. "In the Tombstones Mountains, we hiked all day and camped at Divide Lake. From there we could see our route down. There's something really cool about knowing that you can make your way through that landscape with your own feet all those miles."

As much as she enjoys hiking, she says, "Running carries me. I love knowing I'll just be running for two and a half hours and that's all. It's that feeling of time rolling along and you're rolling along with it."

She and Hector, together and individually, have a close circle of friends and a broader circle of like-minded people with whom they share their outdoor passions. They are active in the wilderness in the winter and the summer.

One of those friends invited Miche to be a member of the Paddlers Abreast voyageur canoe team in the 2003 Yukon River Quest canoe race. At 740 kilometres, it is the world's longest canoe and kayak race and attracts athletes from around the world. But her team wasn't about competition; this Yukon-based group of women raises money for breast cancer research. "Every woman in our boat had been touched in some way by cancer and each was living with every cell of her being. But it's a tough go. Even with a team of eight people, there were challenges. Sometimes you're paddling fast asleep. I learned to just grin and bear it no matter what, whatever aches and pains, you paddle through it." Miche says she has a lasting bond with the people in the boat.

Of personal growth in the Yukon, Miche says, "Nothing is in the way except your own skills, abilities and talent, and you actually have the space and safety to develop those here. It's away from the eyes of the world. It was a great place to incubate, to tuck away and work in a small public. I no longer feel that need for incubation, but the sense of possibility continues."

Patricia Robertson

Pulled Back to the Basics

Born January 15, 1948, in Manchester, England

The growth of the literary community here in the last twenty years has been amazing and I'm privileged to have been a part of it. Here I can make a difference and be part of the community and be recognized as a writer of the community. It's not because I want the attention but because I feel that's who I am.

—Patricia

Patricia Robertson is a central figure in the development of the Yukon's literary community. She knew from childhood that she wanted to be a writer and obtained an English honours degree as well as a master's degree in creative writing from Boston University. Still, she dabbled in writing while "making a living" until a serious car accident shook her. "I remember lying there thinking, 'Here I am, thirty-seven and I nearly died, and I haven't done what I intended to do, so I'd better get doing it.'"

Patricia did get on with it. She wrote a radio play that aired on CBC Radio and began working on her first collection of short stories. She was accepted into the Banff Centre for the Arts writing program. She went to a writers' conference in Port Townsend, Washington, and lobbied to be included in a Seattle writer's group even though she was living in Vancouver. Through Banff, one of her short stories was accepted for an anthology published by John Metcalf and Leon Rooke.

Another milestone prompted her, despite her terror, to plunge deeper. She thought, "I'm turning forty; I'm quitting working for a living. I don't care if I am a bag lady in a year, I either do this or I die." She paid off her debts and with funds from a Canada Council Explorations grant, went to England to research a novel. "It never got published," she says, "and I think of it now as my apprentice novel." When she came back, she wondered, "Now what am I going to do?" She was out of money and doing temp work to have more time to write.

Browsing through *Quill and Quire* magazine one day, she saw an ad for a writer in residence in Whitehorse. The Yukon Library brought her up for four months in May of 1990 and she says, "At the end of four months, I just wasn't ready to go. I had no base left in Vancouver; my place had been sold. In retrospect I believe the way was being cleared." She approached Yukon College with an offer to teach creative writing courses. She stayed and that fall met her partner Erling Friis-Baastad.

They lived in Whitehorse for two years before moving to Victoria, BC, for two years. She lifts a shoulder. "I mourned for Whitehorse. I don't know what it is about this place that gets into the blood. I had been in Vancouver for twenty years and I felt totally, utterly urban. The last thing I wanted to do was live in a small town. But the Yukon must be a creative power spot; Banff is like that, too. I really missed it, although I felt ambivalent about it for a long time after we came back." In the last few years her attitude has become "far more accepting of it as it is. Whitehorse, on the surface, looks like a practical northern town and yet the things going on under the surface are so interesting."

Patricia believes the best thing about the Yukon is the dynamism of the community. "It seems to attract adventurous and interesting people who want something different and who are willing to take a risk." She says the worst thing in some ways is also the best—being so isolated. "If we weren't so isolated I don't think we would have the intense kind of community that we do have. If people could drive down the road one hundred miles to a bigger city, Whitehorse would be very different."

The isolation has afforded her opportunities: "I was on the National Council for the Writers' Union of Canada for two years. That connected me with writers from across the country. I've also met a number of writers through the Yukon's writers' residency program who came north."

But it's the North itself that keeps Patricia here. "I feel pulled back to basics for the elemental aspects of human life here. You can pretend in a city that you're in control but here you know if you broke down between Whitehorse and Carcross at 40 below, you better hope somebody turns up or you're well-prepared because you could die. The natural world is in charge in a sense and you are not. It's healthy to be reminded of that because many of us forget that."

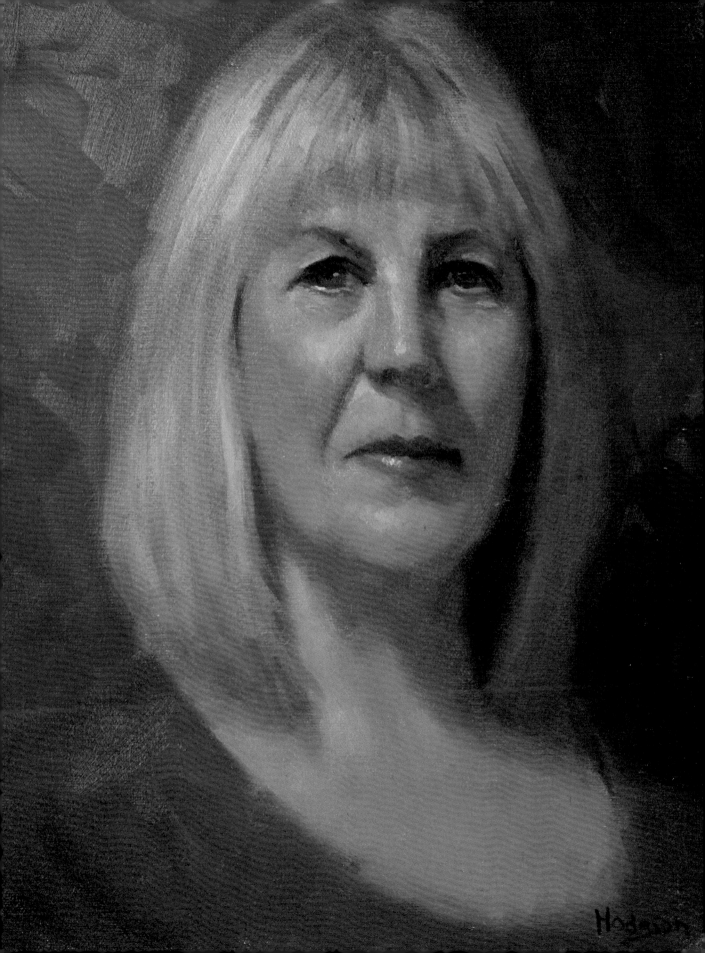

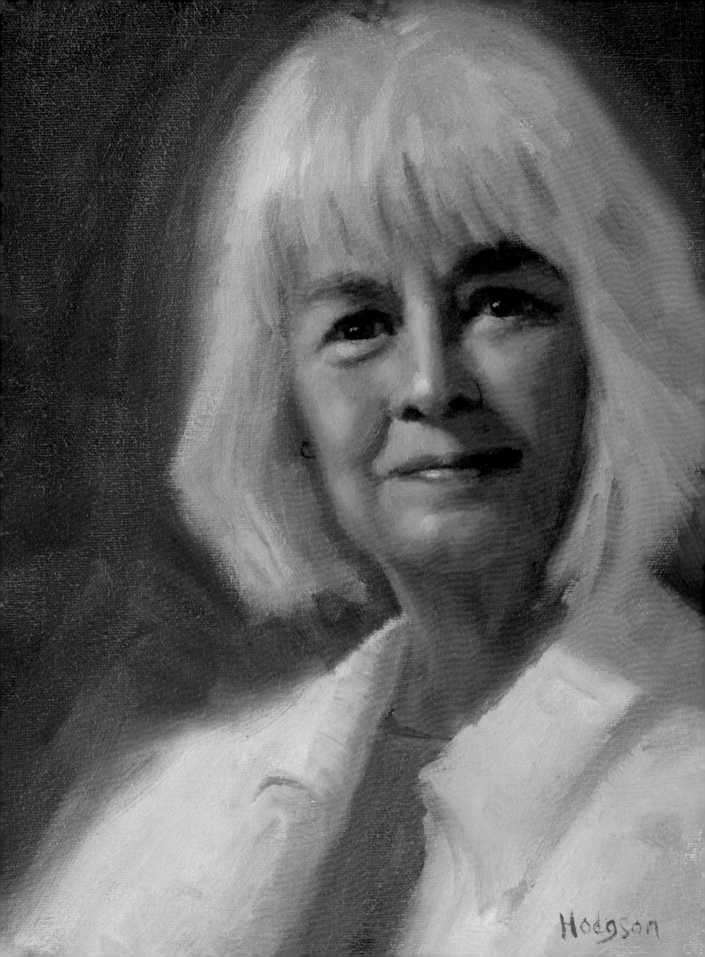

Susan Staffen

When Friends Become Family

Born September 21, 1947, in Vancouver, British Columbia

In the Yukon, our friends became family. In times of sorrow or trouble or happiness, they are always there to support. When our son was young, he did not understand that our friends' kids were not cousins. They're not blood cousins—there's a bit of a difference, there has to be—but nonetheless, they're all very good friends. Friends make where you live home.

—Sue

Sue, trim in a pale blue T-shirt and matching track pants, nervously pours coffee into two Ted Harrison mugs. She smiles faintly, looks over my left shoulder and says quietly, "I'm not one to talk about myself. You'll kind of have to drag it out of me. I'm really quite shy." As we speak, Sue's understated strength of character begins to reveal itself.

When Sue graduated from high school in 1965, her sister's husband was stationed at the air force base in Whitehorse. She says, "My sister was pregnant and didn't know many people. Her husband was ordered to Alert, Northwest Territories, and would be gone when the baby arrived so she asked me to stay with her."

Her sister had the baby and she left with her husband when he was transferred to Germany but Sue stayed. Sue began working in clerical positions and over the years she progressed to bookkeeping, accounting and office management. She attributes her growth to on-the-job training, a willingness to learn and her desire for a steady income because she and her husband owned small businesses.

First and foremost, friends are what make the Yukon home for Sue. The Lang family is "kind of like our extended family." She became friends with the Lang brothers, Archie and Dan, when she first arrived as a teenager. She even met her husband, Ted, through them. Over the ensuing years, their friendships have deepened through their marriages and careers, and their children's childhoods, school years, university years and now their children's adulthood. Sue says, "In times of sorrow or trouble or happiness, they are always there to support. We are very supportive of each other and our kids are the same way."

Another aspect of northern living Sue loves is sports. She says, "I did things here that I couldn't have done in the big city where there is so much more competition. I was able to compete in basketball at the first-ever Arctic and Canada Winter Games and in softball at the Canada Summer Games. Had I stayed in Vancouver, I would not have made the team. I was not that good."

Later, Sue took up running. She can be out her back door and on the trails in two minutes. "Sometimes I won't see another soul for an hour." She says she does not compete but participates. She enters the Mayo Midnight Marathon half-marathon because "it's such a good community event. It's wonderful running through midnight—just novel!" She also runs the half-marathon in the Yukon River Trail Marathon. She says it's a beautiful run, but, "There are a lot of big hills in that baby."

Her signature event is the Klondike International Road Relay. She counts on her fingers, "I've run all ten legs; I've done Leg 1 twice, Leg 4 three times, Leg 10 twice and I'll do Leg 8 for a second time this year. That makes fifteen times, I guess." Sue plans to keep running because "now it's even more fun. Ted and I are very close to our children and I was hoping I could keep running until they were ready to do it. This year, my daughter Bailey and I are running on a team together. My son Jess and I ran the Yukon River Trail half-marathon twice. Next year, Ted wants to run the Klondike Road Relay so all the family will run together." Sue's face glows with the thought.

Sue has had a few special moments on the Yukon's trails. "Jess and I were hiking King's Throne above Kathleen Lake. He would have happily stopped for a break and the dog was really tired, but I pushed, 'We're almost there; let's go to the top until we stop for a water break.' We got our heads above King's throne and there was a bear browsing nearby. He decided to stroll over and see what we were all about. He got so close Jess had to use the bear spray. He was big, but he wasn't mean. He was just curious. We had to turn and start running downhill to get away from him." But bear encounters do not deter Sue from running.

She sighs and smiles. "I have a great life. I have two wonderful kids, a great husband and we live in a wonderful place."

Thérèse Lacroix

A Shining Light

Born April 16, 1950, at Notre-Dame-des-Laurentides, Québec

One summer, Bertrand brought our old tent trailer to Marsh Lake and I stayed there. It was a mild summer—the water at Marsh Lake was warm for once. Every night, I would go for my swim. I'd go into the water slowly—I walked and walked and walked into the lake—until the water was up to my chin and I was almost floating. I was by myself—all alone. All I could see was the water, the mountains, and the snow. The feeling was incredible. After that, whenever I would do relaxation exercises where you have to think of that special place, in my mind, I would go there. It was a very spiritual experience.

—Thérèse

Thérèse and her husband, Bertrand, greet me together. They tell me they revel in every stage of their forty-year marriage. Now empty nesters, their Riverdale home is filled with family photos. Thérèse gestures expansively with arms and hands as she speaks and punctuates her statements with "Oh, la, la!" a sure sign that her Québécoise *joie de vivre* remains intact. Thérèse was raised on the outskirts of Québec City totally in French, but her lack of English did not stop her from moving with her husband to northern Ontario at the age of eighteen. Seventeen years later, when they moved with their three children to the Yukon, it soon became her home.

A stay-at-home mom during her years in northern Ontario, Thérèse learned English by watching *Sesame Street*, talking with her children and looking after other teachers' children. When her daughter showed an interest, Thérèse organized the Francophone equivalent of the Brownies and Girl Guides in northeastern Ontario. In 1985, she received the Ontario Lieutenant-Governor's award for her leadership skills.

When the family moved to the Yukon, Thérèse immediately felt welcome. "People are much more open to Francophones in the Yukon," she says. "Because I was French, I was different, but I never felt out of place. My English improved very much because I felt more comfortable."

Thérèse started a program for the city of Whitehorse called "French Fries," teaching French language to preschoolers. In the beginning, she taught at a facility in Porter Creek, but she says, "Then I said I would prefer to do it in my own house and the city approved it. I had a huge deck and more than half of my basement was open." While she ran the program, she completed the early childhood development studies program at Yukon College.

Thérèse also established the French Girl Guides in the Yukon. She says, "Altogether I was involved for ten years as a leader." For her community contributions, she was one of the first five women to be awarded Yukon Woman of the Year and the first Francophone to receive that honour. Thérèse is humble about her contribution but her face lights up as she recalls, "They gave me a painting of two little native girls picking cranberries and every year I go to Marsh Lake to pick cranberries and so to get the painting of berry pickers was really special."

When the kids were small, Thérèse and Bertrand took them camping in a tent trailer. The family saw the Atlantic Ocean, the Pacific Ocean, and the Arctic Ocean. Thérèse loved it. "I'm an avid cook; even in my little trailer you will have a gourmet dinner in there. All the time I read recipe books. Yes, it's a little bit of an opium for me."

Another passion is quilting, which she started after she retired. But Thérèse says it became much more than a hobby a few years later when she was undergoing cancer treatments. "When I was sick, I made quilts for four of my nephews and nieces and my grandson. It was really good therapy."

Two years later, she had just been for a checkup and says, "So far, everything is good. Now, I go to line dancing, cycling, tai chi and I walk." She takes great pleasure in the Yukon. "I like the outdoors the best about Yukon. When people come to visit, I say, 'Look at those mountains. The nearest town over those mountains is Edmonton.' We have so much room for every Yukoner. I'm very happy to be here."

Thérèse's greatest joy and the part of her life she's most proud of are her husband and their children: Martin, Katherine and Denis. Her eyes shine. "I'm so glad we're at this point in our lives. When your children leave home, you feel torn apart, but they're doing fine and now we enjoy our lives, Bertrand and I. We're best friends." She smiles and places her hand on Bertrand's forearm.

Thérèse Lacroix, a shining light to many, passed away from cancer on December 18, 2009.

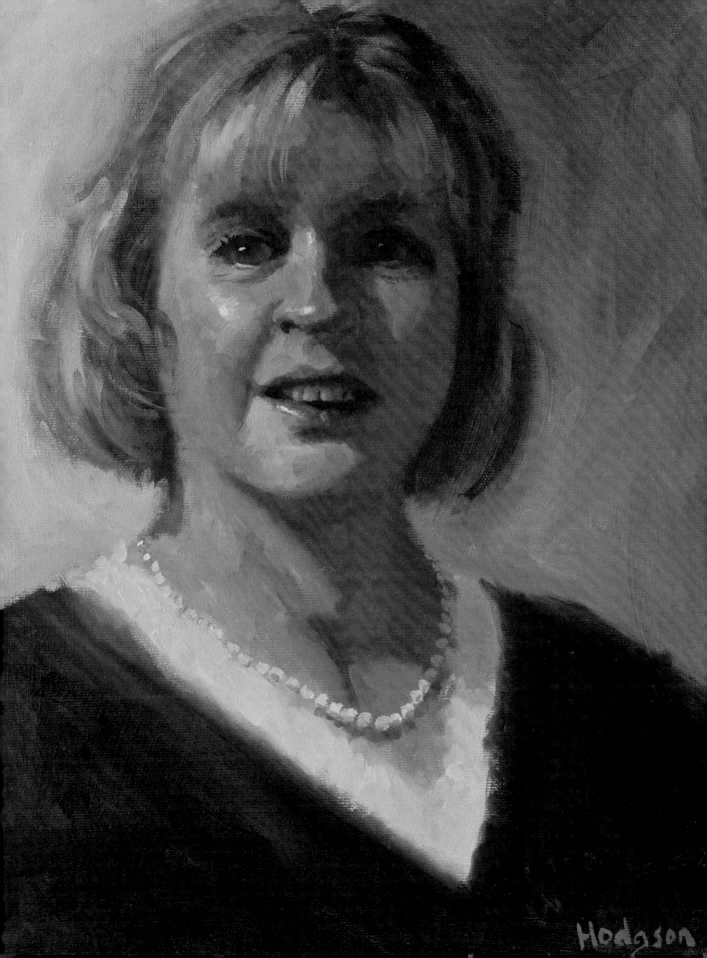

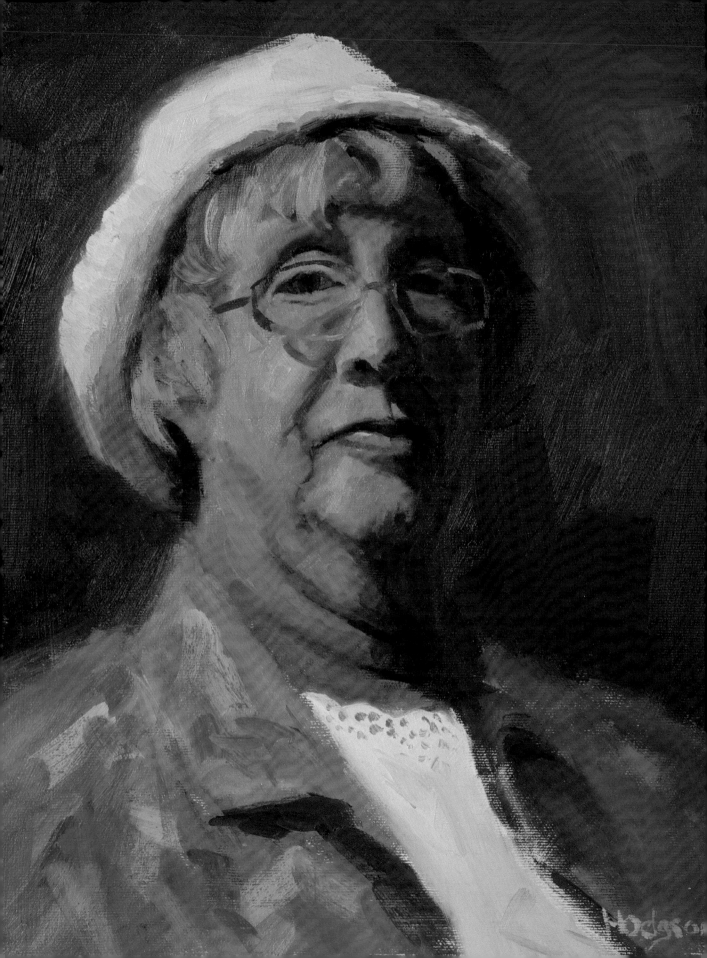

Dorothy *Burke*

Dedicated Organizer

Born October 5, 1939, in Stettler, but grew up on a farm near Alix, Alberta

My organizational skills are probably hereditary. My great-aunt Irene Parlby was one of the "Famous Five" women of Alberta who fought and won the battle for women to be recognized as "persons" under the British North America Act.
—Dorothy

Dorothy meets me at the Canada Games Centre in Whitehorse; I arrive as she is waving goodbye to the carpet bowlers and putting away the equipment. A compact, bustling woman, she speaks in bursts, stopping and starting quickly. Dorothy says she and her husband, Ken, work as a team in many ways, both at home and out in the community.

It was a desire to spend more time together that prompted Ken and Dorothy to move their family of three to the Yukon in 1977.

Dorothy, "a born and bred Albertan farm girl," decided very young, "I wasn't going to get married before I was twenty-five and I had to go and see Europe first." After high school, she completed a home economics course at Olds College and worked for four years with the department of agriculture in Lacombe, Alberta. She smiles. "Then I quit and went overseas for two years and travelled around Europe."

When she came back to Calgary, she went to work and she joined the Swinging Singles square dance club to socialize. That's where she met Ken.

They married on July 31, 1965; Dorothy was twenty-five. She says, "Our square dance club was big and about nine couples got married that same year." She tells me "In 1986, nine years after we were living in Whitehorse, we were at the grocery store one day and bumped into Barb and Blaine McFarlane, whom we knew from the Calgary Swinging Singles." They had moved to the Yukon and just like Ken and Dorothy, they joined the Sourdough Stompers square dance club. That club was the source for forging a very close circle of friends.

From the time they were married until 1977, Dorothy and Ken lived in Calgary. Ken worked on construction jobs in the summer and odd jobs in the winter and in between the arrival of their three daughters, Dorothy worked at University of Calgary. "But," Dorothy says, "Ken was gone basically all summer and he got tired of being away from the family. We talked it over for many evenings and decided we hadn't been to the Yukon so we packed up everything, sold the house and moved. Jennifer was five, Natoline was about seven and Anita was ten." The girls now live in California, Alberta and Ontario.

Within a week, Ken was working at Canada Flooring, a job he remained at for twenty-one years until he retired. Dorothy worked in retail for three months and then got on with Public Works Canada and later with the Government of Yukon. Her main career was in material management.

With a nine-to-five job and weekends free, the Burkes took up camping. She says, "We had a twenty-eight-foot riverboat and we did the Teslin River several times. One of our most memorable trips was when we took our daughters and some of their friends far up the Teslin and camped for five days. It was sunny the whole time and we had a campsite all to ourselves." Ken and Dorothy also did the Stewart, Yukon and Rose rivers.

Dorothy has been an avid gardener since the age of six, but her passion for quilting came much later. A regular competitor in the Yukon Agricultural Fair, she has won a number of awards. She credits part of her success to the greenhouses and special garden bins Ken built for her, explaining, "The area that used to take me a day to weed now takes about an hour to weed and cultivate."

As for quilting, it caught her interest in 1988 but didn't get her full attention until after the children were grown. She belongs to the Kluane Quilters Club, which organizes quilt shows and workshops, and to the Pinetree Quilters, who meet regularly and hold quilting retreats. She was the regional representative for the Canadian Quilters Association for four years.

Ken retired in May 1998 and Dorothy followed in April 1999. She says they are busier since they retired than when they worked. They are key organizers for the ElderActive Recreation Association and on the board that organizes and co-ordinates events for Team Yukon to attend the Canada Plus 55 Games held every two years.

Dorothy keeps herself and her activities organized by using to-do lists. "That way," she says, "nothing gets forgotten or overlooked, hopefully."

Ken and Dorothy were jointly nominated for the Yukon Volunteer of the Year award in recognition of their contributions.

Velma *Hull* (Lyons)

Everything Comes Easy

Born June 11, 1932, in Lousana, Alberta

If I had a major accomplishment in my life, it was marrying my husband and staying married. I was not an achiever; things fell into place for me. For some reason or other, everything came easy.

—Velma

Velma welcomes me to her cozy house in downtown Whitehorse and invites me to come through to the kitchen. As I walk through the living room, I stop short. Four white-frosted wedding cake tops are featured in the buffet instead of the customary chinaware. Velma laughs. "It's a long story."

Born in Alberta, Velma was a shy girl who joined the Air Force "because my older brother was in the forces and he told my mom it would be good for me." She was stationed in Falconbridge and met her outgoing husband Red Hull in nearby Sudbury, Ontario. Two years later they married. They moved seventeen times in the next seventeen years, following mining jobs from Ontario to the Yukon to Alberta to Quebec and back to the Yukon in 1967. They raised four children—one born in Hamner, Ontario, the next in Red Deer, Alberta, the third and fourth in the Yukon, in Mayo and Whitehorse respectively. They bought their own house—this one—for the first time in 1971 and have lived there ever since.

Velma took all the moves in stride. She laughs easily, "We didn't have a lot of stuff. We lived in trailers, we lived in houses, and we even lived in a tent." She describes the place they rented when they first came to Keno City in 1958. "It was a little frame building. There was a mattress on butter boxes, a crib and dishes. After the first day, I decided to scrub the floor. There was dirt between the floorboards, so I started to dig it out. I could see the ground right through the floor." They moved to a snug log cabin soon afterward.

In all their different stints mining, Velma's most memorable experience is the 1966 No Cash Mine fire in Elsa. She recalls, "We had sold all of our belongings, except our sleeping bags and stuff that we needed to travel. We were leaving after shift the day it happened. The fire started at eleven in the morning and they called me about two in the afternoon. I didn't think too much about it but when four o'clock came, and Red didn't come home, it hit. Ella McCullough was at my house from five o'clock that night until after five the next morning, and

there were other neighbours that came and went and came and went.

"By the next morning, all of the miners were rescued, but four miners lost their lives. I saw the wooden boxes, the coffins, as they were driven right past our house. Red was one of the last three miners out alive. I found it very bad afterwards. I just wasn't sure of anything. When he went away to work in a mine again, about a year after the fire, Red developed claustrophobia."

They moved to Alberta where Red worked at a sand and gravel outfit. But he was offered a higher paying job to be part of the crew opening the Faro Mine, so they came back to the Yukon. Then the family moved to Carcross and he worked at the Venus Mine. When he "finally got fed up with mining," he took a job with White Pass & Yukon Route at the "tank farm," a fuel storage facility.

Wherever they lived, Velma was involved in "anything my kids were in." In 1971, White Pass moved Red's job to Whitehorse and the Hulls bought the house.

Being in one place was not easy for Velma. "For the first seven years, there wasn't a spring that I didn't want to pack everything up and move!" But Red had opened a bicycle shop, which rooted them. Velma eventually got over her wanderlust, to the point where Red had trouble convincing her to go on vacation. Velma worked for Supply Services with the Government of Yukon, while also being involved in the bike shop, until she retired.

During winters, she still works every Saturday at the Whitehorse Visitor Information Centre. Their children are grown now—three live in Whitehorse and the other is in Red Deer.

As for the cake-tops in the hutch, Velma planned to save her wedding bouquet but it had been spoiled, so Red suggested they keep the top layer of their wedding cake as a memento. It made every move with the family. The other cake tops commemorate their twenty-fifth, fortieth, and fiftieth wedding anniversaries. Velma says, "Life has been a blast. I wouldn't change a minute of it."

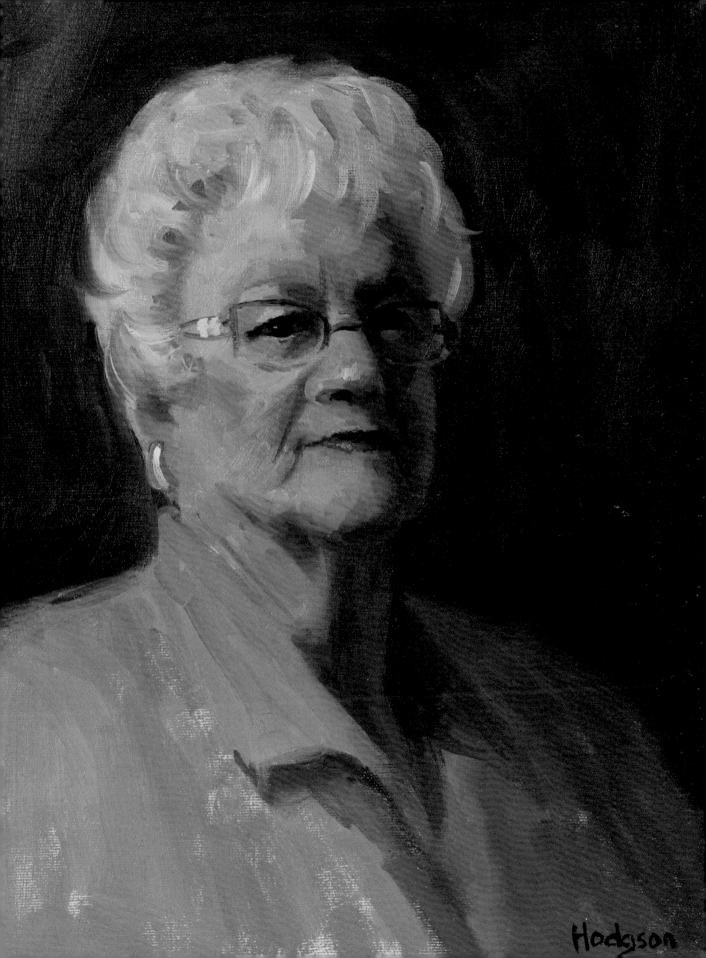

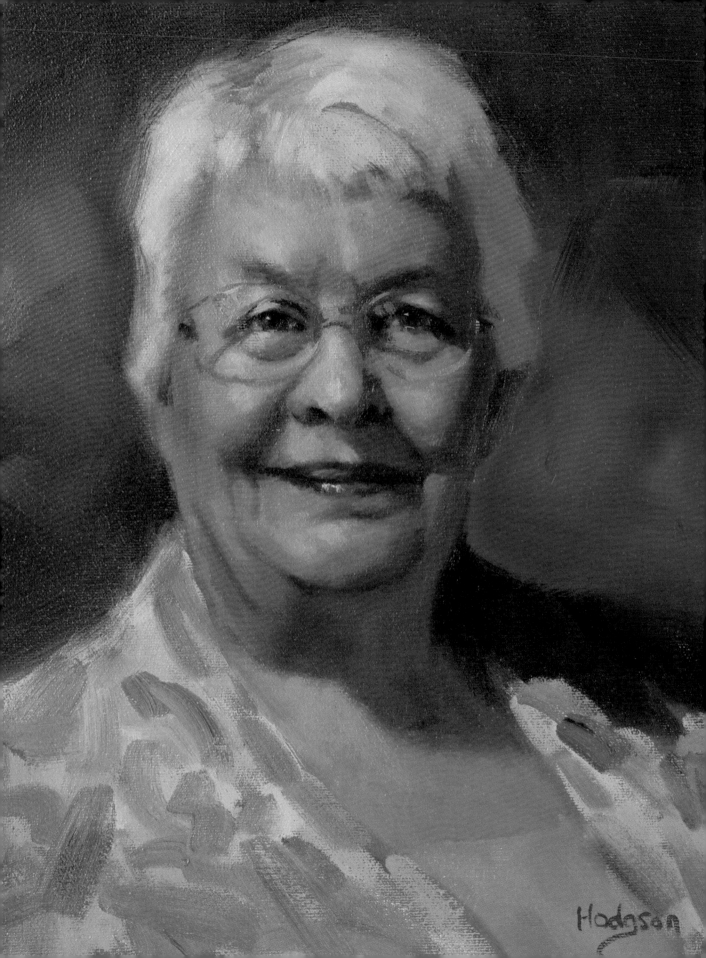

Phyllis Simpson (LePage)

Yukon Kid

Born July 1, 1930, at Yukon Crossing, Yukon

When we arrived by floatplane in Fort McPherson, it seemed like the whole town was out to meet us. After we'd lived there for a while, this Native woman said, "You disappointed us. Most Mountie wives get off the plane in short, tight skirts and spiked heels. What did you do? You and your three girls get off in blue jeans, gumboots, and fringed suede jackets. You disappointed us all." That's what growing up on the Yukon River did for me: I could handle the bush life.

—Phyllis

Phyllis greets me at her condo door, pushing a walker that "keeps getting in the way." She smiles. "Don't mind me. I go slow but I can still talk a mile a minute. I was shy and quiet as a kid, but I've made up for it since I retired."

Phyllis was born in the Yukon Crossing roadhouse, which her mother ran until Phyllis turned two. Phyllis states emphatically, "Growing up on the Yukon River was the best part of my life." She concedes her life was rough in spots, especially as an RCMP wife when the family was away from the Yukon for ten years with four transfers, but she emphasizes, "I enjoyed every part of my life."

Almost every story Phyllis tells of her childhood includes her father. She went everywhere with him. "I idolized my dad and he taught me so much. He taught me how to get my bearings and track in the bush; I'd never get lost. I was the deckhand on our boat; I'd do the sounding and the tie-ups. This was my job."

Phyllis's only sister was born when she was six years old. Her dad supplied wood to the steamers, and at one time operated five wood camps: Yukon Crossing, Rink Rapids, Lake View, Carmacks and Meyers Bluff. Phyllis proudly nods when I ask if LePage Park in Whitehorse was named after him. "After the steamers stopped running, he owned a garage and operated a trucking company. He was involved in building the airports at Snag, Whitehorse and Braeburn." He was inducted into the Yukon Transportation Hall of Fame for his contributions to opening the North.

Being her father's side-kick, it's no wonder Phyllis developed a different outlook on life. "I wanted more than to just get married and have kids right away. I decided to work and save money to get an education." She completed a secretary clerical program at Garbutts Business College in Calgary. Upon her return, the manager of Northern Commercial offered her an office job, and that is where she met her Mountie.

Phyllis and Jim waited three years to marry because at that time, RCMP were required to be in the force five years, be twenty-four years of age, and have twelve hundred dollars in the bank. No easy task when, Phyllis says, "He made under a hundred dollars a month." Luckily, they remained in Whitehorse for a number of years before being transferred.

In the following ten years, they moved four times and Phyllis laughs, "It seemed every transfer, I got pregnant. But when I got to Fort McPherson, I said no way." They had three girls, the first in Whitehorse, the second in Erickson, Manitoba, and the third in Nipigon, Ontario. In addition, they had two postings in the NWT—Fort McPherson and Inuvik. But Phyllis was lonesome. "A transfer to Iqaluit was coming but the OC [Officer Commanding] said, 'Phyllis, you'd like to go home, wouldn't you?' and I said, 'Oh, I'd give anything to come home.'" A few weeks later, they were transferred to Whitehorse. "We were here one year and Jim was being transferred to Ottawa. He was thirty-nine but he had his twenty-some-odd years in and he pulled the pin." They never left again.

Jim eventually worked at the courthouse until he retired and Phyllis worked at several jobs until she got into government and found her niche in communication and transportation. Their girls live Outside, two in Alberta and one in BC.

When the girls were older, Phyllis and Jim bought motorcycles—a Night Hawk and Yamaha 250 and a Gold Wing for cruising together on longer trips. Phyllis says, "Every May long weekend, the whole Gold Wing crew would end up in Skagway and we'd have a big barbecue." Jim retired at the end of June and they were planning a four-month bike trip down the highway the following spring. But it never happened. He was diagnosed with cancer and was gone on March 30, 1992.

For the past few winters, Phyllis has worked Saturdays at Whitehorse Visitor Information Centre, sharing her adventures about life on the Yukon River in the time of the steamboats.

Ione J. *Christensen* (Cameron)

From Fort Selkirk to Ottawa's Senate

Born October 10, 1933, in Dawson Creek, British Columbia

I stood my ground. Sometimes it was awfully hard, but I've always felt comfortable with my decisions.

—Ione

Ione is a tall, powerful-looking woman and one of the Yukon's most recognizable public figures. From sharing her family's famous Klondike-era sourdough starter and "always taking somebody" over the Chilkoot Trail (twenty-one times), to becoming mayor of Whitehorse, commissioner of the Yukon, and a senator in Canada's parliament, she has served the territory—and her country—in small and big ways.

Ione grew up in Fort Selkirk, a trading post and traditional home to the Selkirk First Nation. Located where the Pelly meets the Yukon River, and halfway between Whitehorse and Dawson City, it was a major supply point during the sternwheeler era. Her mother, Martha, was the lay nurse and her father, G.I. Cameron, was the Royal Canadian Mounted Police corporal.

An only child, Ione didn't lack for attention. She laughs, "I was spoiled rotten. The trappers doted on me." With her own dog team, she set a trapline and sold her furs to the Hudson's Bay Company. But when it came to schooling, Ione struggled. In her twenties, she would learn she had dyslexia, "but back then, nobody knew what it was."

At twelve, Ione went to boarding school on Vancouver Island. Even though the school focussed on outdoor activities, this bush girl did not fit in well. She says the experience taught her self-reliance and strengthened her will, and she learned how to be a lady. She excelled at sports. "I always seemed to be in a leadership role." Academically, "I loved reading and my teachers really helped me."

In 1949, Selkirk shut down and her parents moved to Whitehorse, where Ione finished high school. Afterward, she went to California and completed a two-year business administration course.

In 1955, she came home and worked at Taylor & Drury General Store. "One day," she says, "a guy came in to pay the account for CanAlaska Mining and he was so tall he knocked down the overhead sign. I thought, 'This guy is for me.'" Art Christensen had the same idea about her. They married in 1958 and the following year built the house they still live in today. Their two sons, Paul and Phillip, live in Whitehorse.

Until 1967, in between being a stay-at-home mom, Ione worked for the Government of Yukon in a variety of administrative positions. In 1970, the justice department asked her to become the first woman justice of the peace and later appointed her a judge in the Juvenile Court. She says, "I felt I was doing something useful in those positions. These people were victims of circumstance."

She sat on Whitehorse's city planning board and recalls, "When Mayor Paul Lucier resigned to accept an appointment as senator, he urged me to run for city council." At this and all political opportunities, Ione states, "I called a family conference and Art would invariably say, 'Well you know not many people get a chance to do something like this, so give it a try.'" She ran against seven male candidates and won in a landslide, becoming Whitehorse's first woman mayor.

In 1979 Ione served as commissioner of the Yukon but when the federal government instructed her by letter of authority to implement changes affecting the Yukon's autonomy and relationship with Ottawa, she refused. "Changes to government must be backed up by legislation. This had not been done and I felt the only thing I could do was resign," she states. She had held the office for nine months.

After reading up on all three party philosophies, Ione agreed to run for the Liberals in the next federal election. She was defeated, but "I feel that in many ways, I won. I wasn't ready for it and the kids were just thirteen and fifteen." She then worked out of her home until the boys were grown but kept involved in the community.

In 1999 Prime Minister Jean Chrétien appointed Ione to Canada's senate. In Ottawa she worked on many issues, including involvement in how to mitigate the effects of fetal alcohol syndrome, a cause she serves to this day. Ione resigned from the senate early to be at home with Art, who was losing his vision.

She straightens. "The thing that gave me the greatest satisfaction was to sponsor the changes to the Yukon Act through the senate and see that legislation passed by Parliament." She squares her shoulders. "It took twenty years, but it happened." Both Ione and her father are members of the Order Of Canada, but she says as she gazes out the window, "Of all my accomplishments, my appointment to the senate is the one I loved. I was so proud to serve the Yukon in that capacity."

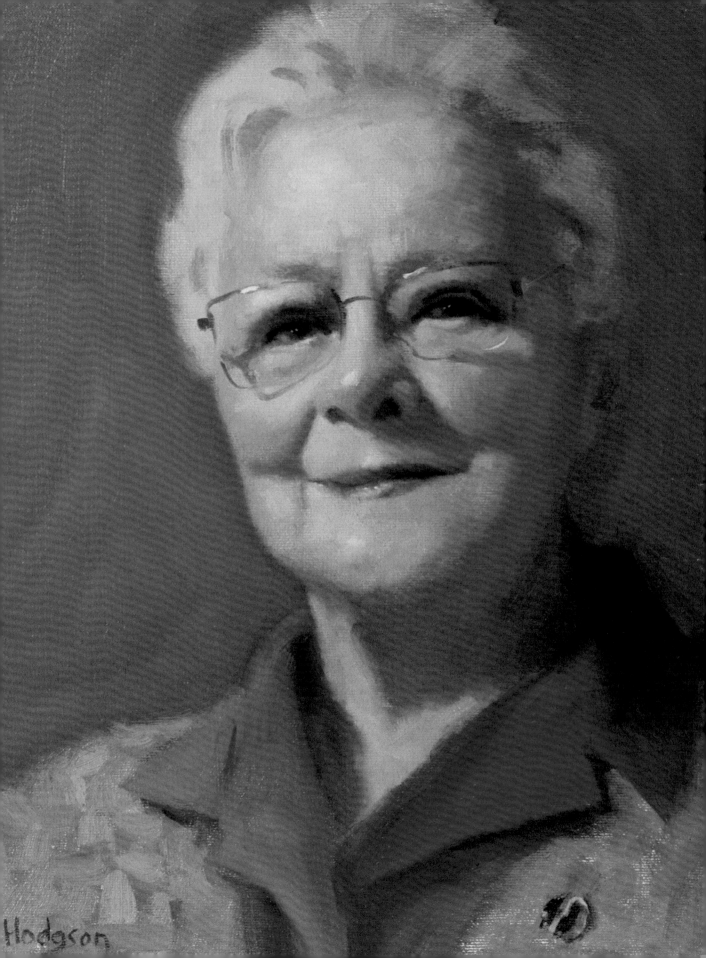
Hodgson

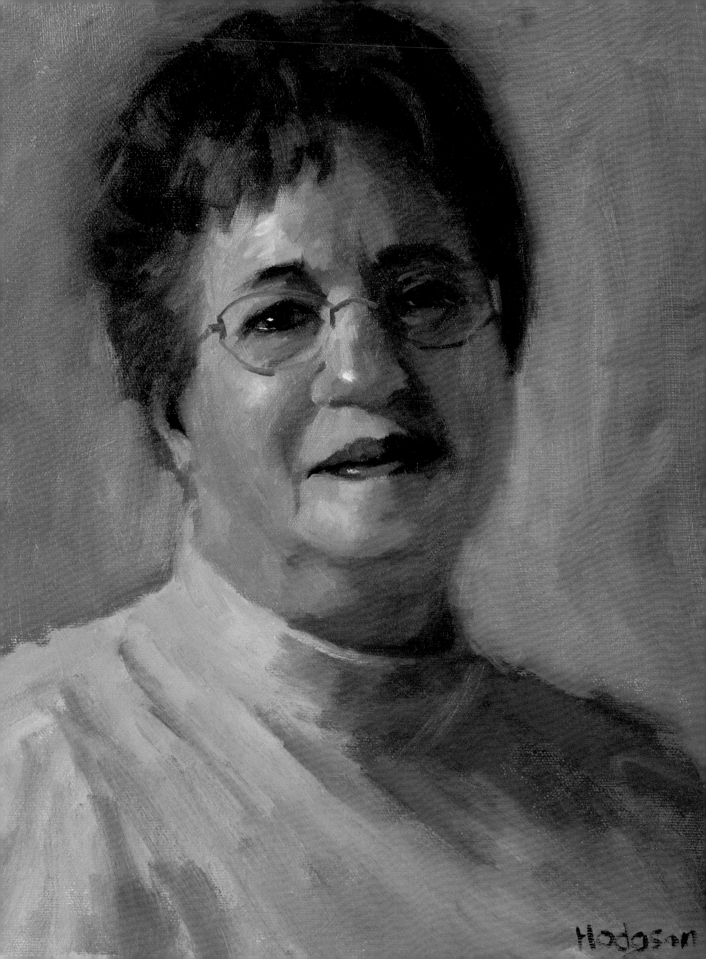

May Blysak (Black)

Going Over the Edge of the Earth

Born March 14, 1939, in Fernie, British Columbia

When we left southern BC for the Yukon, my uncle, who had never travelled, thought we were going over the edge of the earth for sure . . . and when we got out there north of Pelly, I thought maybe he might be right.

—May

May and her husband, Clarke, first met in Jaffray, BC, where she taught and he worked for the BC Forest Service. After they married and had their first child, May gave up teaching and never went back to it, but Clarke got his degree in education and it became his career.

As their family grew to three—Steve, Karen Lee and Patti—May stayed at home and Clarke taught. But he wanted to get into administration, which was really difficult in BC, so in 1977 he applied for and became principal at J.V. Clark School in Mayo, Yukon. They stayed only three years in that community but the Northern lifestyle kept them in the territory.

When the family moved to Mayo, their youngest, Patti, was nine and May got a job in an office, "which was no responsibility," she says, "compared to being a teacher." She had a hard time adjusting to the community but says, "Something good came out of our time there. Our son Steve married Alla, a Mayo girl, and we cherish her."

Next, Clarke became principal of the Watson Lake Elementary School and May really liked living in Watson Lake. She smiles. "We didn't really want to leave but after two years, the school superintendent told my husband 'You probably should put in an application for Jack Hulland School in Whitehorse.' He did and got the job and I've always been happy here."

It turned out Clarke didn't like administration as much as teaching. In his last five years before retiring, he went back to the classroom. He especially liked working with the kids who would drop out if they didn't get turned around.

Some of May's favourite memories are of camping and fishing outings, at Ethel Lake in the Mayo area and later in the Watson Lake area. "Once," she tells me, "we were camping with Eve and Lloyd [Kostechuck] at Frances Lake. Clarke and Lloyd caught a bunch of grayling and brought them back. Lloyd went out in the boat and stopped at various places around the edge of that lake picking up this and that. He came back and soon put together a smoker. He and I decided we were going to smoke these grayling. Clarke was sleeping and Eve was reading and we were having a couple of beer and visiting, adding a stick of alder into the smoker now and again and the next thing we knew the grayling were all charcoal; we ruined those fish."

After they moved to Whitehorse, Clarke and May found another special fishing spot. "Every week there was a chance of getting a fish, we'd go to Dalton Post and camp at Million Dollar Falls. We'd leave Friday and camp at a gravel pit between here and Haines Junction where we had a 360-degree view. Saturday we'd go fishing."

Their other passion was square dancing. "Clarke was a caller. Until he got sick we had a square dance club. We danced for close to twenty-five years." They still keep in close contact with those friends.

May keeps active in the community and with her family. She volunteers with the Canadian Cancer Society and her church. She knits "almost non-stop," providing her grandkids with sweaters and seniors with lap robes.

Two of their three children live in Whitehorse. May attends the grandkids' soccer games and babysits often. One daughter, Patti, and her family, live in Alberta but come home most Christmases.

May says one of her greatest accomplishments was hiking the Chilkoot Trail the year she turned sixty. She says, "I thought I was in pretty good shape because I'd trained but if I hadn't had Steve there, I would have never made it." They planned to hike the trail in four days but it took five. She shakes her head. "It rained every day and snowed on the summit. Going across the snowfields on the other side was not my cup of tea. We were constantly wet and cold. Finally, we got to Lindeman Lake and the sun shone for the first time and the breeze was blowing; it was beautiful. We made it through."

May says she is terrified of boats and water. "All those years at Frances and Ethel lakes, I never saw the end of either one." But when she turned seventy, her kids coaxed her into a boat. She has no idea what she'll do to celebrate her eightieth birthday.

Marlene *Dunstan* (Fuerstner)

Hometown Girl

Born July 31, 1958, in Whitehorse, Yukon

Work was my whole life until I married. I knew I couldn't be mom and an employer and be good at both, so I sold my business when I became a mom.

—Marlene

Marlene's house is spacious, well appointed, tastefully furnished and sits on a spectacular position overlooking downtown Whitehorse and the Yukon River valley. Her mother, Poldi, lives in the attached in-law suite. Marlene has expressive eyes, a down-to-earth demeanour and gets right to the business at hand.

Marlene is a hometown girl born at the old hospital. Her parents, originally Austrian, immigrated to Whitehorse and later sponsored her mother's parents. Marlene says, "We were like most immigrant families. We all lived under one roof in this tiny little house my father had built in the area called Lot 19." It was at the south end of town between the clay cliffs and the railway tracks. On the other side of the tracks, bordering the Yukon River, was Whiskey Flats. Her mother warned her, "Don't play down by the water." But, Marlene says, "The float plane dock was down in Whiskey Flats. And if you went on your belly and reached down under that dock, you'd get the best minnows." At six years old, she also found her best friend in Whiskey Flats. "We're still best friends."

Her father worked for Taylor & Drury General Store and in his spare time built the Alpine Hotel and Bamboo Lounge. She says, "In 1963 we moved in to the hotel and that became our house." Life was restricted. "My brother and I had very little freedom because there were a lot of guests from Europe and hunters from the States." But, Marlene says she and her best friend "lived the life of Riley." She recalls the two town horses, Pickles and Amigo. "For seven- or eight-year-old girls, the big thing was to put a rope around their necks and lead them to a stump and sit on their backs all day. We were so happy to just do that." They played on the White Pass train tracks because the ladybugs were plentiful there.

Marlene continues, "Mom and Dad never took holidays but my dad and I used to go fishing. The Bamboo Lounge closed at 2:30 am and in summer—when it's daylight all night—we'd take off in the old Dodge and go down to Carcross and Tagish. My grandfather came with us. From 2:30 until 5:30, we would jig herring and fish for trout from one or the other bridge.

I used to sit on Dad's lap in the truck and steer and I'd look in the rear view mirror and see the dust blowing up behind."

But growing up in Whitehorse was a mixed blessing. "The downside to growing up in a small town is that everybody knows you and you couldn't get away with much. The upside was everyone knew who the local undesirables were and the adults looked out for us."

After graduating from high school, Marlene and her best friend had a dream: go south to learn the esthetics business and come back to open up their own shop.

It didn't turn out that way. Three years later, her friend came back and worked as a legal secretary. Marlene fell in love with a man in Vancouver and stayed on there to become a hairdresser. After he was killed in a motorcycle accident, she says, "I escaped back to Whitehorse and opened up Kutters Hair Salon in 1982." She eventually started dating again and married twelve years later.

When she and her husband decided to have children, she sold the shop to her assistant. But she continued working because she enjoys the personal contact with her clients. She says, "One client has come to me every Thursday at 11 o'clock since 1982. She is in her nineties, now up at Copper Ridge in assisted living. I go up every six weeks to do her hair."

Marlene's two daughters are now in their teens.

Her biggest challenge was when she contracted adult chicken pox. "It was pretty serious. It went through my central nervous system, through the spine, through my spleen and into the brain. I lost 70 percent of my speech and 80 percent of my sight. Only one other person from Brazil had been through the whole gamut in medical history and survived. What pulled me through was when the minister came in to read my last rites. I thought, 'I just can't leave my kids without a mom.'" Marlene says another good thing came out of it: "My case created a whole new awareness about the disease and Yukon Health now pro-actively combats the disease. That has helped a lot of people."

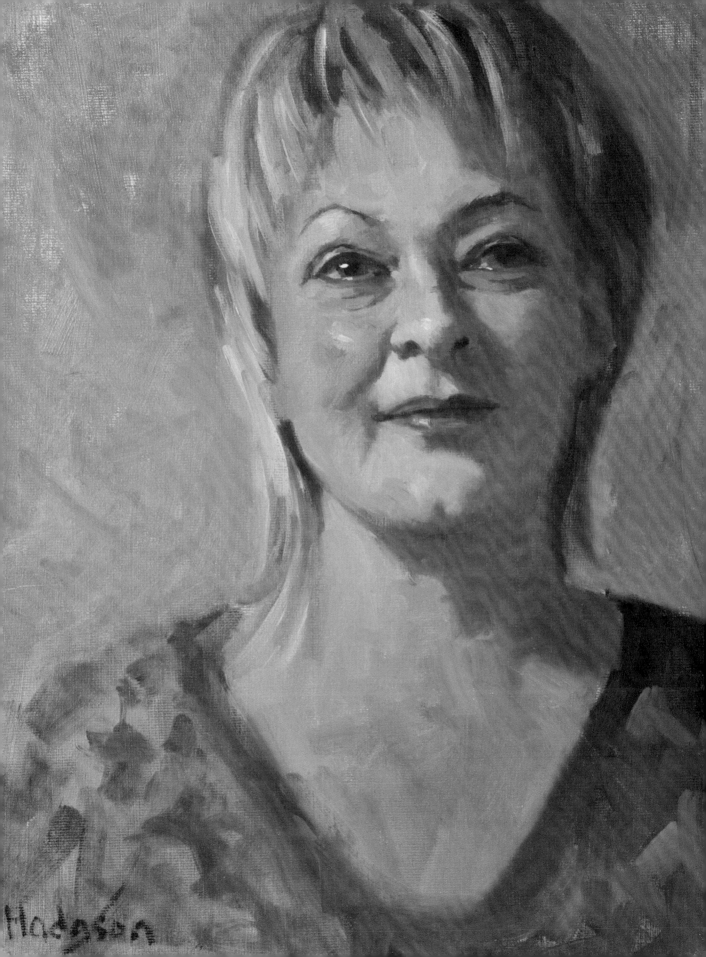

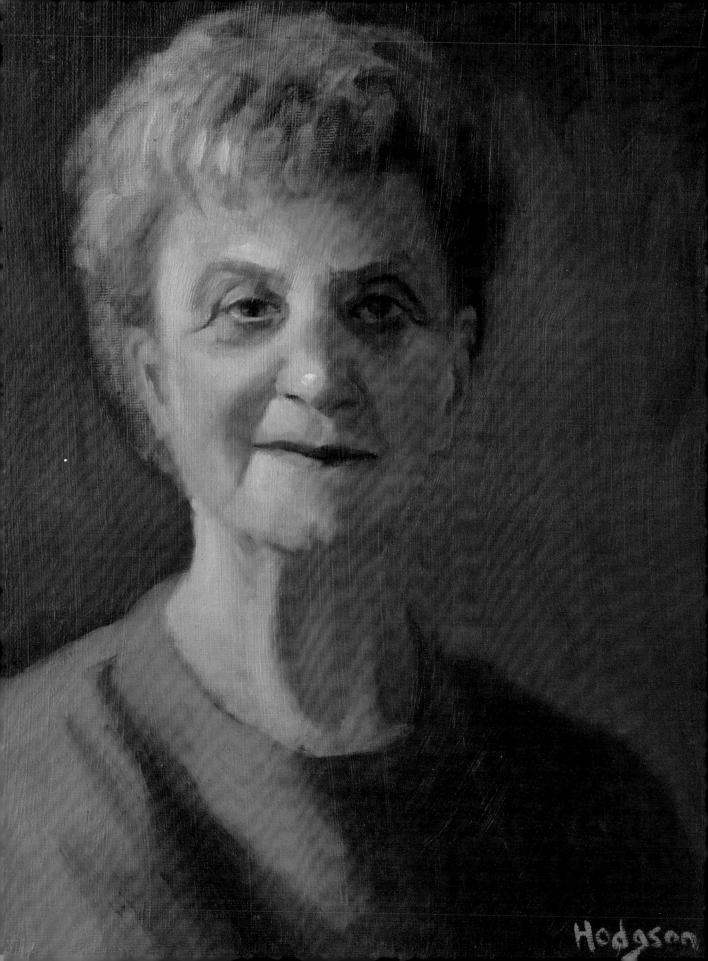

Poldi *Fuerstner* (Treitler)

Making Something Out of Nothing

Born May 6, 1923, in Kapfenberg, Austria

That was that time—we didn't know the time was that hard here. Even so, it was like heaven when we came to Canada.

—Poldi

Poldi lives in a spacious, bright mother-in-law suite attached to her daughter's house. Although she's eighty-seven, her back is straight and her handshake firm. Poldi and her husband, Max, grew up in the small village of Kapfenberg, Austria. After World War II, they applied to immigrate to Canada and in 1951, they were posted to Toronto. When they stepped off the train, a worker called out in German, "What are *you* doing here? We got 35,000 unemployed here in Toronto."

Poldi shakes her head. "That was that time—we didn't know the time was that hard here. Even so," she says, "it was like heaven when we came to Canada."

After six months, they moved to Vancouver where a friend told them, "If you go up North the wages are better. Everything is better." So they moved to Whitehorse in May 1953. Both got jobs immediately, Poldi cooking at the hospital and Max at the Taylor & Drury General Store in hardware and carpentry.

Poldi says the housing situation was a shock. "We lived in the two-storey log skyscraper. We had an umbrella over the table because the roof was leaking. The outhouse was outdoors. There was no running water. There was water delivery all right, but when I asked for it, the answer was, 'Old customers first and then new customers,' and I never got water delivered. We had to chop the ice to get a pail of water from the Yukon River in the winter."

By the next summer, in his time off, Max had built a little house and he continued to build. In 1956, they opened the Alpine Hotel and a few years later added on the Bamboo Lounge. Poldi recalls, "And why we got into the hotel, that's another thing. We didn't want a hotel business. We wanted an apartment. We started to build it and halfway through, the government changed the rules. 'If you have more than four rooms and up to twenty, you are a hotel.' So we got into the hotel business because we had to. It wasn't what we wanted. Seventeen years. Wasn't what we planned at all."

It was a day-and-night operation with very few holidays. Poldi sighs, "And we had two kids. They grew up in the hotel and there was nothing but discipline: don't run, don't jump, don't be noisy, don't, don't, don't. But in the long run, I think they benefitted from the discipline. Then, in 1972, the government expropriated us to build the territorial government building and we had to move out."

Later, Poldi's daughter tells me, "My dad didn't get enough compensation to cover the cost to rebuild. So he asked the officials for permission to separate the buildings and relocate them. They said they weren't structurally sound enough."

But eventually the government did just that and then sold them to two other business people.

Today, the Bamboo Lounge is operated as the Road House Lounge. The Alpine Hotel was moved to 5th Avenue and has operated as an apartment building ever since.

Poldi says the next years—gold mining—were precious. "The best thing was the freedom and openness out in the bush and the experience with the wildlife. After the hotel business, oh, we felt free!" They had two shifts working, crews of three and four from May to September. Poldi did the cooking and says, "I don't want to brag how tidy I did it." She smiles. "I had a huge big wood stove and a great big basin for washing the dishes. One morning I went into the water with my hands and took the dishcloth and squeezed it out and you know it was not the dishcloth; it was a drowned mouse that had slid down the chimney.

"Once I was standing in the cabin doorway looking out. The husky was chasing a bear and the bear was chasing a moose and her calf. Just lined up. The moose ran by and looked at me as if to say 'please help me,' with the little one behind. She and the calf ran into the meadow and the dog chased the bear in a different direction."

Poldi lifts her shoulders and says, "I tell you something, I had an interesting life. It was a roller coaster, up and down. What I have learned in the tough times is that you can make something out of nothing. Before my husband died he said, 'We sure worked hard, didn't we.' But it was fun, I think. I just love Canada. I think it's the best place on earth. I'm so glad we made that move."

Karen Lang

A Fabulous Life

Born May 24, 1950, in Ituna, Saskatchewan

Oh, Archie and I have a fabulous life. We've had so much fun, we've done so many different things, and we've met so many interesting people. Just fabulous.

—Karen

Karen greets me at the family's secluded rancher situated on a flat shelf of land above the Yukon River. An exquisite Rick Taylor bronze of a horse and wrangler unified in a leap sits on a table in the foyer and family photos—graduations, sporting and social events—line the hallway walls.

She and her husband, Archie, designed the house and their panache is evident in the deep leather couches on rich wood floors, high ceilings and French doors leading to a deck overlooking the river. We sit outdoors in comfortable wooden chairs, sipping sodas and relishing the warm August sun.

Of her upbringing, Karen says, "My grandparents emigrated from Poland and settled in Saskatchewan. We had a lot of fun, no money—but nobody had money so we were all in the same boat—and a first-class education." Karen went to university in Saskatoon for two years, but admits, "I really had no direction, and my parents were making a great sacrifice because there were four more kids at home, so I decided 'I'll just go to work for awhile.'" At twenty, Karen hitchhiked up the Alaska Highway to waitress at Watson Lake's Chinese Café. She has lived in the Yukon ever since.

It was an exciting time to be young and in Watson Lake. She says, "Those were the heydays. Canada Tungsten and Cassiar Asbestos mines were operating and Canadian Pacific Airlines had two flights a day. With the mines going full tilt, there was lots of money around." At one point, she had four jobs: waitress, chambermaid, barmaid and cab driver.

In 1972 Archie Lang, a born-and-bred Yukoner, bought the Watson Lake Hotel. Well connected, with a flair for business and a knack for finding humour in the details of life, "he was just dynamic. He was fun and interesting and everybody wanted to go to the Watson just to hear what Archie was going to say," Karen says. They married in 1976 and have three children: Graham, Meagan and Fraser.

Karen soon became an entrepreneur in her own right, running a travel agency, which, with a young family, "got to be too much." She sold it and stayed at home with the children for a few years before going to work at the hotel.

The place hopped. "We had Titanic Cruise Night and everybody would dress in cruise wear and their whites. At the Academy Awards, we gave Oscars for the best performance in town and made satirical news reports like 'The bank is closed for our convenience on Tuesdays and Thursdays.'"

The Langs continued in the hotel business and expanded into grocery stores. When Archie suggested they buy into a big game hunting area, Karen's first reaction was "I'm as far in the bush as I'm going." But they did and she admits, "I loved it. Summers in the bush with the kids were really great. We were fishing and boating and riding horses and building forts. Just fabulous."

By 1994 Karen and Archie felt it was time for a change. So they rearranged their business holdings and moved to Whitehorse. They expanded in the grocery business to Old Crow, Ross River, Tsiigehtchic and Manitoba but later sold out.

Shortly after, Archie ran in the territorial election and has represented his riding in two consecutive governments. Karen continued in the business. "I deal with banks and lawyers and accountants and decision-making—those kinds of things."

With all the personal and business growth she and Archie have experienced, Karen considers her top accomplishment as "having and raising a family. I'm really, really happy that my children are happy. The two oldest have found their passion and Fraser, I think, is going to do something very interesting and I can hardly wait to see what it is." Her voice catches. "Archie's a great dad. He spent a lot of time with the kids and he always, always made them feel important and special."

Karen cherishes her time in the North. "What makes the Yukon special is having this constant stream of new people from all over the world and at the same time the continuity of the people you've known for a long time."

But she and Archie, in their indomitable style, also travel extensively. They head out on a different wilderness river every year. They travel throughout Canada in relation to Archie's political portfolios, with Karen paying her own way. And she researches and plans another annual journey. They're working their way through the alphabet by country.

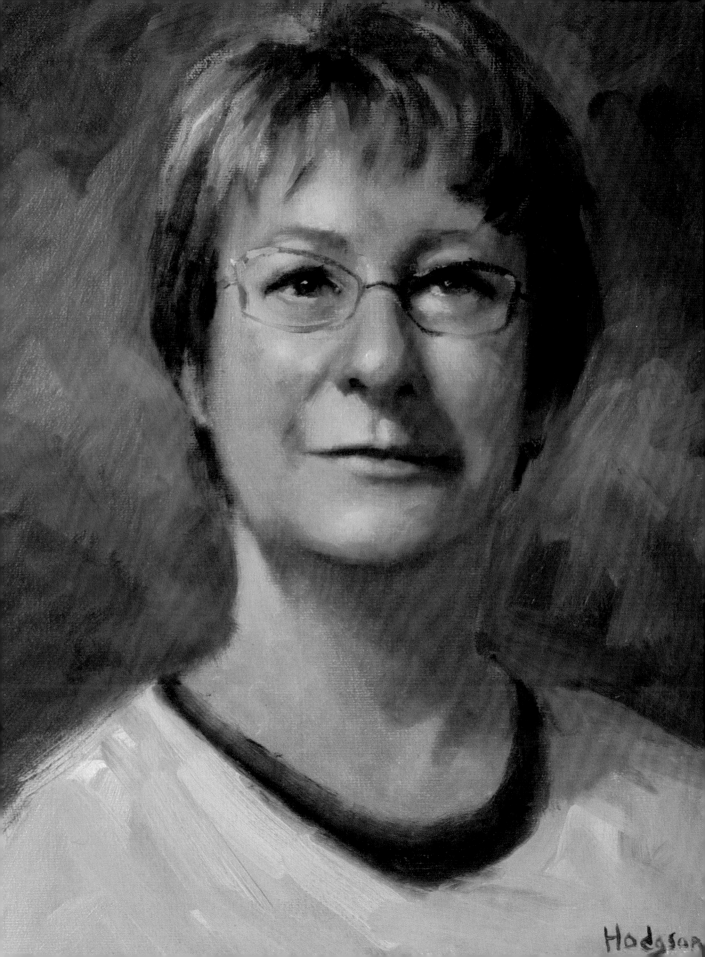

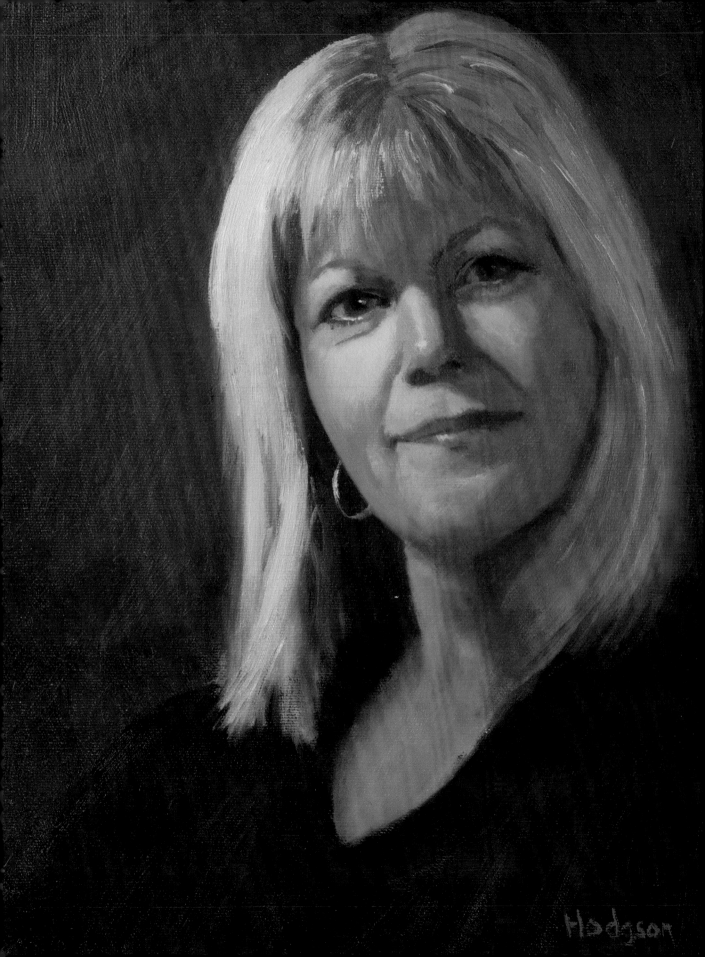

Birgitte *Hunter* (Dohm-Smidt)

Getting Caught

Born November 26, 1957, in Bakkelund, Denmark

I had a beautiful little house and a job I loved and a life I loved. Then I met my future husband at a convention in Vancouver. He had a business in Whitehorse and I had a portable career so I picked up and moved here.

—Birgitte

Birgitte carries herself with a natural poise and has sculpted Scandinavian features, blond hair and clear skin. Slender and in obvious good shape, she's a woman who looks thirty-something for much longer than a decade. She ushers me in to her sunroom overlooking a back yard filled with evergreen trees. Since coming to the Yukon for love, she and her husband, Paul, have raised a family and built a full life.

Birgitte was born in Bakkelund, Denmark, but her family moved to Vancouver, BC, when she was in grade 3. They settled in White Rock, where she graduated from high school.

When she was in her early twenties, her father influenced her when he paid her to read motivational books like *Think and Grow Rich* and *The Power of Positive Thinking*. She partially credits the application of the principles she read about to how well she was doing. "Everything was perfect and in its place. I was twenty-three; I'd bought a house; I had a great job and was completing my undergrad commerce degree at night. I had my friends, and my family lived down the road. My life was wrapped up in a box with a bow on it." And then she got caught.

In November 1980, she accompanied a girlfriend to the BC–Yukon hotel convention hosted in Vancouver. "And I met my future husband, Paul. Six weeks later, I'm engaged and I'm moving to the Yukon." She looks out the window. "He promised that we would be here for about five years," but that's not how it turned out.

They could have left nine years later when he sold the hotel. By this time, they had two children, Kimberly and Jeffrey. They took two months to travel down to California, but Birgitte says, "We decided to come back to Whitehorse because it was a good place to raise the kids." Paul went in to real estate and Birgitte focussed her attention on the children, work and obtaining her accounting degree.

She finished her undergrad degree via correspondence through Athabasca University and went on to complete her studies as a certified general accountant. It is an accomplishment she holds dear. "I slugged through with a lot of blood, sweat and tears. It was a long, tough haul. Hence we support our kids through university so that they have their degree early before they meet partners and decide what to do with their lives."

For Birgitte, life in the Yukon is bittersweet. Although the population of White Rock was about the same as Whitehorse, the lifestyle was different. A smile tugs at her mouth. "A lot of Yukoners, like myself, come from somewhere else and you tend to invite people into your life more than you would if your siblings or your parents are down the street. I had very close friends. I invested a lot in them and then they moved. Early on I wondered if it's worth putting that much energy into friendships when so many leave. But you do because they came into your life at different points and you share experiences so deeply. Some were soul mates when the kids were little. I remember feeling 'where's that someone to pick me up?' And they were there."

She says in her hometown of White Rock, many of the people she grew up with are still living within a five-mile radius of where they went to school and have the same friends. But Birgitte now has friends all over Canada who once lived in Whitehorse. "We still have that really strong connection when we get together. We'll always have that closeness."

Keeping physically active is a high priority for Birgitte. "I like being active outdoors. Golf and running are kind of a passion." She also built a solid career, first operating an investment management and accounting services business and then working for the Government of Yukon, achieving the position of assistant deputy minister at Health and Social Services.

With retirement not too far away, Birgitte says she's not sure if she's waiting to leave. She tilts her head. "There are so many advantages to living in Whitehorse, but I'm always torn. I was born on the ocean in Denmark and raised on the ocean in White Rock and there's a part of me that never left. In winters, we go for tropical vacations in a condo on the ocean. Maybe that's what it takes."

The unstated certainty is that regardless of the destination, she and Paul will be going together.

Joy Kajiwara

Making a Difference

Born November 13, 1947, in Lethbridge, Alberta

One hundred years from now it will not matter what my bank account was, what sort of house I lived in or what kind of car I drove, but the world may be different because I was important in the life of a child.

—Joy's motto

Joy's father was a fisherman on BC's coast but when World War II broke out, the family was moved inland to an internment camp and then on to Lethbridge, Alberta. She takes a deep breath. "When I was born just after the war, it was a period of hope for Japanese Canadians. Being the wished-for girl with three older brothers, Joy was what my parents named me." They were so thrilled to have a girl that "I was the little princess until I was twelve." All attempts after that age to mould Joy into the old Japanese ways for the woman's position "did not go over very well."

The family moved back to BC but there was still racial tension. Her face clouds over. "As a kid, I didn't make the connection that I was a visible minority and no matter what I did, I would stand out." Like her brothers, she learned to ignore the name-calling and she vowed to always be open-minded.

After graduating from high school Joy went in to nursing and worked in a number of areas before finding home care, which she enjoyed. After a few years, she took time out to do a double diploma business program in one year. Afterward, she started her new career path and loved it, but sighs, "In 1982, I met a man, Gord Zealand, and he lived up here. So I moved to the Yukon."

Gord had two children, Laura (7) and Mark (4), who lived down south but came north often. They are now grown with families and Joy says, "I love them as if they were my own." Although they no longer live together, Joy and Gord remain friends. Her extended Yukon family now includes four grandchildren, four god-daughters and a close network of friends.

Joy became the nurse supervisor at Macaulay Lodge. She lifts her hands, "and that was the beginning of my life in continuing care." Over the next ten years, she built and led a team that transformed the senior care facility from a dormitory-type facility to one with individual rooms with private baths.

"Then we wanted a higher level of care, with a home-like environment. We added an occupational therapist and physiotherapist and invited musicians—Moe and the Boys and Herbie—to lead singalongs every week.

And we had so much fun going camping with the residents: Bev Oyler, the recreational therapist, would gather a crew including someone from housekeeping, administration, maybe one nurse, of course the bus driver, and me." She leans back and laughs. "We even started a pet therapy program. First we 'adopted' a stray cat, then there were two cats and a fish and two finches, which soon became six cages of finches. After we added two cockatiels, we realized we had to cut back." But pets are still a big part of Macaulay Lodge.

Joy took on another challenge: opening Thompson Centre continuing care facility, which involved initiating programs that had never been offered before. It was a demanding time; she was also taking a master's degree in public administration. She sighs. "That was no life. I spent all day working with the staff to open the centre and nights doing schooling." It opened in September 1993.

In 1995 she became the senior health advisor and says, "We had a lot of fun introducing Telehealth." She was part of the team that introduced electronic equipment to help nurses do their job and improve access to health services in rural communities.

In 2002 Joy became the director of community nursing while maintaining responsibility for Telehealth. That year, the program was rolled out to all the communities and to twenty-two sites in Whitehorse. Joy smiles. "And people are using it. It may even help with nurse retention in rural communities."

Joy leans back and says with conviction, "If you want to make a difference, the Yukon is a land of opportunity; you can do anything you put your mind to. I feel that I contributed to the shaping of continuing care and was part of introducing technology to health service in this territory and that is a good feeling."

Joy loves her work and the people she works with; she cherishes her Yukon family, but her heart belongs to the children in her life. She's Obi, or Grandmother, to the grandchildren, and Auntie to her nieces, nephews, great-nieces and her friends' children. She says, "I feel very, very blessed to have these children in my life. They are my treasure."

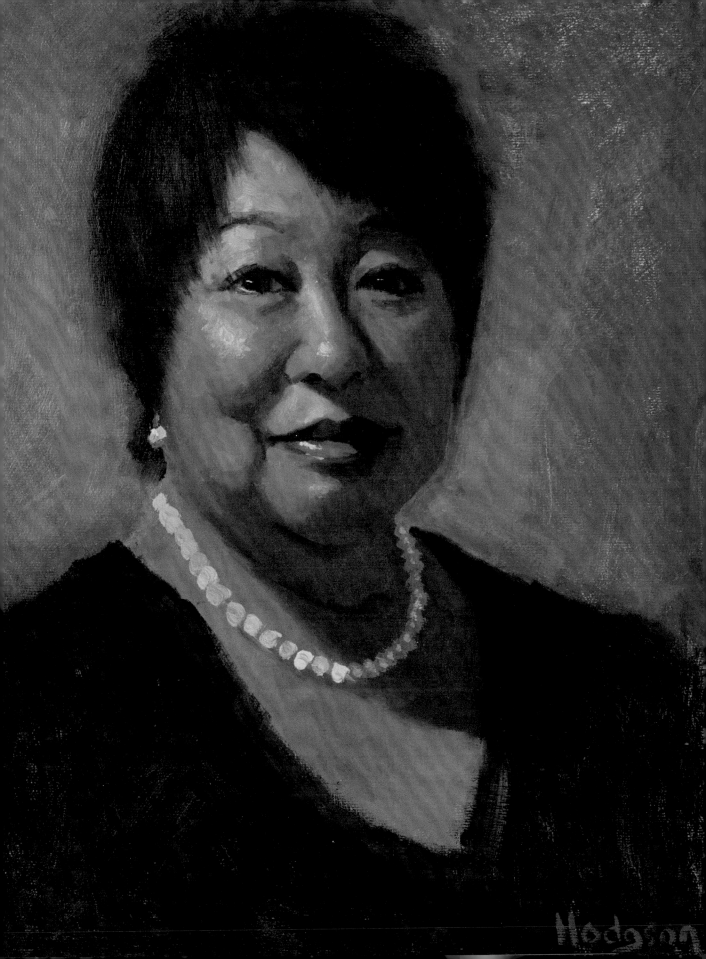

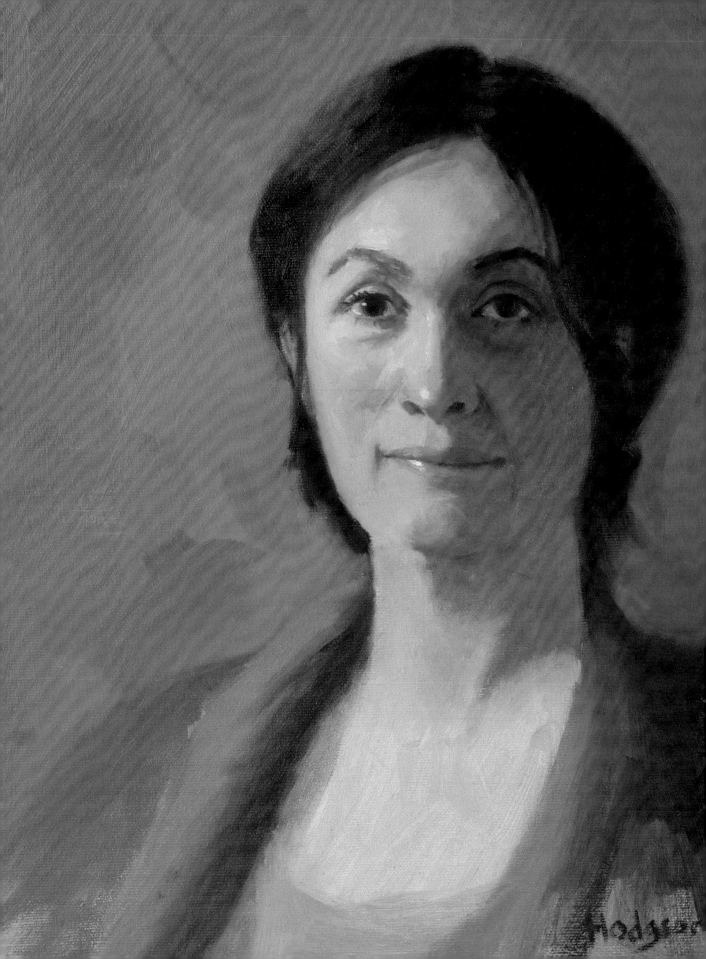

Louise Hardy

Walking the Talk

Born November 30, 1959, in Whitehorse, Yukon

When I was driving back across Canada with our four kids, I remember somewhere around Steamboat Mountain—where the landscape changes and the evening sky turns that special salmon colour—I had to stop the car because I couldn't stop crying. I hadn't known how much I'd missed this land and how much it really did mean to me.

—Louise

Louise arrives on a bicycle and leans it against the apartment building fence. Her thick dark hair springs out when she takes off her helmet. She has the quiet calm of someone coping with difficulty; it's public knowledge that her husband, Todd, leader of the NDP Party, is fighting for his life against cancer. Louise is his main caregiver.

When she was eighteen, Louise and Todd married. She says, "When we were growing up, the expectation was that you would leave. I remember having the sense that if you stuck around here, something was wrong with you." But they were too busy to think about it much; they soon had children and "it was easy. I had tons of energy and I remember going days at a time playing and enjoying life."

She got her black belt and taught karate. "That was a really, really good part of my life, all that happy energy."

When Todd and Louise had their third child, her mom suffered a heart attack and brain damage. She could not live alone so was placed in Macaulay Lodge. Joy Kajiwara, head administrator, told me, "People were wary of Julia. Because of the brain damage, she had very little emotional control. Louise came in every day with these four little kids and took Julia to her home. Every day. For ten years. She epitomizes what I would love to see people do for their parents."

The experience shaped Louise. "We didn't think very much about it at the time; we just did it. Caring for my mom gave me the stability to be able to go out into the world in a different way, to run for Parliament, to take on causes."

She takes a deep breath. "Then my mom died, our dog died, my youngest went to kindergarten and I enrolled in the social work program at Yukon College. It was a huge transition in my life."

Not long afterwards, Todd and Louise headed for Montreal with their four children. Louise shakes her head. "I had not wanted to come back but I'm so glad we did. After that I didn't have that fight, that feeling of should have, or could have, anymore."

She started working in social services and was recruited to run as the NDP candidate in the federal election. She says, "I did it partly around wanting to change the defence of provocation in Canadian law and partly to counter that whole place where society puts women as lesser than. Plus, I really believe that women should run." She loved the election trail. "It's amazing because people open their doors to you and talk to you. It was so moving to listen to what's important to them."

She shared the political life with Todd. A carpenter by trade, he ran at the territorial level and eventually became leader of the Yukon NDP Party. Louise says, "I don't think that politicians have thick skins. But you just have to be able to put it into perspective. That's all you can do. When you run for politics, you represent something bigger. You have to stand up for what you believe and be willing to accept criticism."

After her term, she started working toward a master of counselling degree, with a specialization in Art Therapy from the universities of Calgary, Lethbridge and Athabasca. Around that time, Todd was diagnosed with cancer. She says, "There were a couple of years when I wasn't going to do it but Todd really encouraged me to finish. That is as close as I come to having a regret—was that the best way to spend my time under all of the circumstances?" Louise now works in senior services and adult protection.

Louise says Todd's illness is the hardest thing she has ever faced. "When someone in the family gets cancer, all of the natural growth within the family stops. You turn inward because you don't know what's going to happen. It's very slow, that death, and it's hard to watch; it's hard to see."

Still, Louise takes a long view. "Spirituality is the heart of what life brings us; it's our journey. We define ourselves by how we are going to handle it, walk it, live it. What do we leave for our children and our community?"

At this stage of her life, one thing is certain: Louise's legacy is not yet fully formed.

Sally Macdonald

Epiphanies to Live By

Born August 22, 1951, in Oshawa, Ontario

That night, it all fit: my work, going down the river, having tea in the wilderness. It was as if some part of me—my spirit and my soul—belonged here.

—Sally

At five o'clock on a Sunday afternoon, I'm standing outside the Whitehorse Medical Services building. An SUV swings in to the parking lot, a lithe woman jumps out with a smile and walks energetically toward me. This is Sally Macdonald, MD, who was scheduled for a weekend off but is just coming from a hospital call-out. Although Sally says "I'm a real typical Yukoner with eclectic hobbies and I chose the Yukon because it provides that opportunity to have a balance between personal and professional life," she's a doctor through and through.

Sally grew up in southern Ontario and her love for the outdoors started at summer camp. She says, "I lived my year for that month to go north and canoe. I knew it was who I was." Her love for medicine came in high school. "It was completely out of context for me to become a doctor. I excelled at history and languages but I joined a medical club and I realized it was what I wanted to do. I still feel that way. It's been a great career."

Sally met her husband, Bob Zimmerman, in McMaster University med school. They graduated in 1976 and have been a team ever since. She says, "I wanted to go east and he wanted to go west, so we tossed a coin and came west." They practised medicine in Edmonton and Inuvik but have lived in Whitehorse since 1980. They took time out to work a year and a half in Nepal and for a six-month stint in Zimbabwe. They are avid canoeists and hikers and parents of two adult children, Zoe and Anya.

According to Sally, the nature of practising medicine in the Yukon is different. "People are more open, both patients and doctors. The medical profession is pretty open to looking at the alternatives. In turn, Yukoners seem to know that physicians can't be everything to everyone and know that there are other resources out there that can be tapped into."

But most of all Sally enjoys interacting with her patients. "I was the visiting physician at the monthly clinics in Haines Junction for twenty years. I later see many of those people when they come into the hospital in Whitehorse for treatments. It's an opportunity to sit at the end of their bed and hear their stories, which provides such richness to my life."

Sally was a much-loved baby doctor and it is easy to understand why when she tells me how she values that privilege. "Childbirth is a time that is very intimate and I really got to know people. It's a very vulnerable time in people's lives, it's a very exciting time, and there's just so much going on. I guess it's like survival in the bush; it's so intense with emotions that are at the very high and the very low. You get this amazing bond or connection with people. I'm very grateful for that. I don't take it lightly; I respect it, this opportunity to be present and intimate with people in their lives. Childbirth is such a beginning, so it carries on; I'm invited to potlatches and family celebrations, some happy and some sad. You get invited into people's lives as a doctor in ways that you wouldn't otherwise."

Sally shares another experience that captures why she and her husband stay in the Yukon. "The first summer we arrived in Whitehorse, we signed up for a kayak course. It was the third week of June and one of those glorious evenings. We'd worked all day and we popped into this truck with these kayaks and went out to the Wheaton River. We started paddling about nine o'clock. I'd never kayaked before and it was quite a challenging paddle.

"The sky was so beautiful and we got off the river about midnight and it was still daylight. We boiled a pot of tea while some of the crew went to collect the trucks. And I remember thinking 'life does not get any better than this.' I felt like I had been living in this other world for years and there had been a part missing. I never felt like I'd truly belonged in the city life and never fully fit in with the hierarchal and specialist-based medical world down south. But I knew I liked medicine. That night, it all fit: my work, going down the river, having tea in the wilderness. It was as if some part of me—my spirit and my soul—belonged here. That night, I felt like I had come home."

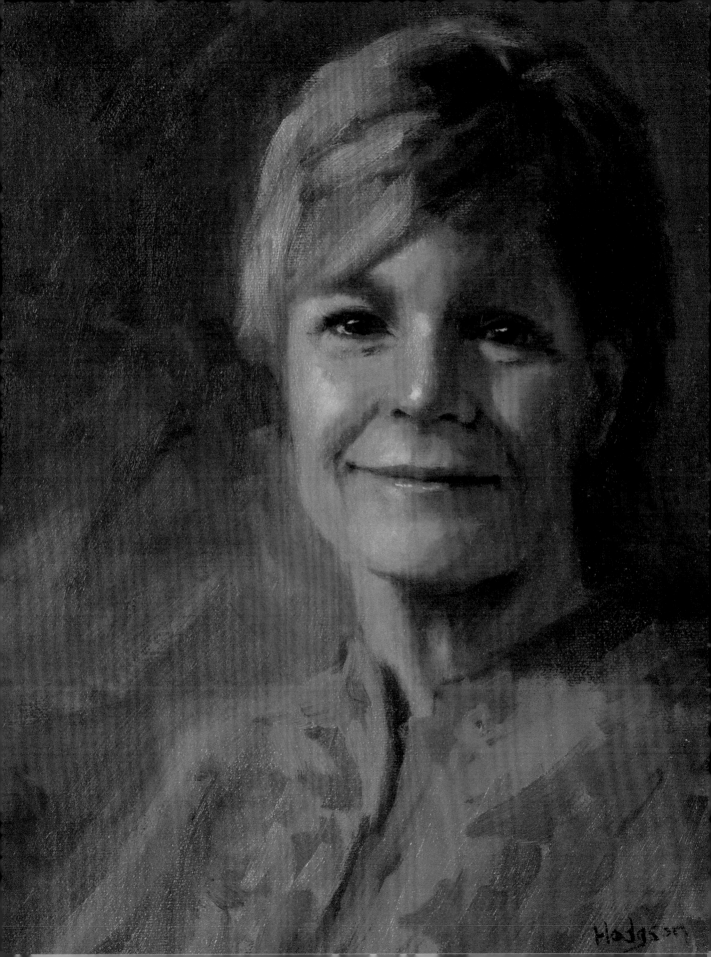

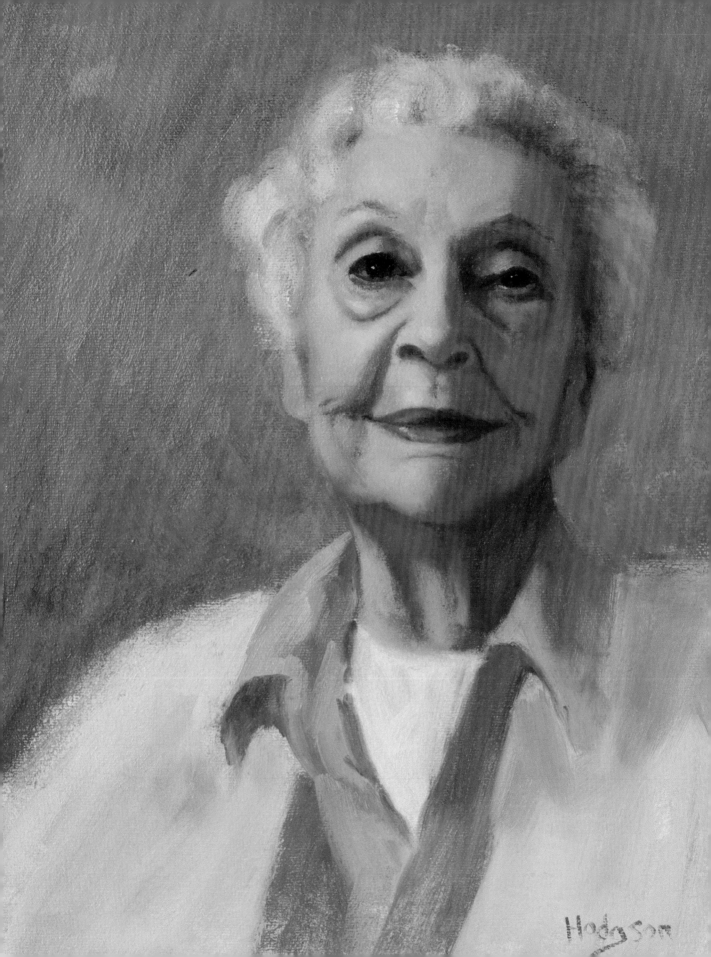

Fran (Fanny) *Wellar* (Hume)

Precious Times

Born January 16, 1916, at Dezadeash Lake, Yukon

Sure, I had hard times, but I got over those after a while and I always had fun!

—Fran

Fran, ninety-three years old, reclines in a hospital bed hooked up to oxygen. This petite woman wears a stylish pink sweater and black pants. She has an easy confidence. Her hands are manicured and her white hair styled neatly. Although she is physically weak, she is alert and totally clear.

Fran Hume was born at Dezadeash Lake on January 16, 1916. Her father, a Scot, was an ex-North West Mounted Policeman who had been stationed at Dalton Post, when he met her mother, a full-blooded Tlingit woman. Together they set up a homestead at Dezadeash Lake and had six children.

The children had to travel to Dawson City to attend boarding school. Fran really wanted to read like her older siblings and her father, who read Shakespeare and Darwin avidly.

When she was seven years old, she went to Dawson by paddle wheeler with her older siblings. "Dawson, at the beginning," she said, "was not a happy story." Fran says the man assigned to care for them at the hostel was abusive and she, like many of the children, suffered. Because of this, Fran went to live with a family where she worked as housekeeper and did her schooling in the afternoons. She laughs. "I never got to understand Shakespeare until much later."

When she was sixteen, the family was transferred Outside but Fran didn't want to leave the Yukon so they set her up working in Whitehorse. Five years later, Fran moved to Champagne to help out a woman she had known since childhood, Sue Chambers (now Van Bibber). Sue and her husband ran an outfitting business and he had died suddenly, leaving Sue a widow with three young children. A single mother with an infant of her own, Fran said, "We both had hard times but we got over those after a while, and we always had fun together."

She laughs. "Teaching Sue to skate was the funniest thing I can remember. The kids were just babies and we used to pack them in the sleigh and hitch up the dogs and take them for a run. One day, we put on skates and went down to the Dezadeash River. It was just glare ice—beautiful. You could see to the bottom, it was so clear. I told Sue, 'I'll go ahead and you hang on to the handlebars and just skate along behind the sled.'

"I was probably half a mile or so ahead when the dogs passed me with the kids in the sled, but there was no Sue! Oh, the way Sue tells it is really funny. 'Here I am crawling around, can't even get up. And Fran, she is gone. The kids are gone. The dogs are gone.' I went back and untied Sue's skates and she walked home in her socks and I skated downriver and brought back the kids and the dogs. But Sue never learned to skate."

In 1940 Fran met her first husband, Harry Fromme. Their early years were full of adventures raising young children on their gold claims in the Kluane area. When the older children turned school age, the family moved to Whitehorse. They had a wide circle of friends and Harry prospered in business but after twenty-five years together, they divorced. With two teenage children at home, Fran went to work in a flower shop. She later bought it, and ran it for a number of years.

In 1970 Fran married Keith Wellar. They bought Blue Mountain Lodge in Haines Junction. After fourteen years, they sold it and moved to Vancouver. In 1988, he died suddenly and Fran moved back home—to the Yukon.

One thing that sustained Fran throughout the years was "getting out in the hills." She recalls, "Sue invited me on a fall hunt when the children were a little older. At first, we hired a wrangler and did the rest ourselves. Sue had handled horses with her dad and the first time we went out, she was teaching me how to saddle the horse. So, I bridled the horse. She looked over to what I was doing and she said, 'What on earth is your horse smiling about?' The bridle was caught under the horse's tongue and was pulling back his lips."

Fran laughs heartily and continues, "Later on, we got so that we hired a cook and some of our friends joined us. Every fall for years and years we would go out—just take time off and go. Those were precious times."

Fran Wellar, who shared precious times with so many, passed away November 17, 2009.

Roberta *Prilusky*

Here Forever, I Think

Born August 20, 1956, in Lamont, Alberta

We packed up the boat and went up Tagish Lake toward Ben-My-Chree. Early the next morning, I sat alone on the shore-line, breathing in the beauty and peace of the place. I felt so at one with myself and with nature. That morning, I knew I had come home. I'm here forever, I think.

—Roberta

Roberta, a petite brunette, proudly tells me her Yukon lineage goes back three generations on her mother's side of the family (McPherson). Her mother was born and grew up in the Yukon and her father was stationed to Whitehorse after World War II, building the highway. She smiles. "They met and married, had two children and then my father wanted to return to his Ukrainian roots in Alberta. I was born in Lamont and when I was twelve, we moved back to the Yukon. I completed grade 12 in Whitehorse and went to college in Calgary for a year."

After graduating with a diploma in journalism/advertising, Roberta wrote to Dave Robertson, owner and publisher of the *Yukon News.* "I said that I was willing to work hard and for any wage." He hired her and became her mentor. Roberta's career grew to encompass almost all aspects of the newspaper industry from designing advertisements to working in the press-plating area.

Roberta settled into a relationship, and in her late twenties, she and her husband had a son, Corey Ross Rich. In 1986, they moved to Williams Lake, BC. After becoming a single parent, she settled in Kamloops and worked at the daily newspaper for nine years while raising her son. Then, with the newspaper industry becoming computerized, talk of layoffs and shift work predominated. Roberta felt it was time for a change.

She takes a breath. "I decided to move back to the Yukon. The first weekend after I arrived, a group of us—close friends and family—packed up the boat and went up Tagish Lake toward Ben-My-Chree. Early the next morning, I sat alone on the shoreline breathing in the beauty and peace of the place. I felt so at one with my-self and with nature. It's not very often you get to experience that kind of connection so directly anywhere in the world; there's always another person or something else in the environment. That morning, I knew I had come home. I'm here forever, I think."

For her new career, Roberta chose office administration. After she retrained at Yukon College, the Government of Yukon hired her. She progressed steadily in her administrative career and volunteered with sports organizations, seniors, and the Yukon Literacy Society. Her son graduated from Vanier High School, moved to Victoria to attend college, and is now settled and running his own company there.

A confessed "Type A" personality, Roberta's lifestyle caught up with her in the form of health issues. She knew it was time to re-evaluate and modify her exercise regime. She says, "Yoga and meditation—slowing my pace—has brought me a lot of peace and content-ment." As her health improved, Roberta discov-ered a sense of appreciation that comes from a place deep within. She says, "I'm on an inward journey now and I have the luxury to do it. I am more secure within myself; I have a solid career, a supportive family and this community is home. It's a solid foundation to branch out from." Family is core but she maintains a broad and varied social network and assists seniors in small ways, whenever there is an opportunity. She says her motto for the future is "never stop dancing."

Roberta's connection with nature also nurtures her and is even more enjoyable when shared with others. "My family loves to get outdoors, loves to camp. The Yukon offers so much; anything we want in life, it's all here." She laughs, "I love to fish. One summer my uncle was teaching my cousin and me how to fly fish. I was having a difficult time learning how to do the roll-cast. But with every cast, I brought in another fish. My cousin was off to a good start, looking like she'd just stepped out of a page in *National Geographic.* Her form was excellent and every cast was perfect. I was quite envious. About forty-five minutes later, her fa-ther looks over and says, 'You might want to put a fly on the end of the line if you want to catch a fish.' So, I had the last laugh."

From her Yukon base, Roberta travels all over the world. She says reflectively, "In all my travels, some of the most interesting people I have ever met are Yukoners. This place attracts really interesting people."

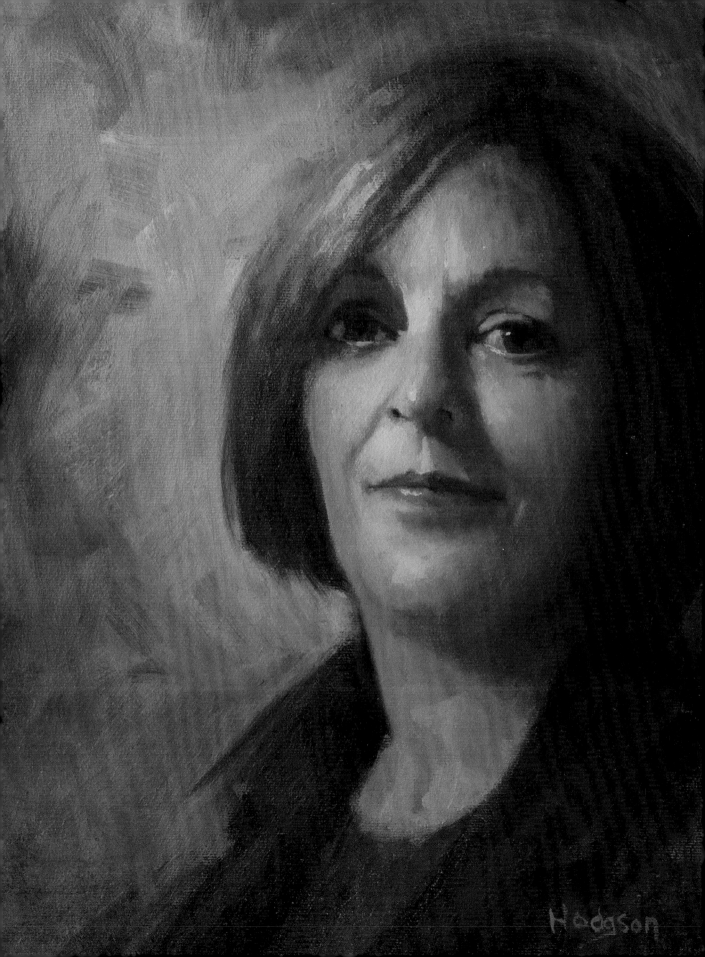

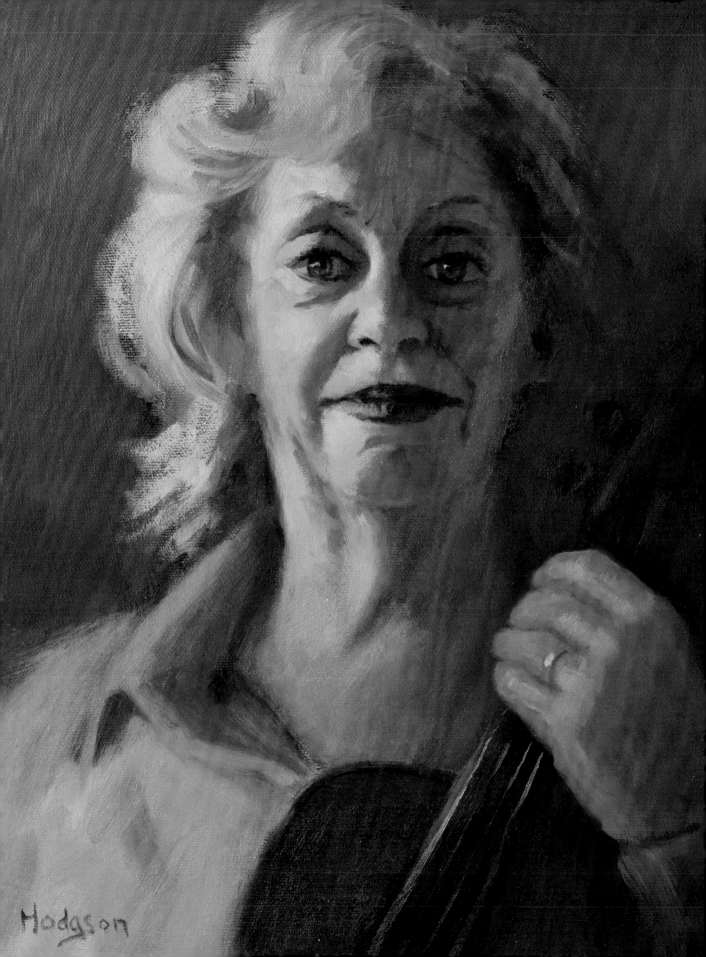

Rusty (Thora) Reid (Parker)

Music Is for My Soul

Born July 2, 1929, in Moose Jaw, Saskatchewan; raised in Lynn Valley, British Columbia

I'm always smiling—it just feels like that's me. Bill and I liked to do things together. We were always going on adventures and we had music in common.

—Rusty

Rusty Reid's easy, broad smile is accentuated by her bright blue eyes and flaming red hair. She greets me warmly at her house in Porter Creek. She moves quickly, offering juice, food, chair or couch, all in rapid fire. As I settle, Rusty hands me a four-page record of her community involvements and accomplishments. This bustling woman has packed more into one lifetime than most could in three.

First and foremost, Rusty was a full partner to her husband, Bill, and a dynamic mother to their daughter, Shelley, and son, Dave.

A friend introduced Bill to Rusty at a dance in Lynn Valley, BC, and soon they were making music together, she on the fiddle she'd inherited from her grandfather and he on the piano.

They were engaged almost right away. Two years later, Bill's sister, whose husband was stationed at the air force base in Whitehorse, invited them to come visit. They did, found work quickly, and decided to stay. On November 21, 1951, they were married in the Old Log Church.

The couple was also involved in music right from the start. Rusty says, "I couldn't live without music. It's something for my soul." They started the Northernairs Dance Band, which carried on for fifty-six years. One year they even played at two New Year's Eve dances, a Friday night in Dawson City and the other on Saturday night—an eleven-hour drive south—in Atlin, BC.

Sports was another passion. Rusty played softball and basketball for over thirty years while Bill was a key fundraiser, manager, and board member of the sports clubs. From the time they bought their children their first pair of skis, Rusty and Bill were avid downhill skiers. They took off on snowmobile excursions throughout the winter, but the big event was always the Haines Summit Easter weekend when over one hundred snowmobilers gathered, rode, camped and got together in the evenings for fun and music.

When he was about ten years old, their son decided he was going to be a pilot. When he was old enough to take lessons, Bill also got his private pilot certification. He and Rusty flew all over the territory, she taking photos of bush landing strips and creating binders detailing their coordinates. "Knowing where there is a safe place to land could mean the difference between life and death." They were founding members of the Yukon chapter of the Civil Air Search and Rescue Association. Bill piloted their plane while Rusty was the spotter and navigator; they participated in many searches.

The list of their involvement goes on and on: Yukon Sourdough Rendezvous, Ladies Auxiliary to the Yukon Order of Pioneers, Yukon Film Society and Photography Club, the motorcycle group, and Macaulay Lodge senior care facility.

Rusty smiles, "I played music at Macaulay every Wednesday evening for going on twenty years, in the beginning with Moe and the Gang and more recently with Ken and the Gang. We play waltzes, jigs and polkas for the seniors. It's only two hours but it means so much to them."

Rusty compiled song binders, green for Irish songs, red for Christmas. She made extra copies for the Golden Age Society and seniors use them whenever they get together—at events, on buses and during special occasions.

It is no surprise her most treasured memory is of Canada Day in 1996. She played the fiddle with twenty-seven renowned fiddlers from across Canada in front of four thousand people on the steps of Parliament. She smiles. "That was pretty special."

Rusty fondly recalls another special day, just before Bill began chemo and radiation treatments for cancer. They played music all afternoon with old friends at a Vancouver Yukoner's event on Vancouver Island. "That day did him so much good," Rusty says quietly. Bill succumbed in February 2006.

She still lives in their house, where Bill's presence is tangible. His glowing smile shines from a huge photo in the living room. She says the support from her daughter, son, five grandchildren and one great-grandchild—phone calls, letters, emails and trips together—gives her strength.

Rusty is not slowing down. Her latest learning venture is Adobe Photoshop. She reads the manuals; she's taking digital photography workshops and figuring out how to lay sound tracks under slideshow presentations. She plans to scan all her film and slide photography into digital and create multi-media DVDs for her family.

Rusty says she lives by the motto, "If you give off love, you get it back."

Florence *Wright*

A Definite Yen to Go North

Born 1932 in Vancouver, British Columbia

No, no, we never had a hankering to leave. We'd go and visit family but we were always so glad to get back. The spell of the Yukon held us firmly in place.

—Florence

I meet Florence Wright at her Marsh Lake cabin in late fall. As I walk past the fallow garden, yellowing willows and berry-laden bushes, four cedar waxwings take flight. A fire blazes in the airtight stove inside the simple cabin. It has all the necessities: a bedroom attached to a larger open room with the kitchen along the back wall and the living room taking up the front half overlooking Marsh Lake. Florence's book rests face down on the arm of her overstuffed chair. Another comfortable chair sits next to hers and a spotting scope is positioned halfway between.

Florence was born in Vancouver but her family moved to the prairies "way out in the country" until she was of high school age, when they relocated to a small town outside Edmonton, Alberta. She says she's not sure how it happened "But I had a deep desire—a yen—to go north even though I didn't know anybody up here. I applied for work and my mother was rather upset but my father said, 'Well if you must, you must, so go.'" On March 25, 1955, Florence arrived in Whitehorse to work for Canadian National Telecommunications. She says, "From the first moment, the Yukon satisfied my yearning."

A year later, she got a job as a telephone operator at the air force base. She chuckles. "A call came in for the heating section and I left a message for the gentleman working there. As soon as he walked in the door, I thought to myself, 'That's mine!' A month and a half later, Neil and I were married. That was in 1956."

They were well matched. "We both idolize country living. We've hiked, driven, boated or canoed all over the Yukon." They lived first out at Two Horse Creek and later at McRae, both outside Whitehorse.

When their oldest reached school age, they moved to town. Florence stayed home and says, "I always had a passel of kids around. We'd go to the woods and I'd show them flowers, bugs and birds. I felt this wonderful connection with the kids in nature."

With their children in tow, Florence and Neil headed out in the bush every weekend. "We started off with tents and graduated to a camper." She recalls, "We didn't want to stay in one spot. We camped up the Canol Road, the Haines Highway, around Dawson City and up the Dempster Highway once it opened. We celebrated our youngest's seventh birthday there. We had a big birthday cake tucked away and candles and a big party up on Ying Yang Creek."

Her face glows as she recollects boating and canoeing so many lakes: Tarfu, Snafu, Aishihik, Chapman, Atlin, Quiet and Frenchmen. "If there were a bunch of people, we cut off to a different lake where we had it to ourselves." She says quietly, "Every trip was special."

In town, Florence and Neil supported their sons in hockey and daughter in figure skating. After her youngest entered school, Florence worked in the public library and later in human resources. Neil worked at the White Pass & Yukon Route fuel storage facility.

Florence says Neil always went hunting, but she had to wait until the children were older. "We'd roam around; try this or that place. It was so exciting to listen to him call the moose and to hear it answer! Oh, the rush of adrenaline when they bang their horns on the trees. One time, we got our moose late in the afternoon. I knew it would take some time before we were finished so I trickled off down this path gathering up wood to make a fire. I had my arms full and I'm walking back toward the camper when all of a sudden this grunt came out of the woods and here was a second moose. Well, I just threw the armful of wood over my head and ran back to the camper."

Another day, they drove up the Canol Road and down the Boswell Mine Road. "We panned for gold on two creeks and we walked up this mountainside. We looked over the top of the world. Oh, that was quite a day."

Since Neil retired, says Florence, "We live in town in the winter and Whitehorse is a great little town, but if I had my druthers, I'd be at the lake all the time."

These two side-by-side armchairs overlooking the lake attest to many quiet moments of this couple just being together.

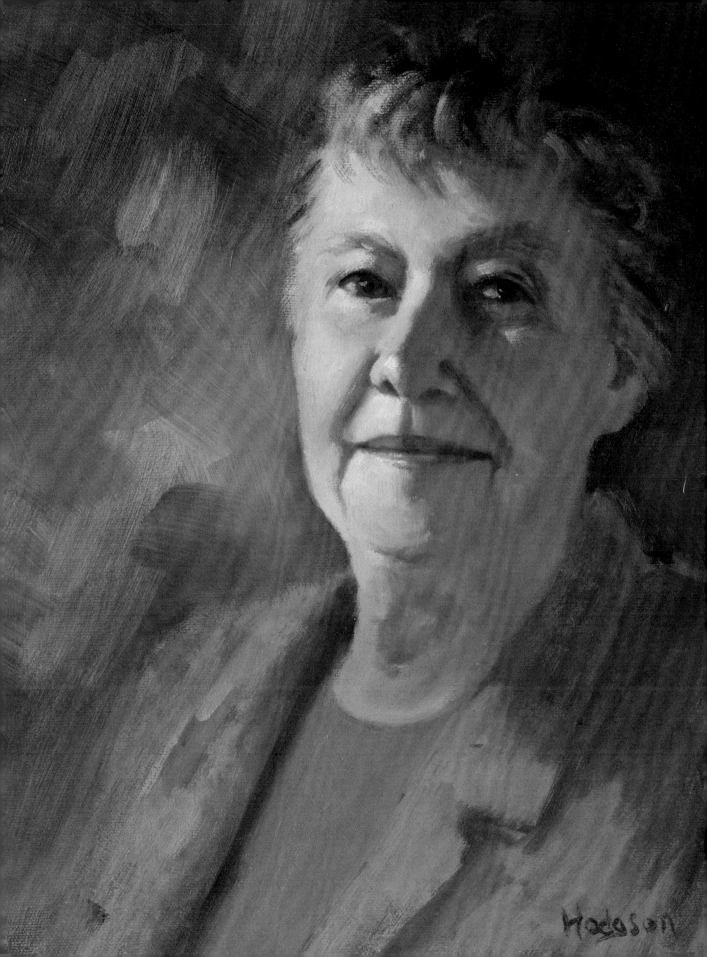

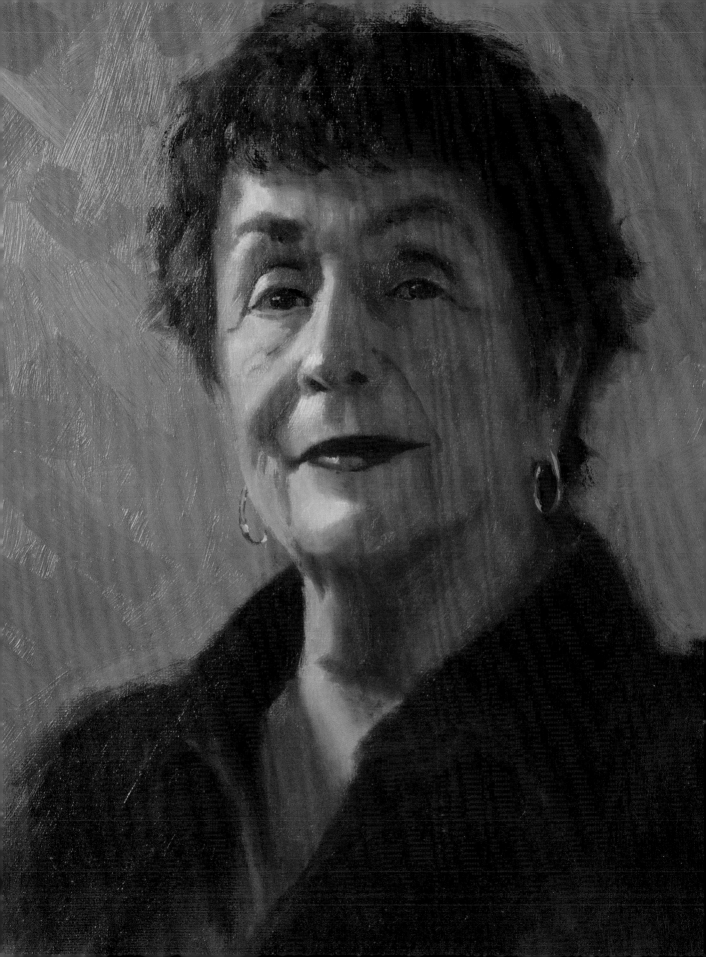

Arleen Kovac

Family Photos

Born November 30, 1928, in Fort William, Ontario (now Thunder Bay)

We've had a wonderful life up here. We've had our downs as well but mostly ups. We've had a happy life with lots of fun.

—Arleen

Arleen's condo is spotless. As the coffee percolates, she chats cheerily, placing the creamer between the cups and saucers.

She tells me her husband Frank passed away; that they had lived many years in Whitehorse but after he retired they spent thirteen years in a house by the water at Marsh Lake. When his health failed, they moved back to town.

When they first headed to the Yukon as newlyweds in 1952, they expected to make it their home. Arleen's sister and an uncle were already living in the Yukon when Arleen and Frank left Fort William (now Thunder Bay), Ontario, in May. She recalls, "The Trans-Canada highway was still being built and the Alaska Highway was pretty rough." They loaded all their possessions in the back seat of a 1948 Plymouth and a small trailer. Just as they were leaving, her mom tucked in two pairs of rubber boots, which they wore every day en route.

She says, "It was a real adventure. Outside of Dawson Creek it was so dark and rainy we missed the detour sign." They followed a slippery clay track with gravel mounds in the middle of the road. Exhausted, they stopped for the night at the first motel—a converted army barracks. The walls absorbed all the smells and there was a hole in the wall between the heater and bedroom. Next day, halfway up a steep curving hill, the clutch gave out. They were forty miles south of Fort Nelson. A week later, they made it to Whitehorse and they never left except to visit and travel.

The pictures on Arleen's condo walls are of family and Yukon landscapes. A framed photo of three generations takes pride of place opposite the main entrance. From brunette to blonde, from tots to grandparents, all are relaxed and beaming, but especially Arleen and Frank. The photo was taken in 2001 for their fiftieth wedding anniversary. They didn't want any gifts and no big party because Frank was suffering from emphysema. They just wanted all three children and their grandchildren together. But, Arleen told her kids, "Your Mother wants one more thing: I want you all to dress up and have a family picture taken." Arleen comments wryly that her children always hated having their pictures taken but loved poring over them later. This photo is especially prized because Frank passed on shortly after.

When asked what she holds dearest to her heart, Arleen doesn't hesitate. "Our children are the highlight of our lives. We adored them and still do. When Frank died, our youngest said 'We were so lucky, Mom,' but I said, 'No, we were.'" Her back straightens slightly and she says with a steadfast look, "They're such good kids."

Arleen has many stories about camping with their best friends, Bucky and Shirley Keobke, with families in tow. On one occasion, the two families were outfitted with a tent and tent trailer on a trip to Dawson City with Arleen's parents and a total of seven children. The camp was filled with laughter over Frank and Shirley's constant bets; they even bet how many loaves of bread would be eaten between Whitehorse and Dawson City. In the era before disposable diapers, their campsites were easily identifiable by the white cotton cloths drying over the campfire.

Turns out Arleen and Frank celebrated their fiftieth anniversary with two parties in addition to the family photo. The kids threw them a surprise party at the Yukon Transportation Museum and friends and siblings came from as far away as Ontario and New Jersey. At the after-party at their son's house, they took more pictures—this time wearing Groucho Marx glasses with the huge eyebrows and moustaches—but Arleen didn't show those to me.

Goody (Gudrun) Sparling

Good to Be Home

Born February 10, 1926, in Whitehorse, Yukon

I've always been in close touch, never away for very long from the Yukon.

—Goody

Goody leans on her aluminum cane and looks through the picture window of her third-floor condo in Whitehorse. She gestures toward the Yukon Legislative Building on the opposite side of Second Avenue. "I was born right here, across the street. The hospital used to be there," she says, smiling. "So much has changed."

Goody was born in 1926 to Kristina and Olof Erickson, the owners of the Regina Hotel at a time when steamboats plied the Yukon River. As a child, she would step outside her parents' riverfront hotel and listen for the swish-swish of the paddlewheel and watch for the telltale smokestack downriver. When the engineers sounded the shrill steam whistle as they neared Whistle Bend, Goody's father would hitch up the cart and drive to the dock to greet inbound customers.

As the transportation hub for White Pass & Yukon Route, Whitehorse was a tight-knit, one-company town with a winter population of nearly three hundred that swelled to five hundred in summer. "We were just in our own little world," says Goody, "I guess we didn't know what we missed, but we had a lot of advantages, too—being a small town, knowing everybody."

Goody's small town felt ripples of change in 1939 when many Yukoners enlisted for World War II. But in the spring of 1942, a flood from Outside transformed the community. "We knew something was brewing, with rumours flying around, but it was all very hush-hush," she says. Then one April day, Goody's father led her to the train depot for a first-hand look at history. The normally single-car train stretched farther than young Goody could see. "Literally thousands of soldiers came off those railway cars," she says. "Nobody had ever seen anything like it."

Overnight, Whitehorse became the administrative centre for the US defence efforts, namely the construction of the Alaska Highway and the Canol Pipeline, which would deliver oil from Norman Wells, NWT. The three-times-a-week train increased to roughly seventeen arrivals daily. New roads connected downtown with the US Army camp at McRae and the Marwell industrial area.

The Regina Hotel filled with southern workers who settled into the comfortable family environment the Eriksons had created. In *The Canol Adventures,* Gertrude Gillis, an accounts clerk on the Canol project, fondly remembered her stay at the hotel. "They ran a clean ship—no rowdiness allowed—and my recollection is of good food and good camaraderie around the big iron potbelly stove in the lobby that doubled as our living room."

Goody heartily welcomed the changes. She and her teenage friends matured in a whirlwind of dances, concerts and parties. "Always chaperoned but oh, it was a fun time. It was great!" she recalls.

Soon, Joe Sparling, an oil-construction expert and hotel regular, captured Goody's affection. They married in 1948 and moved Outside, first to Alberta, where their four children were born, and then to British Columbia. But Goody's Yukon ties were strong. "I've always been in close touch, never away for very long from here," she says. Her children worked at the Regina Hotel each summer, and while Goody lived three decades Outside, she often spent Christmas in the Yukon.

Goody returned for good in 1978, after her husband suffered a fatal heart attack. She ran the Regina Hotel with her brother and nursed her ailing and widowed mother, who died later that summer—the second major loss Goody dealt with that year. "It wasn't easy, but you manage somehow. You have to."

Goody turns from her condo window. "I got involved with the Tourism Industry Association and became a founding member of the BC-Yukon Hotel Association," she says, describing how she passed on her knowledge from years of hotel experience. Eventually, her children pursued different careers, and as Goody and her brother aged, operating the Regina became a burden. In 1997, they sold the family business. The hotel, mere blocks from Goody's condo, was given new life as the River View Hotel. The warming wood stove is gone, replaced by a modern lobby, and the Regina neon sign, with its red crown, now hangs inside Baked Café, on the corner of First and Main, across from the old train depot.

"I wouldn't change a thing," Goody says of her life and years spent Outside. But as her gaze wanders over the family photos hanging on her freshly painted walls, she says firmly, "It's good to be home."

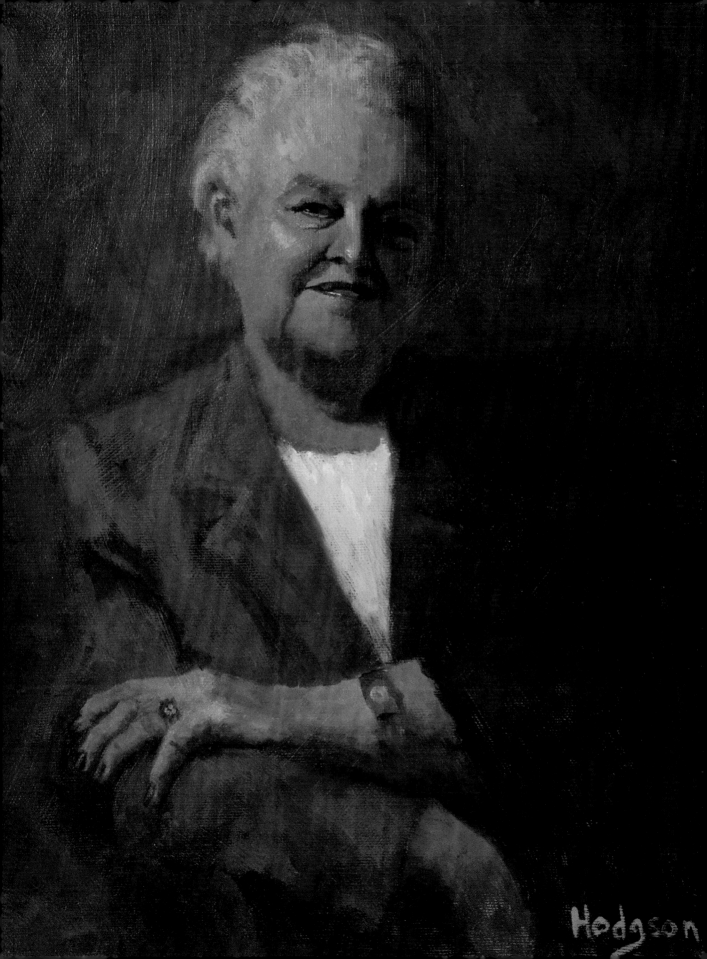

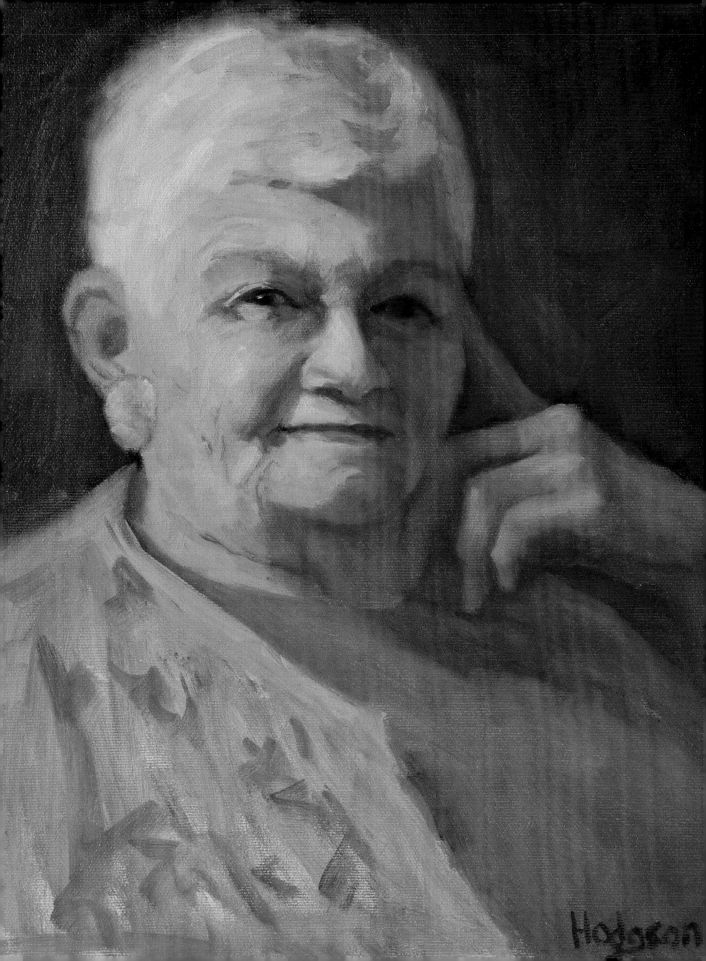

Babe (Evelyn Mae) Richards

Yukon's Own Grandma Babe

Born May 25, 1924, in Whitehorse, Yukon

To tell you the truth, I guess I probably had hard times but I don't really think of it that way and I just get on with it.
—*Babe*

Babe is almost swallowed by the big soft armchair but there's no missing her. Her sparkling eyes light up her whole face. Babe was born and raised in Whitehorse and, except for her high school years, lived in the Yukon her whole life. With an easy laugh she tells me, "I'm the type of person who gets something in my head and when I make up my mind, that's it." It becomes obvious she is also the type who, having made her choices, lives with the consequences. "What other people think," she says, "doesn't bother me."

Fondly known as "Grandma Babe," she cared for scores of children over the years in addition to ten offspring of her own. She is the epitome of how effective tough love can be, when the emphasis is placed on love. Babe says, "I just loved being with all the kids and I know I was strict, but you can't let them run you."

When Babe was twelve or thirteen, she decided to finish high school Outside. Her parents chose Crofton House, "*The* boarding school in Vancouver." After graduating, she planned to take nursing but that summer her older brother died in an accident and Babe says, "I thought, my mother needs me more and I never did get into nursing." She worked in her parents' business at the Whitehorse Inn.

When she was twenty-two, Babe had her first child. She says, "I wanted twelve kids right from the start and where I got that idea, I'll never know." A few years later, Babe left Whitehorse with her partner to operate Totem Pole Lodge on the Alaska Highway. She recalls, "There were lots of tourists. We had about twelve rooms and a restaurant and I ran the whole thing by myself and we had kids living upstairs and I look back at it now and wonder at it. But I'd been working all my life. It's through my mum and dad that I learned to work like I did. And I was never tired." She had seven children when her partner left and a year later she married John Brown.

When the family moved to Watson Lake, even with her ever-growing offspring, she took in boarders. "The parents lived on the highway but the kids could only go to grade 8 in the small schools and so they came to live at my place to go to high school. They all got along with my kids." By thirty-nine she had ten children but in her opinion women did not have children after her age, so she decided, "I guess I got to quit." And she did.

When her family moved to Whitehorse in the early seventies, Babe opened a dress shop on Main Street. During that time her husband left but she says, "I just got on with it." When the five-year lease was up, Babe went back to doing the thing she loved best: looking after kids. She operated a child care facility out of her home. Her face shines. "I would laugh and laugh because they can be so funny." She ran it for many years but, "My knees got so bad and I had to stop—that's all. But I used to get such a kick out of those kids. Oh, I just love them."

Babe keeps in touch with "her kids" and a broad circle of people. She says, "I never forget a birthday. I know it's made some older people very happy. Not that I expect them to call me. Well, I don't do it for me, I do it for them."

Another passion for Babe is knitting, which she has done since she was nine years old. She recalls, "I remember knitting my dad a pair of socks and you'd think that I'd given him a million dollars. He was that proud of me. And I have knit ever since." She's made five-foot by six-foot afghans for her grandchildren and she knits scarves and toques for people on the street.

Babe has over thirty grandchildren—and growing—"and the great ones are coming along pretty fast. They're just little ones now." And then, of course there are the other children whose lives she has touched. She says, "Most of the kids that came to me turned out okay, and I meet them on the street and they say, 'Hi, Grandma Babe!'"

Cecil-Gayle Terris

Family and Friends Are Core

Born September 25, 1946, in Whitehorse, Yukon

Like most small-town kids, I couldn't wait to leave. Just to get away and to have to look after nobody but myself. I moved to Dawson Creek and worked night shift from four until midnight and when I came in at midnight, nobody cared. I always had curfew at home so that was a big shock—there was nobody there to care.

—Cecil-Gayle

I enter Cecil-Gayle's house by the side door, hang my coat with the family's, and climb four steps to the kitchen. The interior has been remodelled and the overall effect—furnishings, plants and colours—is harmony. It's a real home. As I chat with Cecil-Gayle, I realize the warmth and order are a reflection of the woman herself.

The oldest of ten siblings, Cecil-Gayle says relationships are at the core of her life. "I took on the mother role with my brothers and sisters." She refers to her mom, Babe Richards, in tones of deep respect. Her son, his wife and their two children live nearby. She is so close to her colleagues at Yukon Electrical they call each other "work sisters." Over the years, she has lived in Dawson Creek, Kamloops and Cassiar, BC, but Whitehorse will always be home for her and her husband of more than thirty years, Dave.

Cecil-Gayle's grandfather, T.C. Richards, was a key businessman in the territory. When she was young, her parents operated Totem Pole Lodge on the Alaska Highway but she says, "We always spent Christmas at my grandpa's. It was special because he didn't have a house; he lived in a hotel. We would have Christmas dinner in the ballroom at the Whitehorse Inn."

Living on the highway, she had to go to boarding school in Whitehorse. She explains, "The closest school was eighteen miles away at the Watson Lake airport and my parents didn't have a car." Being the oldest, the first year was tough but "every year there was another one of us coming and it was easier because I knew the ropes."

Later the family moved to Watson Lake. "Then we got to go to school and live at home." Their house was always full of extra children and she remembers the meals. "Back then, you didn't have fast foods. To have pork chops, my mother would start cooking them at one o'clock in the afternoon. She'd brown batches in the frying pan and throw them into this huge roaster that went into the oven where they would bake all the way through. And we would go through a case of bread a week."

Cecil-Gayle went to work at a young age, first in Watson Lake and later in Dawson Creek. In 1967 she married and they had two children, Gordon and Kimberley. When the marriage "didn't work out," she and the children returned to Whitehorse in 1977. Cecil-Gayle's dad managed a road project at Marsh Lake and offered her a job running a road packer, which is where she met her husband, Dave Terris.

They married in 1978 and lived in Cassiar. "The mining town was its own little world. Most people only spent about two years there," she says. "That was our goal too, but we quite liked the lifestyle and it was a good place for our children so we spent nine and a half years there." The constant turnover was not easy, "so many people that I got attached to left and that's just the way it is in those mining towns."

The most difficult thing of her life happened in Cassiar when she lost her daughter in a skiing accident. Cecile-Gayle looks me in the eye. "But you try to pick up the pieces and go on. If my mom taught me anything, it's that." She goes on to list the things she liked about Cassiar: the progressive dinners and the Christmas parties, where "it's the only time of year you get to wear a dress and you hope to God that nobody else at the Christmas party or the Firemen's Ball has the same dress."

Dave was transferred to Whitehorse in 1988 and Cecil-Gayle says, "We never looked back." She upgraded her education and started working for Yukon Electrical in 1991. She loves it. "We work very, very closely with one another. We have twenty-year workers and thirty-year workers and it's a real special place. We like to go out for drinks together and we invite each other to our homes."

Cecil-Gayle loves cooking. She also enjoys camping, gardening and quilting. She tells me about her latest project: a latte quilt made on an embroidery sewing machine. We go to the guest bedroom and I catch my breath at its elegance: cream swirling flowers stitched on a cream base. And yes, her guests do sleep under it.

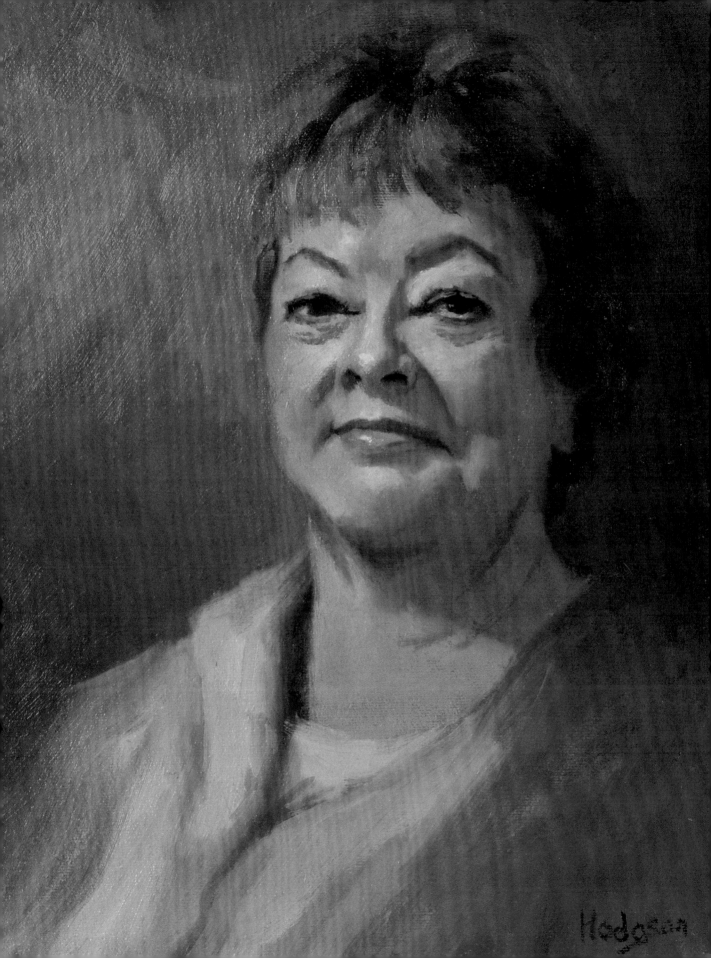

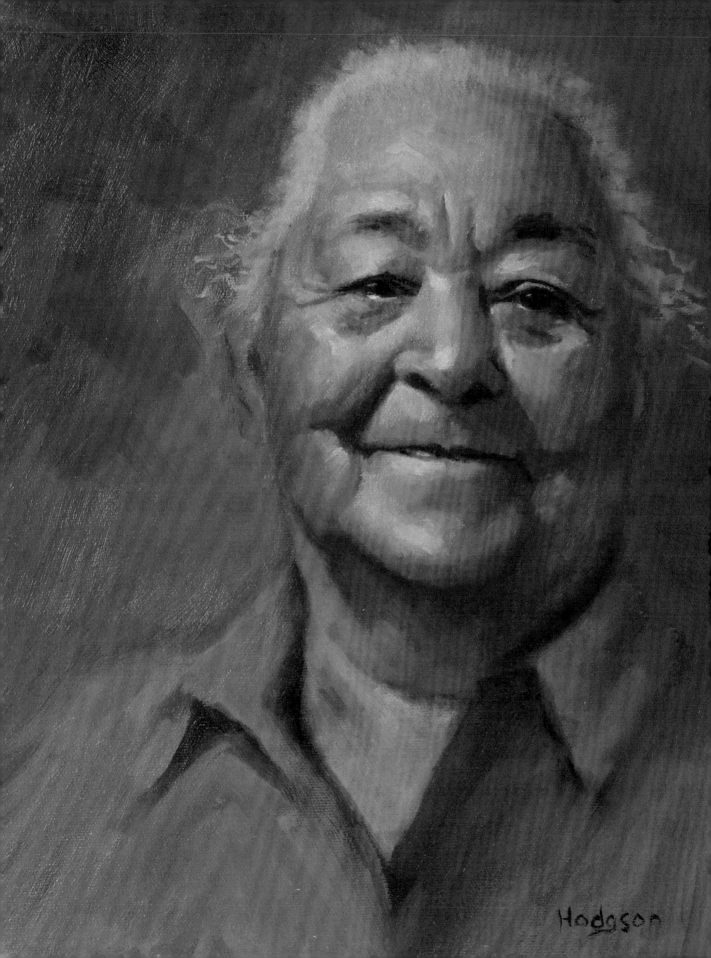

Pearl Keenan (Geddes)

Tlingit name: T'aakhu
Tla, which means
Mother of the Taku
River

One Foot in Each World

Born October 10, 1920, twenty-four miles up the Nisutlin River, Yukon

The different things I did in my life—it amazes me that I did those things. It's due to the people who pick you up because they believe in you. It's just wonderful the way people helped me out. I got to those places but it was never on my own.

—Pearl

I drive 183 kilometres from Whitehorse to Pearl's house on Teslin Lake on a mild November day. Fresh snow loads the spruce tree boughs and the sun breaks through broken clouds, sending shafts of golden light onto the immaculate snow. Pearl's house is tucked onto a shelf below the Alaska Highway overlooking Teslin Lake.

Pearl, eyes sparkling, greets me with a warm smile, takes my hand in both of hers, and says, "Welcome, welcome." I breathe in the smells of wood fire and fresh baking. Pearl has prepared a feast: smoked salmon, fish chowder, and tea and cake. It speaks to a lifetime devoted to staking her ground and exceeding expectations.

Pearl is a highly respected First Nation elder but she earned that recognition. She explains, "I was born to a Scottish father and full blooded Tlingit mother and that makes me half and half. Mother was twenty when they married and Dad was fifty but they really loved one another. My mother was somewhat put aside—not as involved with her own people—because she married a white person. Dad's peer group was another story; they called him all kinds of names. It was a hard path to follow.

"When I was young, some white people—certainly not all and I have so much respect for those who never discriminated—but some, they called us breeds, a mixed, everything. That's where Mom came in. She told us, 'Never, ever profess that you are a Native or a white person. You are not; you're different from others. Our Creator has put you like that, with one foot in each world. You have to find your own way, how to walk in both worlds. You are a spiritual person. Keep your head high.' You couldn't compare another woman to her; she was such a wise woman."

A picture of Pearl's mother hangs above the kitchen table.

Pearl went to school for a total of six weeks over two years. But now, "I can read pretty good and write too." She chuckles. "Only thing, I don't have enough fingers for math. You have to lend me yours."

Pearl married a heavy-duty equipment operator and his work took them to British Columbia from 1956–59 and 1968–1990. They had three children but when her oldest son was twenty-five, he died in a car accident. She shakes her head and says, "That took everything I had and then some. But, I survived it. The Lord was with me; I became a strong Christian three months before he died."

Pearl's lack of schooling did not hold her back from becoming a leader and life teacher. She worked with kids in prison for about four years as a Christian outreach worker. She was chancellor of Yukon College for seven and a half years. "I helped those youth with their outlook of life," she states.

The appointment Pearl holds most dear is the Yukon commissioner of Expo 86. She smiles. "Being commissioner was an important thing because the whole Yukon was depending on me. To think that I could do it and that I really was there with all those eighty-six commissioners from around the whole world and the only other woman was a Chinese woman. I was right in the thick of it. India put on a social and you had to dance with this sword all around the room. They handed me the sword first and I did it. The house just came down." Pearl enjoyed it so much she says, "I was lost when it closed down. It was fun and a great challenge. Fulfilling—just a great thing."

After that appointment, Pearl continued her life work. She teaches the Tlingit language and always shares the message that culture and tradition are important. She sits on a number of committees, advises youth on life choices, and visits women in the correctional centre. In 2007, she became a recipient of the Order of Canada, recognized as "an invaluable source of wisdom for Aboriginal and non-Aboriginal people in the North."

Her head high, Pearl takes a deep breath. "My work is not done yet." She credits her success in life to others, but as she shares her stories, I see her as a bridge linking past and present, firmly joining two worlds.

Carel *Alexander*

This Is It

Born May 1, 1948 in rural Manitoba

I'm always busy but I do things in my own time and at my own speed. And everything gets done, eventually.

—*Carel*

Born in small-town Manitoba, Carel's family moved to Saskatchewan when she was two and to Vancouver when she was eight. She went from farm girl to urban teen to chic jetsetter to delayed pioneer to suburban soccer mom to Yukon entrepreneur. When she moved to Whitehorse, she felt like she had arrived home and decided, "This is it!" Here, Carel has brought the best of the qualities from her disparate life phases together. She has a reputation as a hard-working, fun-loving, community-minded businessperson whose contributions make a difference.

Carel grew up "at the time of the Beatles and the start of throwing off conventions." She laughs. "I really had a good time." After high school, Carel went to work in banking and married a man twenty years her senior. Residents of tony West Vancouver, they led a chic lifestyle. "We travelled all over North America with Toastmasters and I had nice clothes, several fur coats, a pair of shoes for every outfit, and we ate out lots." After ten years, she felt the marriage had broken down.

In 1980, she left it all behind. She stowed away with a suitcase and her sewing machine on a fishing boat bound for the Queen Charlotte Islands and stayed. A short time later, she met her second husband, "a self-proclaimed delayed pioneer," while working as a deckhand on a salmon trawler. For the next four years "we lived the hippie life in a floathouse on the dock, collecting rainwater off the roof for all our household needs and never had a fridge." When fishing took a nosedive, with two young children, they left to find work.

Carel and her family headed to Edmonton, Alberta, and later Winnipeg, Manitoba. "I went from being a hippie mom to being a suburban soccer mom." But they were not satisfied with urban living and began looking for a smaller town.

In 1993 when their sons were nine and twelve, they arrived in Whitehorse. "I didn't know a soul but I felt like I had arrived home and the kids settled right in. My husband never did care for Whitehorse." He eventually left and Carel says, "I went out on my own and became an independent woman. I've done more things here than I would have ever dreamt of doing." She worked as a loan manager for a local bank but then set up as an independent mortgage broker. "I really enjoyed doing that. I did property management on the side. I was working two jobs to get myself established."

Once they were grown, her sons went off for "some big-city experience for a couple of years and decided the Yukon wasn't so bad after all." Both now live in Whitehorse.

Carel continued to grow her business interests. Because of her administration background, she was invited to invest in a Century 21 real estate franchise. When the person who initiated it backed out, Carel and three women realtors went ahead. She stayed in the partnership for six years and then sold her shares to the others. Since then, she has concentrated on property management.

Carel is a patron of the arts; she takes in most performances at the Yukon Arts Centre and many of the exhibits at the Art Gallery. She's a regular at the Chamber of Commerce Business After Hours. But she does more than hobnob and network. When she believes in something, she gets behind it. She spearheaded the group that lobbied for the Canada Games Centre to be located at the top of Two Mile Hill instead of on the waterfront. She says, "I took out a full-page ad in the newspaper. I composed it and put it in there on my own dollar." Her efforts and those of the supporters she rallied won the day.

Carel also takes time off with her long-time partner Mike. They love country dancing, fishing and RVing, often with friends. They laugh a lot together.

It's the people that make the Yukon special for Carel. "I can't see ever leaving Whitehorse to retire somewhere else. It's nice to be able to walk down the street and say a few words to so many people you know. It's home."

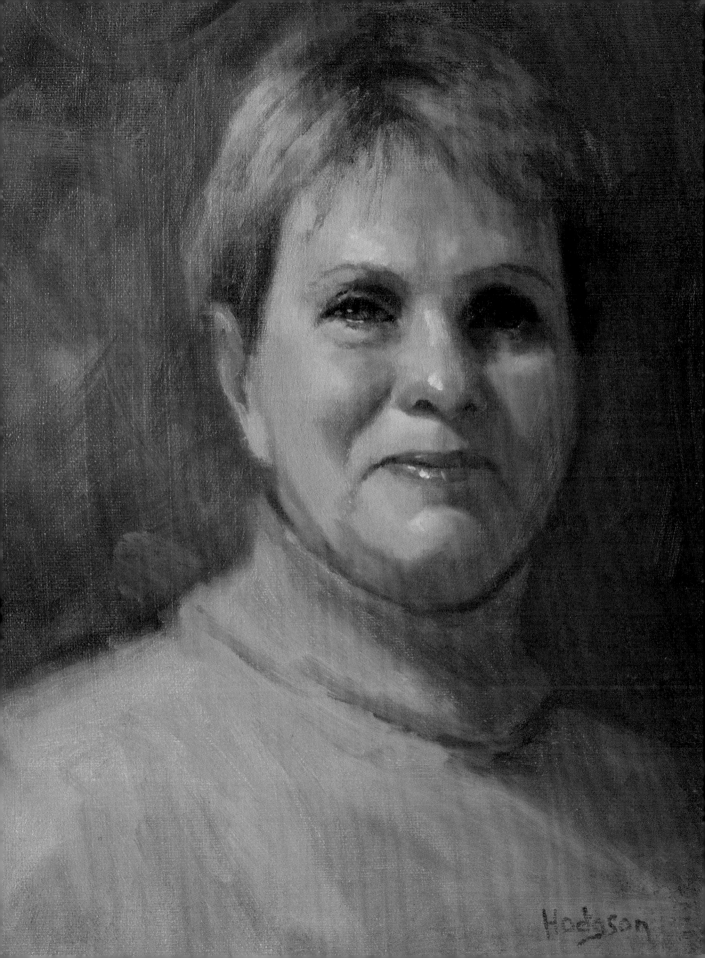

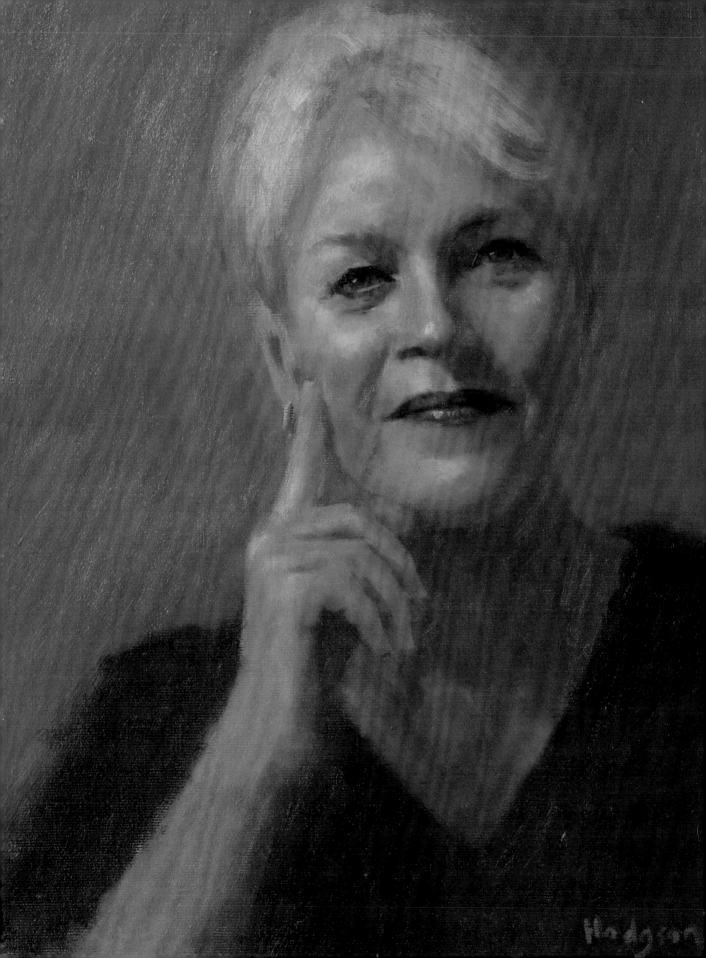

Judy Miller

The Quality of the Light

Born in 1942, in Vernon, British Columbia

What I love about the Yukon is the long light-filled days of summer and the quality of the light on the mountains. When it's sunny until midnight, it's comforting to me.

—Judy

Judy was born to a large Ukrainian farming family and grew up in Swan Lake, BC. When she graduated from high school at age eighteen, her dream was to save money to become a nurse. With visions of Jasper or Banff in mind, she responded to an ad in the *Weekly Free Press* to be all-round summer helper at Rancheria Lodge on the Alaska Highway.

She was offered the job, and says, "Of course, I accepted, and they paid my way and the whole nine yards and I thought 'Wow, this is really something.'" But it was not at all what she had imagined. Although the family was good to her, she was very lonely. There was no town. The lodge is literally in the middle of nowhere, located 120 kilometres west of Watson Lake and 140 kilometres southeast of Teslin—the closest towns in either direction.

After two months she left but she still needed work. She smiles. "I didn't dare tell my parents what I was up to! And so I took a job at Joe's Airport out near Burwash Landing. And guess what? I met a man and the rest is history."

Judy and Jim Miller were soon a couple. On their first date, he asked her to a dance at the community hall and Judy wanted to impress him. She laughs. "So I got all dressed up, just like a real city girl." He liked the dress but the black gloves didn't go over so well with a man who had grown up in the Yukon's bush.

A driver for the Canadian Army maintaining the highway, he was not always around that summer, but "meeting him made all the difference. Any thought of a nursing career was gone and I created a wonderful life with him. We got married in March of the following year."

Wanting stable jobs, they moved in to Whitehorse and Jim was hired on full-time in the White Pass & Yukon Route trucking division while Judy worked in various jobs. They had two sons, Jody and James. Over the years she volunteered in the activities they took up: Cubs, Boy Scouts and figure skating.

She smiles. "You know, my working helped us get ahead. We started off renting. Then from there, we bought a trailer. From there, we bought a duplex in Riverdale, and from there, we bought a home. And then, after that, we built up in Granger. So we were able to really get ahead and get those things that everybody strives to get, a home and a car." The home they live in now is neat as a pin.

Later on, Jim was operations manager for Yukon Alaska Freight Lines and still later branch manager with Trimac Transportation. When the Yukon economy hit a downturn in the mid-eighties due to a worldwide mining recession, they had to move Outside. Trimac transferred Jim first to Terrace, BC, and then it closed down so he was transferred to Prince George, BC, and that's where he retired at the age of sixty-five. A few years later, in 2004, they moved back to Whitehorse. Judy says, "We knew we were coming back, because this is home. Always has been and always will be."

Judy is content with her life. She does the books at Shoppers Drug Mart and likes her job. Their son James and his wife drop by often with the grandkids. She gazes out the window. "I suppose I could say that we're very comfortable now, and Jim and I are best friends. We really are. We really enjoy life. We do everything together, it seems, and we enjoy it." Since Jim had a heart attack, they relish every day.

In summer, they drive up the Alaska Highway toward Burwash Landing and Judy says wistfully, "My heart is there. I keep wanting to go back there and we do but there's nothing there any more, just a memory."

Other times, they head off to Dawson City, soaking up the beauty of the area and the "days of '98" atmosphere. Judy leans back in her chair. "We go up on a weekend, enjoy the casino, come back, go to work, carry on. We're able to do that and we both have our health. Life is good."

Joyce Andersen

Stick-with-it-ness

Born September 12, 1944; conceived in Dawson City; born in Edmonton, Alberta

I admire women who have suffered greatly for things you can't even begin to imagine, for things that are hidden away in families and don't come out. The ones with that stick-with-it-ness; they are the everyday heroes.

—Joyce

I meet Joyce, a beautiful woman with soft skin, green eyes and her greying hair swept up in a fashionable bun, at her office in Peacock Sales. The clerk points me off to the side, behind metal shelves full of hotel and restaurant equipment. Joyce clears a small wooden chair and hands me a cup of tea. Reg, her partner in business and in life, pokes his head around the corner and tells me to spell her name correctly, the Norwegian way. She smiles. "He's always looking out for me."

Joyce says "I was a seedling when I left the Yukon; I was conceived in Dawson City and born in Edmonton." Joyce grew up in Salmon Arm, BC, where she was raised in a foster home, and went to live with her mother when she was a teenager. "My foster family was wonderful. Their children are like my brothers and sisters."

After she graduated from high school, Joyce came to the Yukon for one winter to get to know her dad. She smiles. "That was in 1963 and here I am all these years later."

Joyce did not always have it easy. She married at twenty-one and divorced at twenty-five. She sighs. "I made an honest mistake, just an honest mistake. I went into marriage thinking I'd be married for life like all my generation and it went wrong. I didn't want that kind of life for my children so I took them away from it." When she divorced, her two boys, Ashley and Richard, were under five.

Her eyes turn serious. "I managed somehow. I was with my kids a lot. They went with me everywhere because I couldn't afford a babysitter but we had lots of fun. Our big thing on Friday nights was to go to the laundromat. While the wash was in, their treat was an ice cream at Dairy Queen."

Joyce enrolled in an accounting program by correspondence and says, "The boys were in bed by eight, and afterwards I would sit down to study till midnight." That went on for a number of years.

Joyce's face opens in a wide grin. "Then I met my sweetheart and have been with him ever since. He took on the whole package: two children and me. I think that's incredible. I do cherish him." Joyce and Reg have been partners in life since 1972 and in business and working together since 1974. They even have offices next door to each other. They own and manage three active businesses.

When Joyce's first son went to college, she says, "I missed him so much I couldn't believe it. So when my second was in grade 12, I signed up for first year university courses in general arts. That really helped me get on when my youngest left."

She's very proud of her sons. She smiles. "They are two fine young men. I didn't go out and march in the streets with a banner, but I taught my sons how to cook and clean house and to do simple things on the sewing machine. I trained them to be full-fledged citizens— responsible and capable of looking after their families." Both her sons live Outside and are very close to her foster family. She says with pride, "My grandson's first name is their family name. They are just as pleased as can be."

Joyce and Reg often head off to their retreat in Atlin, BC. She says, "We have put our hearts and souls into it. The original house was built in 1902. We fixed it up, moved it to a bigger property by the lake, built an addition and put in gardens, and planted more trees. It's been very rewarding for us."

To relax, Joyce reads history books and, she says, raising her chin, "My family is surrounded by warmth from my quilts. When my oldest grandson moved into a big bed, I make him a quilt that shows the story of his favourite book, about friendship. My granddaughter's quilt tells the story about unconditional love." There's a baby due soon and Joyce is going one step further: she's writing a story about their family and she's making a quilt to go along with it.

Joyce bubbles with energy. She says, "I never plan to retire. Retiring means what? You're tired and I'm not. I keep adding new things to my list."

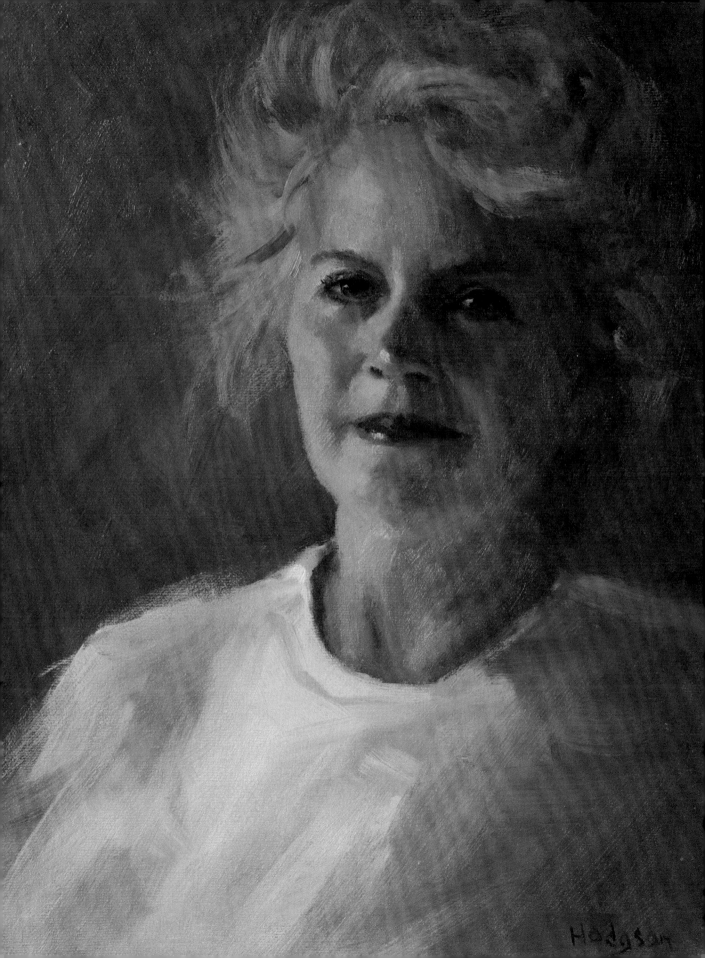

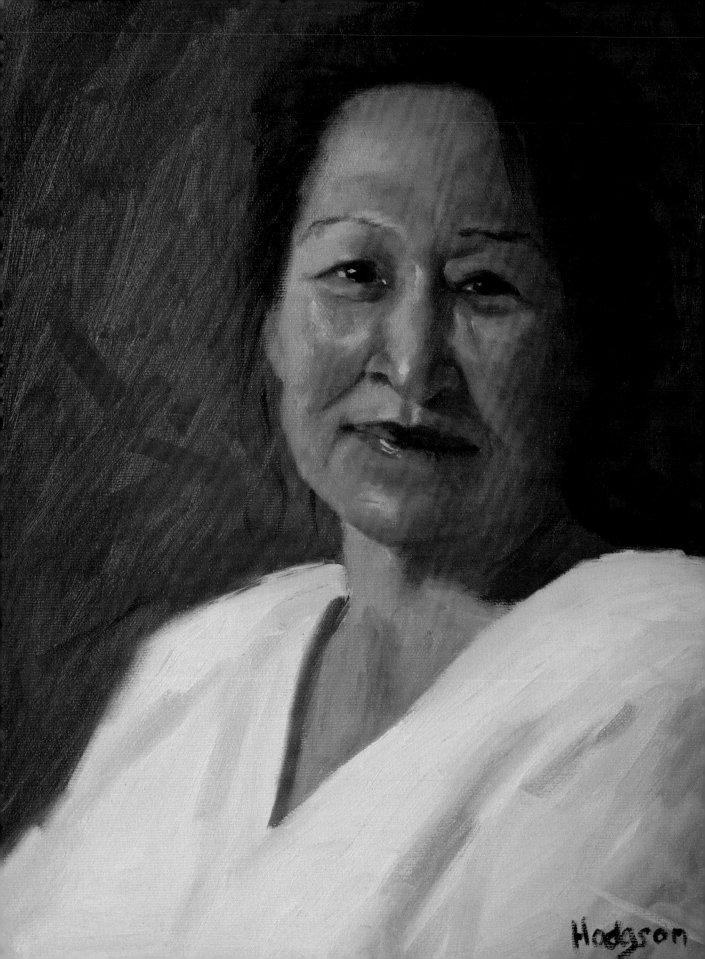

Sarah Lennie

Born for a Reason

Born May 18, 1956, on Banks Island, Northwest Territories

You don't realize you are having a tough life until you're not. I think every single person on this earth is born for a reason whether they live for one second, one minute, or one hundred years. Sometimes I think my purpose is to tell the next suffering person "It'll be okay. It's not going to be like this all the time."

—*Sarah*

Sarah speaks softly, her face calm, her body still. She is the first of ten siblings, delivered by her dad in a hunting camp out on the land in Canada's Arctic. Her grandfather was from Fairbanks and her grandmother from Fort McPherson; her father grew up around Tuktoyaktuk. Her mother grew up on Victoria Island; her people are Inuvialuit. Sarah says, "We're related right across the North."

Sarah grew up out on the land—trapping, hunting and fishing. "I remember living in igloos and tents and using *quilliq*, a soapstone lamp with seal oil. In the fall time my brother and I picked cotton grass, then you twirl it and make it into wick for the lamps."

They hunted on Banks and Victoria islands. She says, "My dad was a great polar bear hunter and my mom is an excellent sewer. She just looks at you and can make a parka that fits you perfectly."

In the mid-sixties, they moved to Sachs Harbour where she went to school up to grade 6. That year, her father died and three months later her infant sister also died. Sarah went to Inuvik residential school for grade 7 but her mom—aged thirty-three and with eight children at home—asked Sarah to come back and help raise the family. Sarah and her mom have been partners ever since.

In 1975 the family moved to Inuvik. Her mother got a job at a sewing centre. Sarah had an offer to work on the drill ships. "It was seasonal work," she says, "which was fine because I had a little boy. When I got pregnant I was not ready to be married and my mom said, 'We can look after him.'" Sarah says quietly, "She kept us together. She is my rock."

Sarah became the main provider but she says, "I got into trouble with alcohol abuse. I was about eighteen and a half, working in camps, and on time-offs that's what you do. At that time I thought I was having a good time and later I thought it was a way of life and I deserved it and stuff like that."

About 1979 Sarah moved her family to Yellowknife "because when they start realizing what's going on, then it's really tough. But I was still working on the ships." Four years later, she moved the family to Whitehorse. Sarah smiles. "It has become our home."

On the ships, Sarah discovered a passion. "This Chinese cook amazed me. He put ground beef in these great big pots. After a while he's adding vegetables and all kinds of stuff and that's the first time I ever watched somebody make spaghetti. I loved it and I thought 'someday I'm going to do that. I'm going to learn how to do what he does.' I started paying attention and asking questions and on my time off I went to Fort Smith to take cooking courses. So that's what I did—I cooked in construction camps in the western Arctic for over twenty years."

In 1997 when her granddaughter, Raven, was born, she resolved to stop drinking but says, "I got help. I could not do it on my own." Two years later, her grandson, Jonah, was born and that gave her more incentive. She also enrolled in college, first completing her high school equivalency and then taking the nursing home attendant and community support worker programs—simultaneously. She smiles modestly. "I graduated 2004 and have been working at Alcohol and Drug Services since 2005 and Copper Ridge since 2006. I'm happy where I am."

Sarah swallows. "Before I stopped drinking, I was pretty much homeless and almost jobless, just barely hanging on and today I live like I don't ever have to have that drink for today." She pauses.

"When they say it's tough out in the streets, yeah. When they say it's their choice, no. It's not."

Sarah bends forward and says quietly, "In my language we have a saying, 'A-unq-naunq-maun-ela.' It means 'when something happens to cause suffering, there's nothing you can do about it. And the quicker you accept it, the quicker you will get through it.' They don't say it directly to that person until lots of time passes, until the person starts opening up first and you can tell they're getting ready. I guess as humans we need that permission to let go."

Evelyn Loreen

Planted Myself in Dawson

Born September 16, 1955, in Aklavik, Northwest Territories

Dawson City is really community-oriented; it's what it was like when I grew up in Inuvik and I never saw it again until I came to Dawson City. I kind of planted myself in Dawson; it's my home now.

—Evelyn

In an eager, soft voice, Evelyn tells me she is Inuit: her father is from Alaska and her mother from the Western Arctic. She was raised up on the Mackenzie Delta between Aklavik and Inuvik. A wide smile crosses her face. "My father wanted a son for the first one but I showed up so I got to learn how to hunt and trap on the land with him." She continues, "I was a little strange to begin with anyway—very independent."

Evelyn walks a different path: childless by choice, an artist who does not show or sell her work, an oil-rig worker who saved money like a miser to travel in winters, and now, a Dawsonite for keeps.

Evelyn was hunting with her father until she was eight, but then the family had to move to Inuvik because she was of school age. She raises her head. "My father was homeschooling me so when I started school I went from kindergarten to grade 1, to grade 2, to grade 3, in a week and a half."

She had an aptitude for art and after grade 11, went to the Banff School of Fine Arts to improve her skills. She shakes her head. "When I returned to go to grade 12 in Inuvik, the principal said I couldn't continue. I was too advanced."

Years later, she completed high school. But by then, she was legal age so she bought a one-way ticket to Edmonton and lived there for three years before making her way back north.

Evelyn was twenty-three when she came back to Inuvik but she didn't settle. Instead, she says, "I worked in the summers on the oil rigs and travelled in the winter." The ships were a forty-five-minute helicopter ride from Tuktoyaktuk out on the Arctic Ocean and held over three hundred people. She chuckles. "It was a bigger community than where I was born. I was in the kitchen; we worked twelve-hour shifts. I was always so tired after my shift that it was straight to my room, read and then fall asleep because then I'm off again at four o'clock to go back to work. You're there for two weeks and if your cross shift doesn't show up, you're there for two more and then you have to do your rotation, so six weeks sometimes. My theory is: the situation you're in is what you make of it. You can have a difficult six weeks or have fun with it."

For her winter travels, Evelyn set a deadline to leave Inuvik before the ferries were pulled out of the rivers at Tsiigehtchic and Fort McPherson. She smiles. "I just love being in a warm place where I can wear shorts and dresses. For me, travelling was an education in itself." She has been all over the world, including Thailand, Malaysia, Mexico, Jamaica, Belize and Costa Rica.

But her travels came to a halt in 1997. Her eyes turn serious. "I was in Dawson City on my way to Africa to climb Mount Kilimanjaro when my middle sister died from an aneurysm." Because it was a hereditary condition, her whole family was tested. She needed surgery and was cautioned to curtail any adventures involving altitude.

It was time for her to settle and she says the choice was easy. "Dawson City is really community-oriented; it's what it was like when I grew up in Inuvik and I never saw it again until I came to Dawson City. I love that it has mountains and I'm still close enough to go home and visit. I go berry picking across the Yukon River for blueberries and strawberries and make jam. And if I need solitude, I do a trip to the Tombstone Mountains and that keeps me going."

She met Claude Audet from Quebec and chuckles, "We've been together since 1999 and we're not married but he's my hubby."

Evelyn works at the Northwest Territories tourist office. She says the job suits her because she can relate to the people who've travelled. "I get so busy talking with them that someone has to remind me when it's time to go home."

Evelyn bought a house in 2004. She laughs. "Now I have no more money to travel—it all goes to my house—but I loved that house the minute I walked in. I kind of planted myself in Dawson. It's my home now. I sure love it."

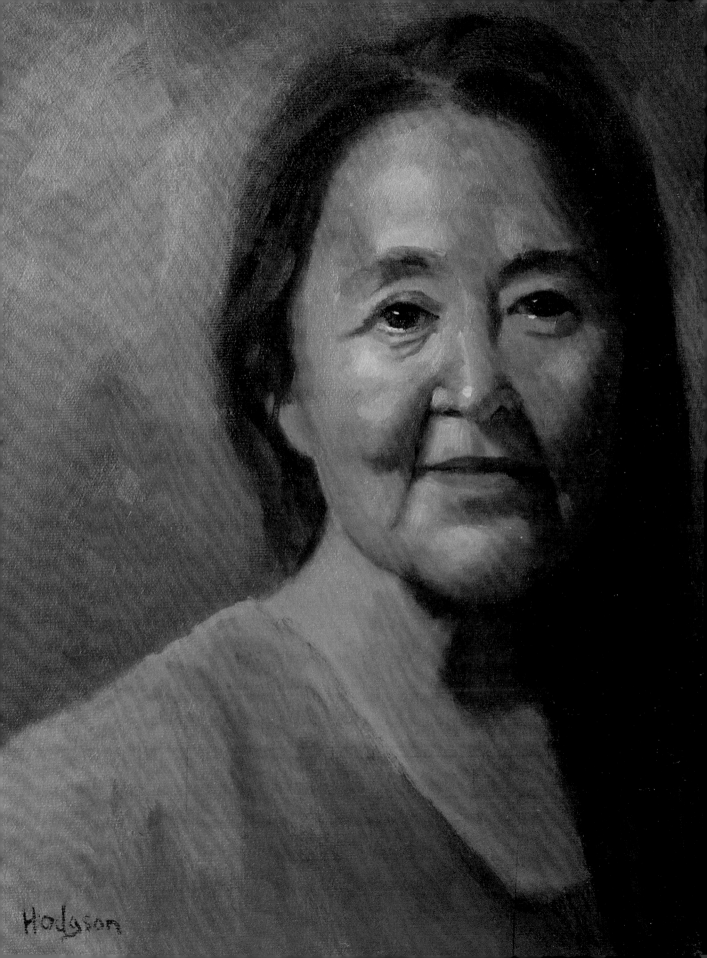

Hodgson

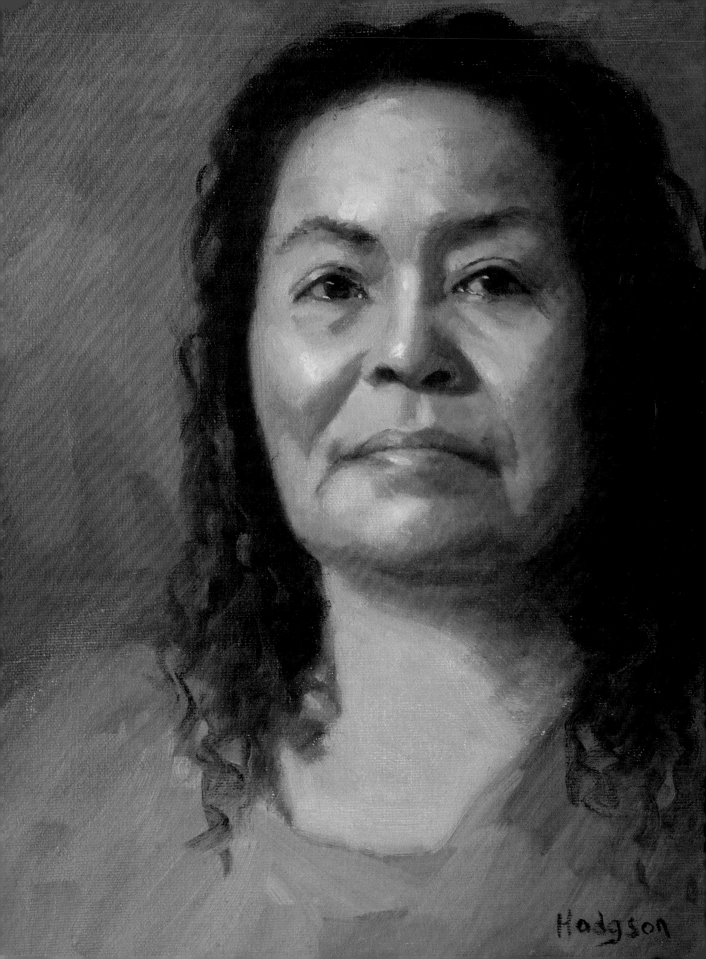

Hodgson

Clara Irene *Dionne* (Linklater)

The Ability to Be Honest

Born July 27, 1959, in Aklavik, Northwest Territories

When you have that drive for change, that energy feeds you.

—Clara

Clara's parents are both Gwich'in but her father comes from Old Crow and her mother from Fort McPherson. Her family lived in Aklavik, the regional centre for the Northwest Territories government. That's where she was born.

Clara pushes her long black hair back with both hands and sighs. "When I was born in 1959, Inuvik was being built. It was referred to as East Three at that time." Aklavik was prone to flooding and the town had little room for expansion, so the federal government decided to relocate the town to the west side of the Mackenzie Delta. Aklavik survived but many residents—Clara's family included—relocated to Inuvik for work when it became the new regional centre.

Growing up in Inuvik was not always easy. The social upheaval was compounded by the influx of workers for the Canadian Forces base and oil exploration companies. Clara fondly recalls the times at her grandparents' fish camp at the mouth of the Peel River. "We always looked forward to going to fish camp. There was no alcohol. There was no fighting. You didn't have to worry about your safety. Those were good times."

In his youth, Clara's father was the maintenance worker at the Carcross residential school and he vowed his children would go to regular school. Clara shakes her head. "He had quite a fight with the government and he had to give up the right to hunt and fish. But we never, ever went to residential school." Her family consists of two older stepsisters, three brothers and three adopted sisters.

As a teen, Clara became rebellious and left home at seventeen. "I just wanted to go out and do my own thing." When her family moved to Whitehorse in 1977, her father persuaded her to come, but she says, "I stuck my nose up from going to school and I got work and moved out of my parents' place."

Clara tells me she soon met the father of her four daughters. "And that," she says, "was a really awful, brutal relationship." She left him after six years but the violence continued. "The attacks were random and they were brutal. Right on Main Street, he would grab me and beat me and jump in his vehicle and drive off."

By this time, she had returned to school and was working. She looks out the window when she talks about how it ended. "The last assault was an attempt on my life. He was American and he was court ordered out of the country."

Clara says her healing came in the form of regression therapy. "This lady took me through my childhood and I got to see how I became susceptible to being abused. Not that I let it happen. I never say that. But your family history and your community history sets you up for that." She says with deep conviction, "When you finally get back the ability to be honest, it's the only way to be."

Healing also came in another form. Clara worked at Kaushee's Place, a shelter for women, as legal advocate, preparing victims for court and legal aid. "It was empowering to say to these women 'These rights are yours,'" she says. From that job, Clara became involved in victims' rights and was part of the team developing the Family Violence Prevention Act. "I gave a voice for victims as opposed to people studying us constantly and telling us what was good for us." She nods. "I was constantly going, constantly going. But when you have that drive for change, that energy feeds you."

In 2000 Clara decided "I had to do something else with my life," so she moved to Grand Prairie, Alberta. She worked in a women's shelter and after two years, she says, "I hit a wall and there was no going around it." She quit and concentrated on getting her younger daughter through school. When her granddaughter was born in Whitehorse, she thought, "It's time to come back home."

She says she knew what she wanted: "A simple job where I don't have to take anything home or figure out a strategy to survive while I'm at work. So, I went to work for Walmart and I loved it. I got to visit all the people I hadn't seen in years and got paid for it. It was great."

Clara married Remie in 2007 and "lives a simple life." She says she turns her energy toward family. "I love spending time with my grandkids, teaching them and taking them out to the bush. I'm getting back into beadwork the way my mother taught us, the McPherson style."

Donna *Isaak*

Major League Volunteer

Born January 27, 1941, in Winnipeg, Manitoba

My husband and I met in late September and married, to our families' horror, on December 17, 1963. I was always a stay-at-home mom; I chose to do that. I made the right choices. We've had a great life together.
—Donna

Donna's house in downtown Whitehorse is set behind a fenced-in flower garden still colourful on this early September day. The living room is a treasure trove of family photos, knickknacks, plants, brown leather furniture, a guitar on a stand, a TV and stereo, and the soothing strains of a water fountain. Music, she tells me, is a theme woven deeply through her family's lives.

Donna was born and grew up in Winnipeg but came to the Yukon very young. Known equally for her beauty and caring nature, she is a down-to-earth woman. She hesitates and says, "My boys wanted me to tell the story of when I first came here."

I nod and she continues, "In the spring of 1963, I was waitressing at the Winnipeg Playboy Club. The magazine shot a "Girls of Canada" issue and I was chosen to pose as Winnipeg's girl. It was tastefully done, discreet."

In August, seeking adventure, she hopped on a bus and headed to Whitehorse for a job at the '98 Hotel. She says, "The '98 was a lot different then. It was really a cozy bar and a happening little joint." It hopped even more after the "Girls of Canada" issue came out. She laughs. "I'm telling you, I was popular! I was making tons and tons of money because everyone wanted to see this Playboy girl. I was quite a splash in Whitehorse."

By this time, she had met Ed, whose band was playing a three-month gig at the Whitehorse Inn. Donna says, "We really hit it off and I was faced with an interesting little dilemma. I started getting calls from New York and Chicago and I was thinking, 'Do I want to follow up on these big city offers or marry this guy and go live on a strawberry farm in British Columbia?' So, we got married on December 14, 1963, and it's been great. We've had a lot of fun together." They have two sons, Chris and Brandon, and their daughter, Tammy, died tragically when she was twenty.

Ed and Donna did move to the farm in Langley, making it their base. It was a good fit with his music career; Donna and the kids went along with the band as they toured in BC, Alaska, California and the Yukon. But in 1968, after three successive crop failures, they sold the farm and moved north to manage the Whitehorse Inn. When the boys were of high school age, they moved to White Rock, BC, to connect with a broader music scene.

Shortly after, Yukon's tourism department asked Ed and Donna to put together a summer stage show with a 1940s' theme. Ed's band, the Canucks, would provide the music and she was to write, produce and direct it. Donna says, "I had never directed in my life, but I learned fast." The show ran for seven seasons in Watson Lake and another four in Whitehorse.

Then life took a tragic turn. In a one-year period, Donna lost three people close to her. She was devastated. Her voice fills with emotion. "Losing my daughter nearly destroyed me. I would not have made it if not for Ed and my two sons. We loved and adored her so much. I'm still thinking of all the 'could have beens.' I miss her every day." As a way of coping, Donna volunteered with Hospice for five years, helping others to deal with their grief.

After the canteen show, Ed was asked to take over the Discovery Bar (the Taku), which he ran until he retired. Her sons, both living in Whitehorse, were successfully going down career paths in the music industry.

Donna continued to help others, becoming a major league volunteer. "One year, about a month before Christmas, we had this brain wave. I started an annual Christmas fundraiser for needy families. In five years we raised just under $400,000 through the schools and business community. It was called 'Adopt a Family.' In the sixth year, Donna was diagnosed with breast cancer so she turned over the program to others; it's now known as "Share the Sprit." She sighs. "It was quite a ride."

Today Donna is still tired from the many years of cancer treatments, including two surgeries and radiation. But she is buoyed and gratified by the recognition her community has bestowed on her: the Rotarians named her a Paul Harris Fellow, she was awarded the Queen's 50th anniversary medal, and she is a recipient of the Governor General's Caring Canadian Award.

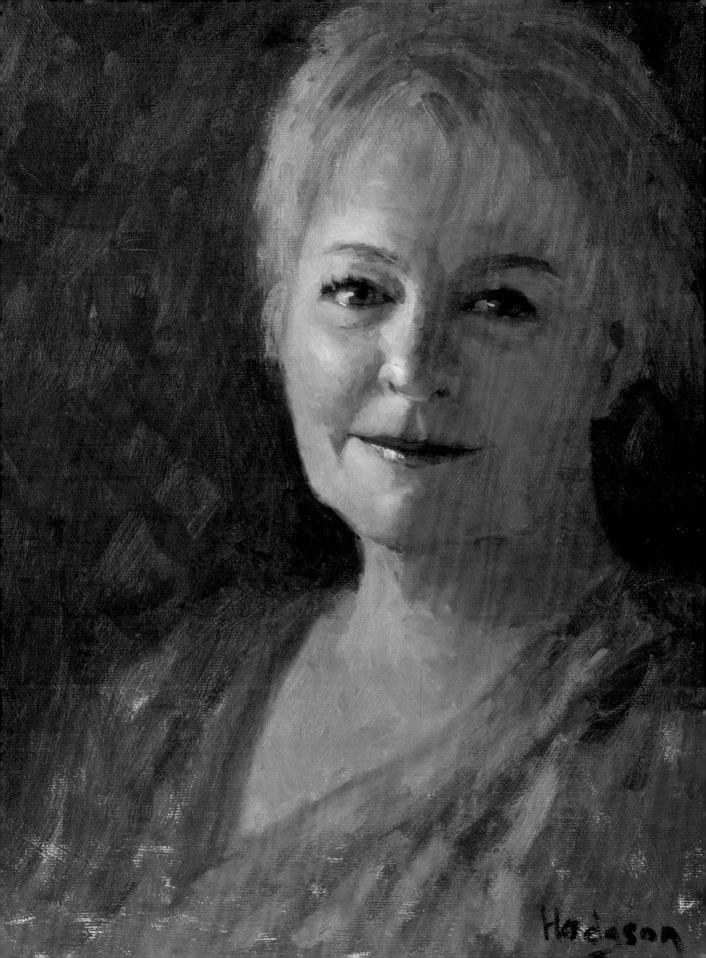

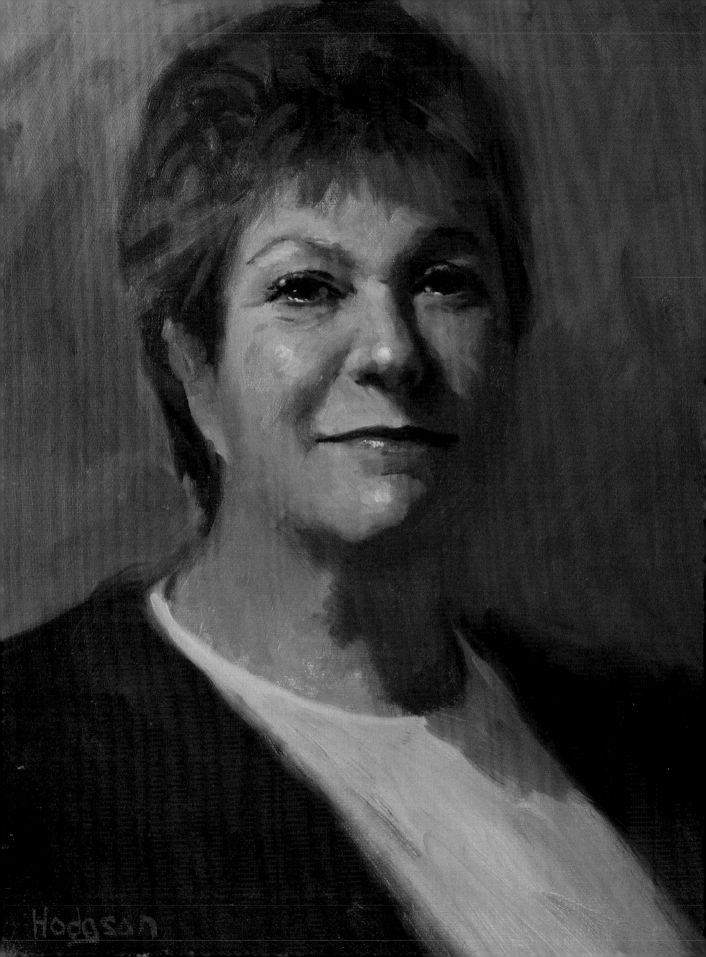

Nancy *Huston* (Firth)

Finding the Balance

Born January 12, 1951, in Dawson City, Yukon

I'm at a stage of my life where I am balanced between being connected to my community and having anonymity. All those years, I was "out there," but now I'm content and blessed to live a quieter, more reflective life.

—Nancy

Nancy waves me into her living room. Books line a wall, a pastel yellow couch set with floral cushions stands out against burgundy walls, an oak coffee table artfully displays Yukon photo books, and flowers bloom under the bay window. I look around in amazement. Nancy laughs. "Looks peaceful, doesn't it?"

I suddenly understand that this outgoing, flamboyant woman, whom I've known for years through our business and community connections, fosters the same need for refuge as me. But I'm to learn that while her home in Whitehorse provides a place to recharge, the place that feeds her soul is at Tagish Lake.

Nancy is a Firth, a family name synonymous with Yukon history. In 1898, during the height of the Klondike Gold Rush, her grandfather arrived in Dawson City, then a bustling centre of forty thousand. The following year, the rush had ended and the population plummeted to eight thousand and then remained stable. It became the Yukon capital.

By 1906 Nancy's grandfather had established T.A. Firth Insurance. The values he instilled in future generations were a strong sense of business acumen and a commitment to service. He married and had one child, Howard, who in turn married Nancy Hughes, whom Nancy is named after. Nancy has four older siblings and a younger adopted brother.

Nancy was born in Dawson City but after World War II, the Yukon's transportation and economic focus shifted to Whitehorse. In 1953 it became the capital. With a family of six, her parents had to move.

Sixteen-year-old Nancy, like all her siblings, was sent out to private high school—in her case, St. Ann's Academy in Victoria, BC. She says, "That was marvellous because we found out who we were without being attached to the Firth name and that the Yukon wasn't the centre of the universe."

When she graduated, she enrolled in the University of Victoria, but laughs, "I didn't come out of it with any degree, just fun times. I floated around and my parents worried terribly about me because I was so outgoing and gregarious and didn't have a clue about the next day." But that outgoing character always served Nancy well. She says, "People took a chance on

me. I would fall into jobs or doors would open. I think my number one asset is attitude: having the ability to laugh at myself, know my limitations, and be willing to learn anything."

In 1973 the Yukon government's department of tourism asked her to work at Yukon House in Vancouver. "I encouraged people from the lower mainland to travel to or move to the Yukon. It was a blast. Here I am renting a highrise apartment and getting paid to talk about the Yukon."

Nancy attended many functions in her role and it was at a Yukoners Ball in Vancouver that she met her husband, David. Nancy gives a hearty laugh. "My mom and dad were at the same function and they said, 'If you're not going to invite him home for dinner, we are.'" Nancy and David became a couple shortly after. "David is my total opposite," Nancy says. "He's quiet and introverted, but he always makes me laugh. He is my rock."

Nancy and David moved back to Whitehorse in 1984. Three years later, when she was thirty-six and David was forty, they had their only child, Wesley. She shakes her head. "I was scared stiff of being a mother. I was pretty much spoiled and looked after, being the youngest. But, oh, how blessed we are to have had Wesley."

Nancy says her biggest career accomplishment was going into partnership with Dale Stokes. "At Midnight Sun Gifts & Gallery, I discovered I had the ability to come up with good product ideas like campfire coffee, fireweed soap, and dressing teddy bears in the Yukon tartan. We had so much fun and we did very well together."

After twelve years they sold the business. It gives her a great deal of satisfaction to know that she and Dale built something "that lives on after us. The store is still functioning and people are still employed and that's an awesome feeling."

Now semi-retired, Nancy turns her attention more inwards. "I'm not 'out there' anymore. I can walk into a room and recognize only half the people." She spends as much time as possible at Tagish Lake, where she dabbles in gardening and carpentry. What was once a cabin is now a home. It's her dream to retire there with David.

Dale Stokes (King)

Integrity—My Bottom Line

Born June 4, 1943, in Toronto, Ontario

In everything that I did, I tried to do the best that I could.

—Dale

Dale sits at her dining table, oblivious to the panoramic view framed by her windows—South M'Clintock Bay and the forested hills rising from the shore all the way to Pyramid Mountain. She says reflectively, "There was never an 'aha' moment in my life, never an end goal. If anything, I looked after my children who depended on me and did what needed to be done." A businesswoman and a single mom, Dale upheld high standards for herself on both personal and professional levels.

When Dale was six, her family moved to Vancouver because, she says, "My father found out he could finish his law degree a year earlier in BC." While he was articling in 1955, he took a trip north "to get the lay of the land." The family moved up to the Yukon that Christmas, when Dale was twelve. Her father opened a law practice and later purchased the Edgewater Hotel, which became part of Dale's family experience over three generations.

At nineteen, Dale married Lionel Stokes. They lived in Whitehorse, then Kamloops for a few years, but came back north to work in the family hotel business. When her parents retired south to Vancouver, they took over ownership.

As their family grew to include two sons and a daughter, Dale became a stay-at-home mom. Seeking outside contact, she signed up for the YMCA "Take-a-Break Club," designed to give young mothers some time out from child care. A speaker would talk about women's issues at one participant's house while the children were all babysat at another's. It meant a great deal to Dale and before long, she was presenting a speech entitled "Day Care: Quality, not Quantity." Dale says, "I became socially activated. We organized the woman's minibus society and a woman's drop-in centre in the Y." Dale was recognized as a woman of the year by the Yukon Government for her involvement in bringing public transportation in the form of the mini-bus service to Whitehorse.

When their youngest was about three, Dale began working full-time at the hotel, where, she says, "I worked as everything: on the desk, cleaning lady, sometimes as a waitress. In a twenty-four-hour, seven-day-a-week family-run business, if someone doesn't show up, you do it."

Not long afterward, Dale became a single parent. She gained sole custody of the children, which was normal at that time. What was exceptional was her attitude. She explains, "What was important to me was our children. So they had a lot to do with their dad and we just got along." She continued working at the Edgewater, by this time in the office. When they were old enough, the children worked there as well. Their oldest son eventually co-managed the Edgewater Hotel with his father until they sold it in 2009.

Dale's high standards show through when she says, "My biggest accomplishment and what I'm proudest of is my children. They're all good people who look after their families well."

Dale was always business-oriented. When she wanted more independence, she bought the Diet Centre. "It never really occurred to me to get a job." Her social activism led her to get involved in business organizations and then to run for territorial politics. While campaigning for a seat in the Yukon Legislature, she was politically mentored by Doug Phillips. He won his riding but she lost by sixty votes.

That was the end of her political career but the beginning of a relationship that would culminate in their marriage. The best thing about their marriage, Dale says, "is our two families truly became one." They have two sons living in Vancouver and a son and two daughters living in Whitehorse. They dote on their grandchildren.

Dale sold the Diet Centre after eight years, when Nancy Huston, a close friend, proposed they become partners in retail. Both their husbands warned them, "Don't go into business with your friend, it's not a good idea." But, Dale says, "We did it anyway." They started with Midnight Sun Gallery and Gifts and expanded with the Whitehorse General Store. She says, "What worked for us is we have two different brains. I was good at money, financing, figuring out how to do things. She was outgoing and making contacts, good at interior design and creative ideas." They shared a commitment to quality customer service. Dale says, "Integrity was always important to both of us." After twelve years in partnership and with their friendship intact, they sold the company to retire.

Dale and Doug built a home at South M'Clintock where they are "living out their dreams." While they pursue separate interests—genealogy for her and gardening for him—they share a commitment to family and a passion for travel.

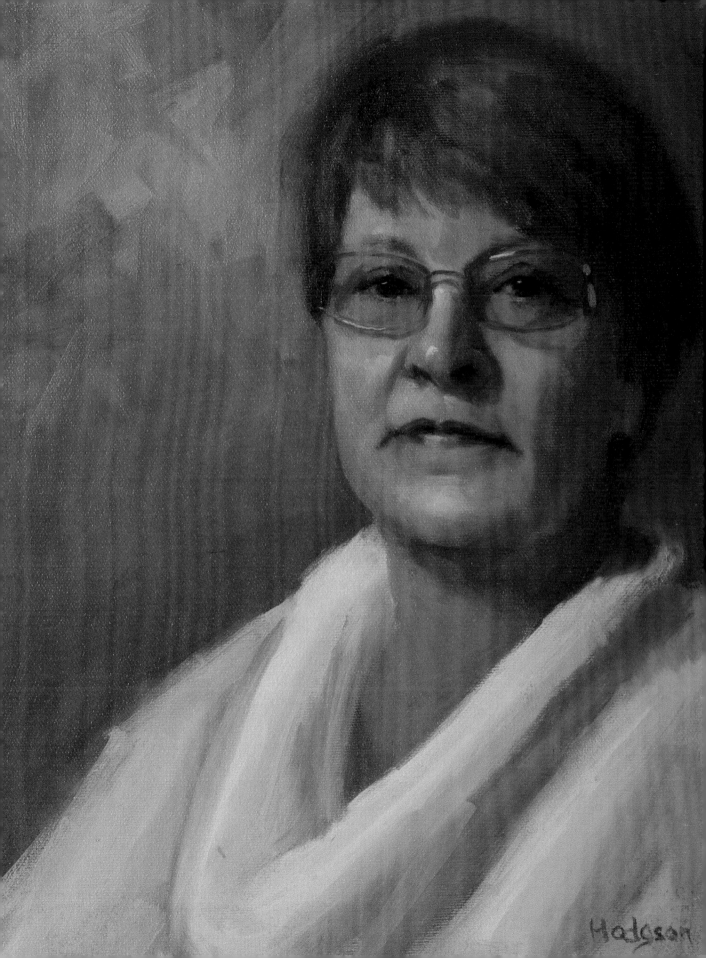

Hodgson

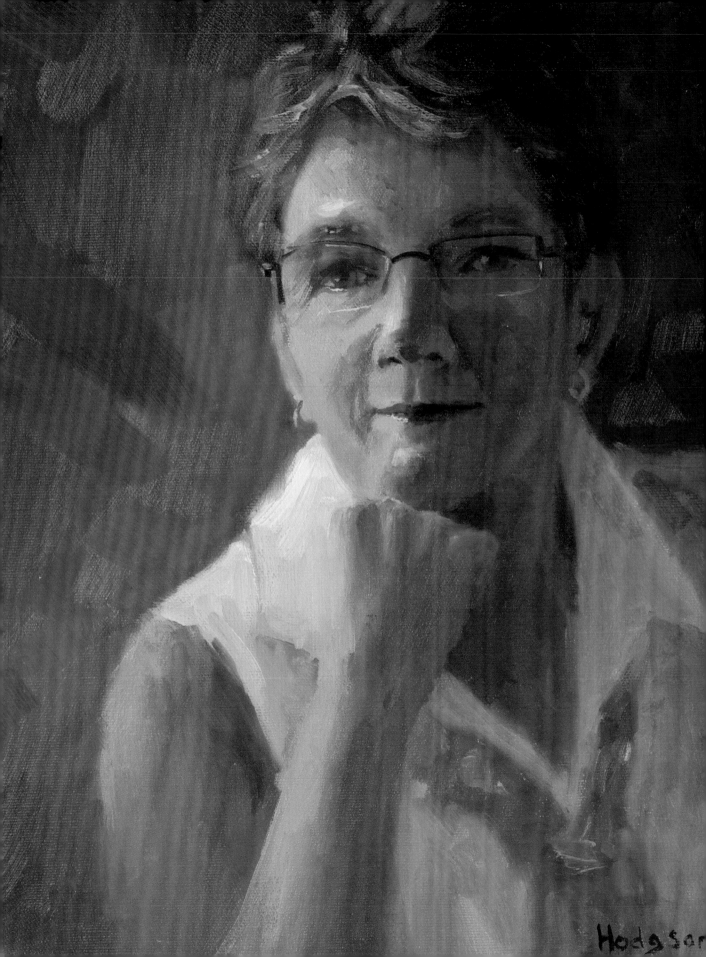

Penny Kosmenko

Forgot to Go Home

Born November 27, 1946, in Victoria, British Columbia

I never have any thoughts of leaving. I couldn't leave my friends just to go somewhere for better weather and better gardening. We go travelling and that sort of thing and spend the rest of our time here complaining about the weather, which is what we do.

—Penny

Penny Kosmenko's bright blue eyes are full of life and she sits on the edge of the couch as she talks to me. "My older brother came up here to work in 1965," she says. "Five years later, I was living in Vancouver and at loose ends. He said, 'Come on up!' so I did—in February—for the Yukon Sourdough Rendezvous winter carnival and forgot to go home."

Penny laughs. "In the early 1970s, Whitehorse rocked. I worked as everybody did at two or three jobs and had the most wonderful time of my life. It was absolutely fun, the ratio of men to women was about ten to one, and the nightlife, and the food and restaurants—it was absolutely incredible!" She shrugs and says, "And then I met my husband and got married and had children." But her adventures continued.

Until he retired, her husband, Ed, trapped and mined so he was away a lot and Penny took time off work to be at home for her girls, Abbie and Jennifer. She says it was not easy. "When I grew up in Victoria, all my aunts and uncles and cousins were always there but here I was alone."

Penny soon formed better connections. "A group of us became each other's extended families. All of the kids are like cousins because we would do Christmas and Halloween and Easter together." Still, she says, "After five or six years of staying home with babies, I really began to wonder whether I could carry on an intelligent conversation and my self-esteem was in the basement. I felt incredibly bummed out."

She wanted to improve her education so she signed up for university courses through Yukon College. "It was the best thing." This later gave her entry to better jobs in the insurance field, where she has worked for many years. She also took assertiveness training, which changed her outlook.

Ed mined a gold claim out on Livingston Creek. The road was too rough, the work day too long, the distance too far, and the mining season too short for him to come home. So, Penny told him, "I'm not raising these two little girls by myself for four months every summer. And he built us a little cabin and the most wonderful outhouse—with no door on it—and it had the most beautiful view." Those summers on the claim were some of the best times they shared as a family.

The claim had a dirt road and Penny says, "You could hear somebody coming for miles and if company was coming, that was a really big deal. We had a radiophone, where you could listen to one side of the conversation and imagine what the other side was. I learned to love CBC Radio because it was in the background all the time." Over the years, she says those radio programs helped her develop a keen interest in politics and books, and strong opinions.

Her favourite times were the gold cleanups "when the kids would be looking in the sluice box for the nuggets," and rainy days. "We all read a lot and we coloured. I brought out the markers and the colouring books. So there were the four of us sitting around this little table in the cabin, colouring. This is where their dad taught them you really could put pink and red side-by-side to make the colours more vibrant. The kids still talk about that."

Her daughters, Abbie and Jennifer, live in Vancouver but feel strongly about the Yukon. "They have to come home quite often," says Penny. "They say that it's the dirt or the earth—something about the Yukon—that makes you come back and once you're back for a few days, well it's okay, you can leave. But they always get the yearning to come home again."

Penny says, for her, the Yukon is also all about the people. "I find when I go to Vancouver or I go anywhere, I'm constantly scanning, looking for a familiar face and there aren't any."

Penny's husband is retired now, and she planned to be too, but she remarks wryly, "I don't have any hobbies. That's my problem, that's why I'm still working part-time." In winters, they travel to warm places like Costa Rica and Australia—and they never forget to come back.

Pam Makarewich

Things Just Happen

Born 1941 in Auckland, New Zealand

Things just happen without you really sitting down and analyzing them. My friend and I left New Zealand headed for the 1964 Innsbruck Winter Olympics but we had to make money in Canada to carry on. We planned to work in the Yukon for two months. Before I knew it, I'd met my husband. I stayed.

—Pam

Pam greets me at her back door, smiling and covering her ears against the whine of her husband's steel grinder. She ushers me into her kitchen, which overlooks a landscaped back yard featuring a garden and a brick outdoor kitchen area.

Pam was born in Auckland, New Zealand. An only child, she spent holidays on the family farm and was close to her cousins. Following high school, she went to teacher's college. In 1963, after teaching for two years, she and a friend set out on a rite of passage—an overseas journey. Their goal was the 1964 Innsbruck Winter Olympics.

Pam and her friend planned to be gone from home for eighteen months. After a month in Japan, they continued on to California by ship and then took the bus up the west coast. At that time, Commonwealth citizens could easily work in Canada and the girls needed to make money to carry on. They checked out Banff but there were no jobs. However, Backe's Lodge (now the Kluane Park Inn) in Haines Junction was looking for waitresses.

They planned to stay for two months but they didn't make it to the 1964 Olympics. Pam says quietly, "Things just happen without you really sitting down and analyzing it. Before I knew it, I'd met my husband." Three years later, Pam and Paul were married. Her friend met an American and still lives in Anchorage, Alaska. Pam says, "We finally finished our trip; we met in London in March of 1995."

Pam fondly remembers arriving in Haines Junction. "It was really, really small and they made a bit of a fuss over us because we were from overseas." The girls worked seven days a week; the lodge owners didn't give them days off because staff had a record of going to Whitehorse and not coming back. "We didn't know about labour laws," Pam says.

The following year, when Pam and Paul moved to Whitehorse, she worked in a bank until she began teaching in 1965. Pam says, "My teaching career was very important to me.

I taught for thirty-one years in schools up here." She taught grades 4 and 6, "a nice group, independent enough to do lots of things and young enough that they listen to you."

Pam and her husband had two children and she enjoyed raising them in the Yukon. "It was really fantastic. They could wander off to go fishing by themselves and I didn't have to worry. One year, I had a sabbatical and we lived on the University of British Columbia campus. My son played hockey and baseball and his team in the Yukon had travelled a lot. He made the A team in Vancouver but he travelled much less and that was a real surprise for him. The kids learned they have so many opportunities here in the Yukon." Now grown, their son is a police officer in BC and their daughter is a computer contractor in Whitehorse.

Pam and Paul both worked but were also very busy in their free time. She remembers, "For the first eight years, Paul's spare time was taken up building our home, while we lived in the basement. He also built the outdoor brick barbeque that we used a lot. When we had some money we spent it on things we needed at the time. One summer, every payday we got a truckload of dirt and that's how we got our yard." She still spends a lot of time gardening and doing yard work. Genealogy is another hobby.

Friends are an important part of their lives. Throughout the year, Pam meets regularly with a group of her retired teacher colleagues. Every summer, she and Paul spend a few weeks at Frances Lake with a group of friends—one couple from the United States, two couples from Edmonton and more from Watson Lake. "When everyone arrives, we have 'Christmas in July.' We cook a large turkey and hold a potluck and invite everyone in the campground. A few years ago, we met a family from Switzerland. The daughter played the violin and the son played the accordion; they gave us a concert. The next day, we took them for a long boat ride."

Pam reflects, "The best thing about the Yukon is the feeling of belonging," she says.

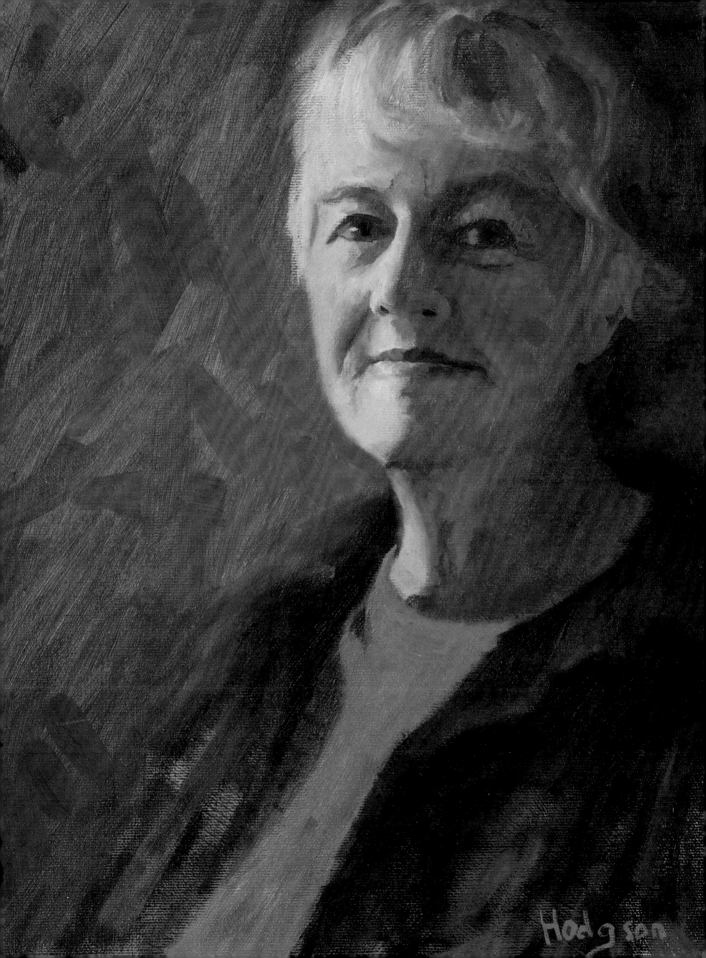

Hodgson

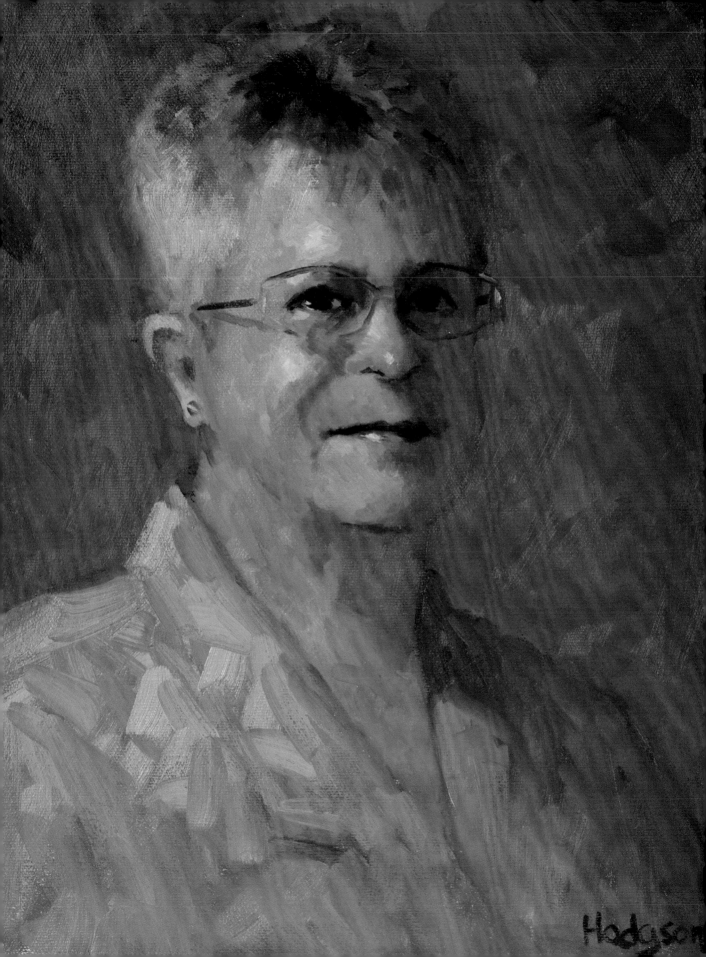

Maura *Glenn*

Captivated by the Yukon

Born July 28, 1936, in Galway, Ireland

When we drove the Dempster Highway, my sister and nephew were with me; we stopped the car, got out, and just walked. Oh, to experience that vastness and peace was amazing. And hearing the silence—it was extraordinary. The Dempster has an awesome presence.

—Maura

Maura lives in a wee, cozy house tucked close to a hill in Riverdale, Whitehorse. When she speaks, her Gaelic lilt is noticeable; she has a natural shyness. Maura says she was a born teacher as had been her mother, and her grandmother was one of the first trained teachers in Ireland. Upon obtaining her teaching diploma, she taught for several years in Ireland but then her spirit of adventure kicked in.

"It has been said," Maura states quietly, "that it is the gypsy in the Irish people that make them travel." Distant shores still beckon and Maura travels far and wide but she smilingly says, "It is undeniable that I fell under the spell of the Yukon. I am here for the duration."

In 1973 Maura responded to an advertisement from the Frontier Apostolate seeking volunteers for a two-year teaching stint in northern BC. She taught for a stipend at the Catholic separate schools in Burns Lake and Fort St. James.

In 1985 the Yukon department of education hired her to teach at the one-room school in Beaver Creek. "It was very challenging being the only teacher but I enjoyed the challenge," she says. "I always loved kids—even the bratty ones I really liked. In Beaver Creek, it was more like tutoring. I had kindergarten to grade 7. The kids were like a big family, but like a big family they always knew how to get one another going too."

Maura relocated to Whitehorse in 1990 to teach at Golden Horn school and later at Selkirk Street School, retiring in June 2000. She smiles. "I taught for a good forty years, fifteen of them in the Yukon." She admits she was exhausted toward the end but she says, "Even now, my ex-students come over and give me a hug when they see me."

Maura soon found a renewed zest for life in retirement. She beams. "It is the best time of my life; I'm spending all my savings while I can on travel." Maura has been to Southeast Asia, Antarctica, the Galapagos, Europe, and all over the Yukon, but says one of her most memorable journeys was driving the Dempster Highway. "Oh, to experience that vastness and peace was amazing. And hearing the silence—it was extraordinary. The Dempster has an awesome presence."

Although Maura won't commit to long-term volunteer work, she helps with the Elder Active bingos and other short-term activities. She says, "I'll try anything once." She's hiked the Aurial Trail, completed the ten-kilometre section of the Mayo Midnight Marathon and took up bowling and quilting.

Of the activity that gave her a stage name, Maura says, "I fell into being a can-can dancer." She had signed up for line dancing classes at the Golden Age Society and was recruited to practise for a can-can performance during the 2004 Canada Senior Games held in Whitehorse. That national event came and went, but the Yukon Golden Girls dance group continues. "I used to have stage fright but I got over that. It's a lot of fun," she says.

This group of ten women, with an age range from sixty-three to eighty, kicks it up during the Yukon Sourdough Rendezvous Festival, at the Legion Hall, and at regular visits to Macaulay Lodge and Copper Ridge senior care facilities. They also do gigs at birthday parties and for conferences, and danced at Hank Carr's sold-out performance at the Yukon Art Centre.

Mischievous Maura, as she is known, laughs. "It's not easy to get ten old ladies to do the same thing at the same time. Mondays we practise and if a performance is coming up we practise on Thursdays, too."

They made their own skirts out of fabulous deep purple satin with red and yellow ruffles. Maura continues, "We have so much fun together. Sometimes not all ten of us are there but there are always enough. We were scheduled for an eightieth birthday and one of the gals had her foot in a cast, but she still got up and danced. It's good for the soul. The strange thing is people seem to enjoy us."

Their repertoire includes choreography to the songs: "If They Could See Me Now," "Everything Old is New Again," and the Yukon favourite, "Paddle Wheeler."

Having fulfilled her life purpose by teaching for over forty years, Maura keeps connected to the things that feed her soul: travel and the Yukon spirit.

Millie Jones (McMurphy)

Born to Teach

Born August 11, 1932, in Whitehorse; grew up in Carcross, Yukon

When I was a kid, winter was a lot about survival. We snared rabbits and had to pack water and chop wood. But we had a lot of fun too. We had so much freedom, being outside playing, skiing and sliding. Every weekend we got together and played board games. There was always a band and dances in the little one-room schoolhouse. Going down to the post office to pick up your mail was a social event.

—Millie

The framed photos on Millie's condo walls are of her favourite Yukon scenery and all are from the Carcross area: Bove Island, Book Mountain and Windy Arm. Millie, the second of five children, grew up in Carcross, and from the time she was little she wanted to be a teacher. She never thought she'd make it but eventually she did.

Millie travelled to Langley, BC, to go to high school, "but," she says, "I was terribly homesick and in those days you went out in September and stayed till June. So I didn't go back."

It seemed her dream of becoming a teacher would not happen. She continued with correspondence courses but didn't complete high school because at sixteen she met Don Jones, who had come to Carcross from Vancouver to work on the riverboats. They married and she says, "We never had a lot of money but in those days nobody did and we all did things where you didn't need money." Don found the Yukon winters long, and one year he lined up a good job in Squamish, BC, so they moved Outside. Millie says, "I cried all the way down the highway. But we came back after a year and Don never complained about the long winters again."

In the early years of their marriage, Millie focussed on raising their son and two daughters. But she still worked with children, volunteering at the school, leading the Brownies and teaching Sunday school. When the kids were a little older, for two consecutive summers she enrolled in a six-week kindergarten instructor course even though she didn't have her high school diploma.

Kindergarten was just being introduced into Yukon schools around that time and John Freby, superintendent of schools, offered her the job in Carcross. When she protested that she wasn't qualified to teach, he said, "I know, but you've taken the courses and we really need someone."

She worked in that job for four years until John approached her again, saying, "Millie, you know you're not qualified to teach." She said, "Yes, I know I'm not. I told you that."

He offered support for her to work toward her education degree from the University of Alberta through a partnership with Yukon College; she qualified as a mature student. Over the next four years, while teaching full-time in Whitehorse, she took courses on weekends and travelled to Edmonton for summer school.

John approached her a third time. "Millie, there's a clause in the contract that says if the superintendent directs you to take courses, we hold your position, you get full wages, tuition and moving expenses, and I'm directing you to go to Edmonton for one year to finish off your degree."

Millie protested. "Oh, John. I can't do that. I can't leave for a full year."

But her husband urged her to go, her children were independent, and she realized it was too good an opportunity to pass up. "The first few weeks I just wanted to leave. I'd phone my daughter and she'd tell me, 'No, Mom, don't go home.' She even came to be with me over Thanksgiving weekend. That's the only way I could have done it, with support like that. And that's how I finished my degree in education. It was 1978 and I was forty-six years old." Her lifelong dream had come to pass.

Sadly, while they were building a house in Carcross in 1985, Don died suddenly. Millie has lived in Whitehorse ever since except for four years while she taught in Carcross. After twenty-five years in the classroom, Millie retired in 1993 but continued substitute teaching and volunteered in the schools for a number of years.

These days, Millie volunteers with ElderActive, cooks for the soup kitchen, and is a board member of the retired teacher's association. She smiles. "And I knit. That's doing something worthwhile." She's up at 5:00 most mornings to go swimming. She often goes to her cabin at Carcross. And she loves to travel. "All I need is somebody to say 'Let's go' and I'm off!"

Millie is proud that four generations of her family have taught in Yukon schools: her mother's aunt in Whitehorse, her mom in Carcross, and Millie in both communities. Her daughter and one grandson are now teaching in Whitehorse.

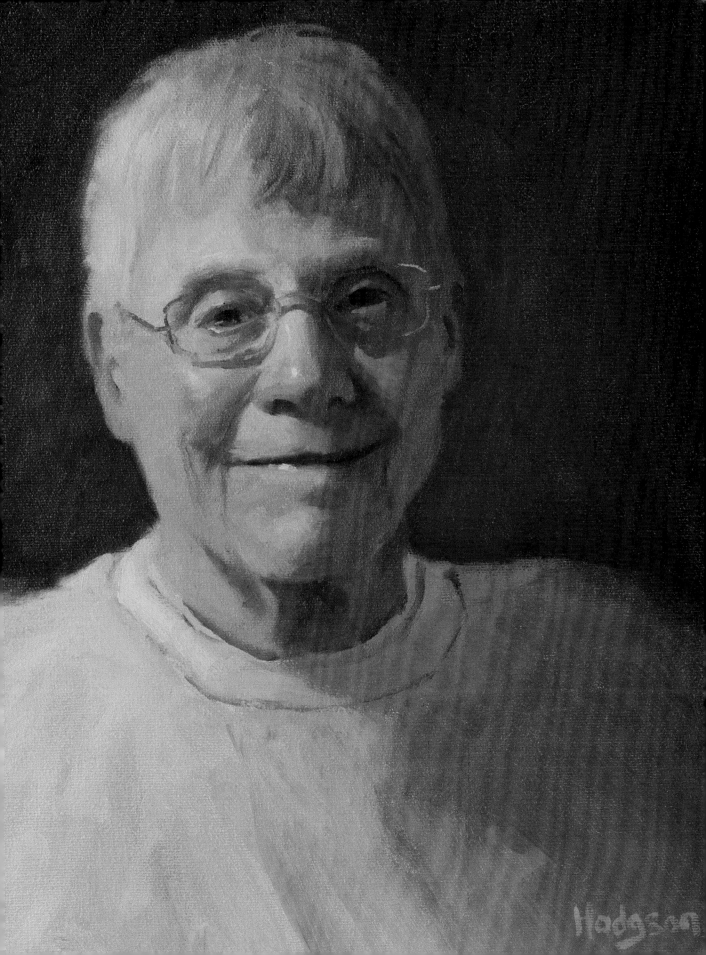

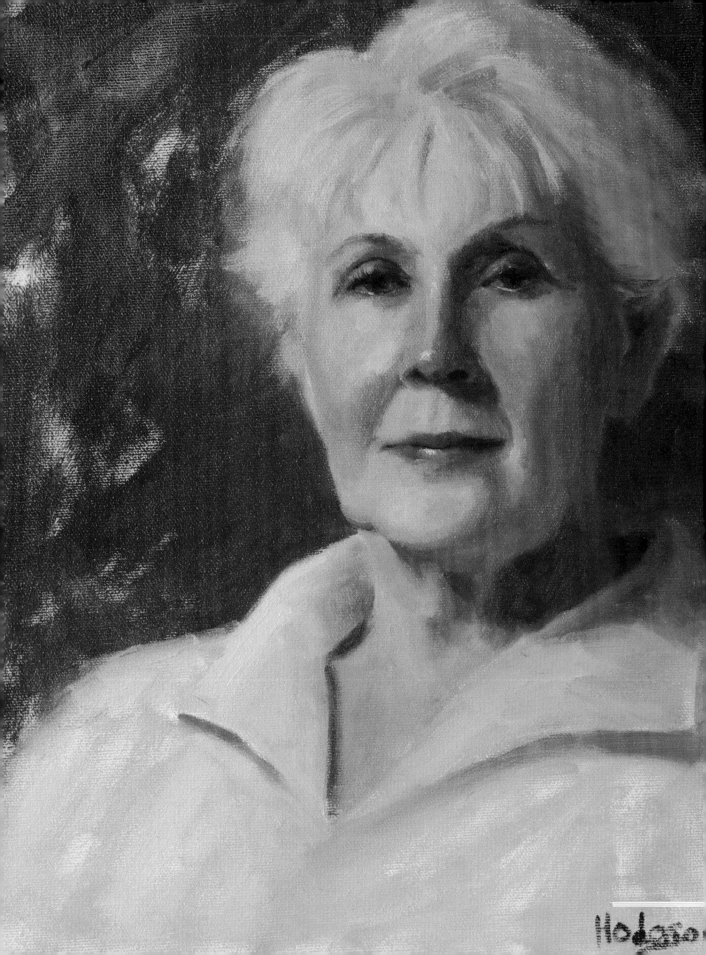

Barb *Zaccarelli*

Best Friend

Born August 16, 1944, in Montreal, Québec; but is from Regina, Saskatchewan

When I was young, we were very poor but nobody had much in those days. I always wanted to have a nice house but now material things aren't what I treasure the most; it's family and friends.

—Barb

Barb, a striking woman with a young face and thick, pure white hair, carries herself straight. With a graceful turn of her head, she invites me into her spacious Riverdale home. She tells me the lower floor contains two full suites, which she operated as a bed-and-breakfast for many years. A retired teacher, she now divides her time among family and friends, volunteering, working "part-time" for a conference coordination company, and operating a jewelry business out of her home. To say she has a full life is an understatement.

Barb applied to the Yukon for a teaching position in 1966. When she was offered a choice between Whitehorse and Watson Lake, she looked at the map "to see which town had the biggest star… and I came to Whitehorse."

During Barb's first year, she shared an apartment with another teacher who, on the first night of Christmas holidays, came home and said, "Come to the Bamboo [Lounge]. There's a guy there from Regina. You might know him." He had never been to Regina and didn't know anything about the place—but he did play on the local Regina Hotel ball team. She smiles. "And that's how I met my husband, Ralph." They were married in 1967 and have two sons.

Barb is a lifelong learner. She says she continues to work because she likes meeting new people and "because I get to learn skills I wouldn't otherwise. I was tasked with conducting business interviews and I told my boss I couldn't do it but she said 'Yes, you can, and you'll do a good job.'" She nods when I ask if she did.

Running a jewelry business is also a completely new experience. "I never thought I could do sales but I don't really feel like I'm selling. It's such a good product that it sells itself. Plus, I love having people come to the spring and fall open houses; it's so much fun." Barb decorates the house to make everyone feel welcome.

Barb insists she does not volunteer much and she's surprised when people tell her, "I see you everywhere!" But her commitment is big: she is involved with Whitehorse Concerts, the Golden Age Society, Grandmothers to Grandmothers, the Order of the Eastern Star, and the Hospital Auxiliary. Barb also belongs to TOPS (Take Off Pounds Sensibly). She says it's a collaborative effort. "We take turns to make it interesting. We invite guest speakers and get members to do skits. The expectation is that everyone has to do their part." As she tells me about her tasks, it becomes clear this is a woman who signs up to actually do something.

In addition, Barb visits seniors at the Macaulay Lodge and Copper Ridge senior care facilities. She considers it "such an honour to spend time with some of these folks." She visited often with Elly Porsild, listening to her stories about her childhood in Denmark, her years in the Arctic and operating Johnson's Crossing Lodge. When Elly turned one hundred, the family invited Barb to the party. She pauses, "We were in Vancouver but I came home early to go to that party."

The cold climate has always been a challenge for Barb; she doesn't enjoy outdoor winter activities. But, she says, "As long as I can travel Outside when I want to, I love the Yukon." In winters, she and Ralph often travel south with one or the other of their sons and grandchildren. One son lives in Fort McMurray and the other in Whitehorse. Barb says, "As long as we have family here, we would never leave."

Her strong friendships also bind her to the Yukon. "I'm so fortunate. Every Friday I go for coffee with a group of women. I have a special bond with them. I consider it a real treasure." Barb celebrates her birthday with two friends born in the same month. They jointly host a shared birthday party—with a twist. "We invite a house full of friends and everybody gets goodie bags. We're celebrating that we're still here—some aren't. Why not celebrate life while you're here!"

Barb tells me of a friend who went to Toronto for her sister's funeral. At the reception afterwards, all these women came up to Barb's friend and said, "Your sister was my best friend." Barb says her friend continued, "Barb, that's what's going to happen at your funeral. We all feel that you are our best friend."

Mary *Mickey* (Young)

Helping Others— A Way of Life

Born August 15, 1933, in Rose Prairie, twenty miles north of Fort Saint John, British Columbia

If a person has time, why wouldn't you help? And so I do. But it's not a big thing; you're just doing the things that need to be done—not for the glory of it—because it makes a difference.

—Mary

Mary Mickey is a slender, angular woman with the delicate complexion of a former redhead. She holds herself straight as a ramrod, speaks softly and is obviously nervous with this interview. She admits she would never say it of herself but the qualities she admires most in her friends are reliability and always being there for others. However, these are truly her traits. Being reliable and helping others are not an obligation for her; they are a way of life.

She tells me her philosophy developed as she grew up in Rose Prairie. "My mom and dad were the pillars of the community. He was the Justice of the Peace and she was the first out-post nurse. He always did for everybody around the area. It was just their way; and if a person has time, why wouldn't you help? And so I do, because it makes a difference."

Mary went as far as grade 8 in her home-town's little red schoolhouse and completed grade 9 by correspondence. Then she went to Fort Saint John and worked for Canadian Pacific Airlines. Later she became one of the first girl gas jockeys and that's how she met her hus-band-to-be, Tom, who had come from Alberta with an oil service crew.

Mary says, "Tom thought the Yukon was the greatest place and he wanted to move here from the get-go." But it took years before they could realize that dream. They married in 1957 and followed jobs in northern BC and Alberta for nine years. Then opportunity knocked: Tom was offered a job managing Gordy's Trucking Company in Whitehorse.

On March 31, 1966, the Mickey family, now with three boys, arrived. Mary says she liked Whitehorse right from the start. "Everybody was kind of like the people I grew up with. It felt good being here." Mary made many friends through her children and her volunteer activities.

Within a few years, Tom opened a twenty-four-hour tow-truck company and Mary did the dispatching. She also ran a coffee wagon; she cooked and baked, and a friend drove. Mary and Tom often went camping, usually on short notice because of their work. Nine years after they arrived, they started their own trucking company, Frontier Freight Lines. Their sons are still involved in trucking.

Mary says, "Tom loved Dawson the most and he never did lose his love for Dawson City. He retired in 1988 and went placer mining every year until 2007; he got to live his dream." Mary visited weekends but her passion for gar-dening keeps her close to home.

In her quiet way, Mary noticed a northern phenomenon. "The Yukon seems to attract people who are running away or wanting to make a new start. And there always seems to be room for them. You can come here and not be judged."

Over the years, Mary's community com-mitment has added up to a big contribution. She is a solid member of the Order of the Eastern Star (O.E.S.), the women's affiliate to the Freemasons group. She is particularly devoted to the Stamping Out Cancer program. It's a year-round activity involving more than sixty Yukon businesses. "But," Mary says, "we're always looking for more businesses to partici-pate." The businesses save envelopes with can-celled postage stamps, which volunteers pick up on a monthly basis and then get together to trim and clip the stamps and send them to Vancouver, where a contact sells them to stamp collectors. With the proceeds, the O.E.S. buys gauze, makes it into dressings and these are given free to cancer patients.

For the past twenty-five years, Mary has been a mainstay of the Canadian Cancer Society. She is the "Monday girl" helping out for "two or more" hours every week at the office. In addi-tion, she's involved in selling daffodils, raising money in the April door-to-door campaign, vol-unteering at the Relay for Life, and dispatching Mr. and Mrs. Claus in the month-long Rent-a-Santa program.

Earlier, one of Mary's friends had told me Mary is a recipient of the Commissioner's Award for Public Service. When I ask her about it, Mary blushes. "I had no idea it was going to happen. I just about died that night. I didn't think I was going to make it through. I don't know what I got it for."

She shows it to me. The award reads: "In recognition of her many contributions to the improvement of the lives of others."

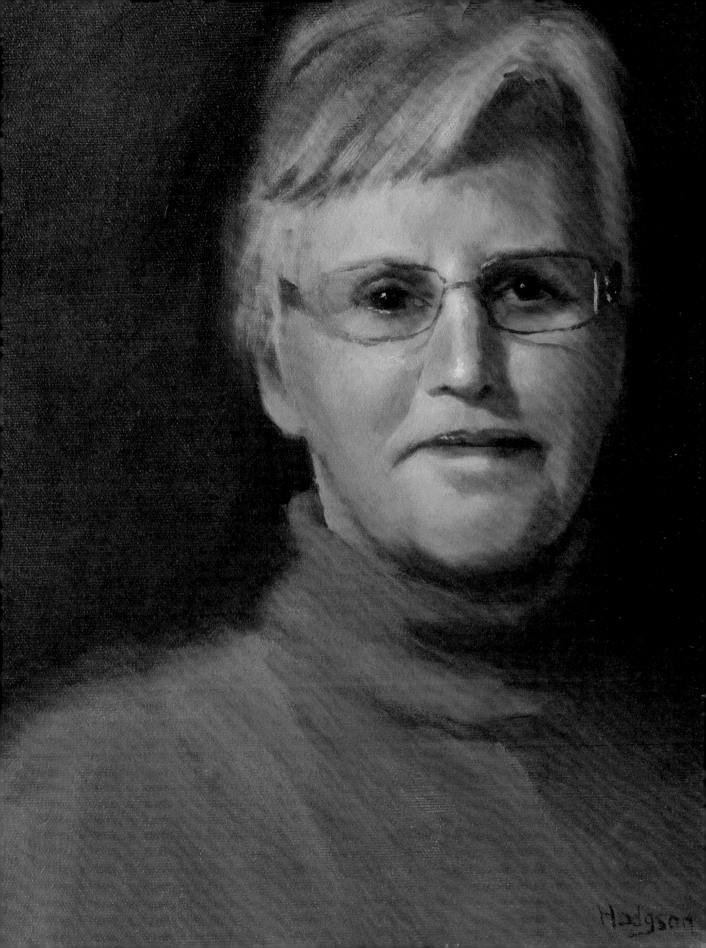

Hodgson

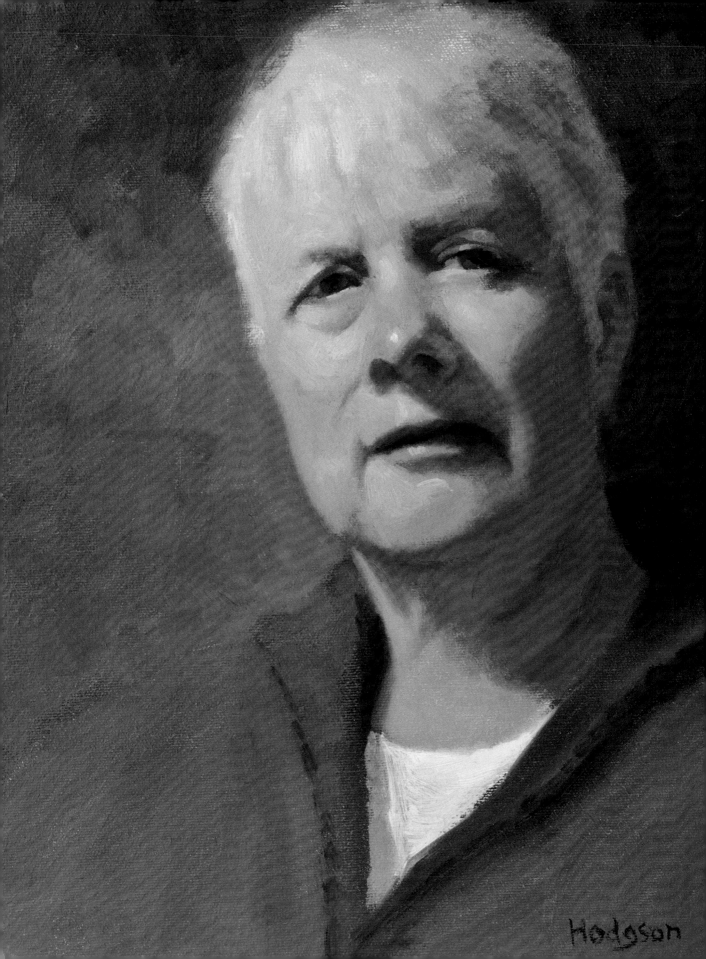

Jenny *Skelton* (Waligorska)

Get Involved!

Born August 20, 1943, in Berkeley, Gloucestershire, England

Winter is my favourite time—with the skiing. I wouldn't leave in the wintertime. April is ugly when things are melting but we're getting the garden going and we have to be here to tend it in summer. In fall we get in all the crops and I lead the ski patrol training. Really, there is no good time to leave Watson Lake.

—Jenny

You'd never guess Jenny Skelton's upbringing by her current home. Her front yard is bursting with a garden hedged by honeysuckle, currant and raspberry bushes. Row after row of vegetables thrive in her garden: carrots, beets, potatoes, beans, peas and broccoli. As I walk up the drive, pigeons fly in to join the clucking chickens in the roost.

Sitting at her kitchen table, through the trees I glimpse Second Wye Lake, another vegetable garden, and artfully arranged patches of rhubarb, scarlet runners and flowering shrubs. The garden is a passion for both Jenny and her husband, John. When they bought the property in 1973, "the small two-bedroom house was surrounded by gravel." Their two children grew up here but Ben now lives in Vancouver and Sara in California.

Since first coming to Watson Lake as a registered nurse in 1971, Jenny has invested as much energy into her community as she has in her garden but she says, "I get back much more than I give; being involved gives me such satisfaction." When she was a young stay-at-home mother, she launched the Watson Lake Play Group that is still going strong today. She was involved in the swimming club and is one of the organizers for Watson Lake's annual yard and garden contest, part of the national Communities in Bloom program. One of Jenny's favourite annual activities is checking the volunteer list posted in the community centre. "It's really quite amazing when you see all the names of people involved in this community," she says.

Jenny's most devoted contribution is to downhill skiing. Not only is she the president of the Canadian Ski Patrol, Watson Lake Zone, Jenny commits eighty hours every year as the training officer and has done so for over twenty-five years. "That's a big thing for me," she says. "The people I've trained have gone all over Canada, some all over the world."

But the Watson Lake Ski Club is probably closest to Jenny's heart. The school integrated ski lessons into the physical education program of grades 4 to 7. Jenny says, "We've had some pretty good skiers come out of Watson Lake."

Volunteers run every aspect. Another popular program is a joint effort with the Liard and the Lower Post First Nations. "The First Nations put money up front for their children to ski and snowboard and we submit our accountability."

Jenny is particularly excited about working with children who have fetal alcohol syndrome. She explains, "These are the kids who come to the hill and they shine because they can finally do something that's easy for them; they're very coordinated and athletic. The attention span is not there so we try and work on the positive. If they're really good, I'll ski with them and they can choose the run they want." She smiles and shrugs. "They usually choose the black runs."

She insists the rules apply to everyone. "I had a class once and it was complain, complain, complain from the students for the whole period, so they had to take a ski lesson for the whole two hours since this was part of the school day." Jenny laughs. "The next time they came, there wasn't a peep out of them. The children did their fifteen minutes of lessons and then could go free skiing. It worked." She becomes serious. "My reward is seeing the kids with beaming faces and having them call to me on the street, 'Oh, Jenny. Hi!'"

As for Jenny's upbringing, her British mother and Polish father met in London when they both worked for the British intelligence during World War II. After a two-year stint in Kenya, her father, an anthropologist, moved the family to Krakow, Poland. Because he refused to join the Communist party, he remained a senior lecturer for many years before becoming a professor at Jagiellonian University. To make ends meet, her mother taught English. Jenny recalls, "My mother really wanted us to know and understand how the other half lived because we were considered to be intelligentsia, so in the summers, we would spend time in the village where our nanny/housekeeper came from. We would run around barefoot, play with the village children, and help bring in the harvests."

Her mother and brother, a nuclear physicist, still live in Poland but Jenny has solidly planted her roots in the Yukon.

Nora *Mirkel* (Edzerza)

Attitude is Everything

Born January 26, 1935, in Telegraph Creek, British Columbia

My kids are my greatest accomplishment. I cannot ask for anything more out of life than how they turned out. They're good people. That's something that no money can buy.

—Nora

As I step off the elevator on the third floor of the Yukon College senior condo, a smiling head pops out of a doorway down the hall. "Come on down!" A huge pot of soup simmers on Nora's stove and its aroma mingles with the smell of freshly perked coffee. Big mugs sit on the kitchen table. "Pull up a chair," she says. Nora was born sixth in a family of twenty children, all born to one set of parents. Family is at the core of Nora's existence and purpose.

Nora's parents both grew up in Telegraph Creek but she says, "My dad felt blocked from being an independent person so he signed us off from the (Indian) status record. It set us apart from others." He moved the family to Ten Mile, a homestead outside of town. Nora recalls, "We raised a garden and it was huge. We sold berries and vegetables and fruit. It was big enough to supply all of Telegraph." Still, her family struggled in those first years.

Although Nora's dad wanted all the children to go to school, some of her sisters got very little education. She says, "I managed to get through grade 8." Nora is proud that her siblings all grew up and did well. "We are blessed with the entrepreneurial spirit. Even the ones that didn't have an education made a fantastic living—none ever on welfare. Our kids and grandkids are all well educated."

Nora left home very young to work and in 1955 while she worked as a cook at the Teslin Motel, she met Ralph, a carpenter working on the Teslin Bridge. Nora recalls, "He spent a lot of time with me from the minute we met but we only went on one date before we got married and he was so shy I didn't even know his full name." They married August 6, 1955, at the old log church in Whitehorse and moved to Whitehorse shortly after.

Ralph worked on construction and Nora stayed at home as their children came along: three boys and a girl. Nora says, "In our earlier years in Whitehorse I wasn't very happy. I stayed to myself a lot. I was a slave to my house—I cleaned and cooked." But life changed when Nora took a job as a dorm supervisor for the department of education. "I worked with the young people and I loved it. I felt let down when I retired. I still see some of my students. They call me Mama and give me a big hug."

After working outdoors all those years, Ralph wanted to retire to a warmer climate. They chose Victoria, BC, and Nora decided, "The only one way I was going to get along was to start going out and joining: seniors' clubs, water aerobics, and playing bridge. I made a million friends. Those were good years." Although they lived Outside for twenty years, "Ralph loved the North; his heart was here. We came back for four to eight weeks every summer." Then, in the forty-eighth year of their marriage, Ralph passed away.

Nora gets up from the table quickly, disappears into a back room and returns. She holds an armful of colourful children's parkas. She is beaming. "I always did a lot of sewing. Down south, I sewed a full line of ladies wear for all seasons. It took over my whole house; everywhere you looked there was material and sewing machines." She sold her clothes at Naked Colours in Nanaimo and says with pride "My clothes have gone all over the States." Now she sews the parkas and sells them at Yukon craft sales. She laughs. "It's my therapy."

Her face turns serious as she remembers the tough period she went through after her husband died. She shakes her head. "But then, it was like I was told, you can be morbid or you can choose life. I chose life and I'm not sorry. My life is really full now." She sews, plays cribbage weekly, goes for coffee with friends, and contributes to the condo monthly potlucks. Once in a while she'll head south on road trips, visiting friends along the highway and in Victoria.

But the most important thing to her is that her family is close by. That delicious-smelling pot of soup on the stove is for her son and his worker. Nora nods, "I'm happier than when I lived here before because I have a different attitude."

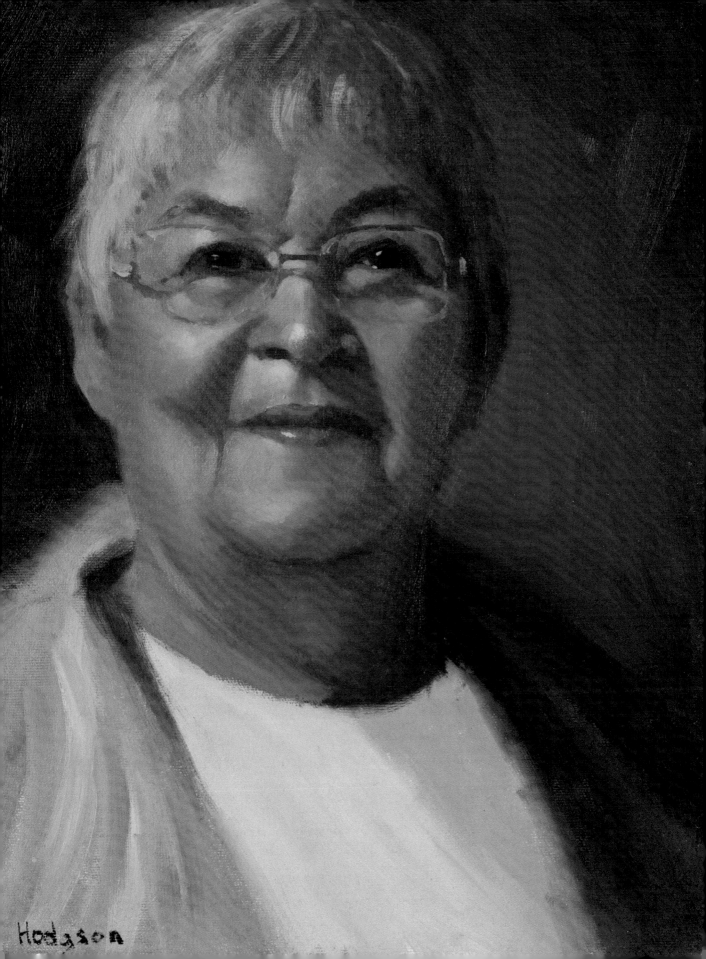

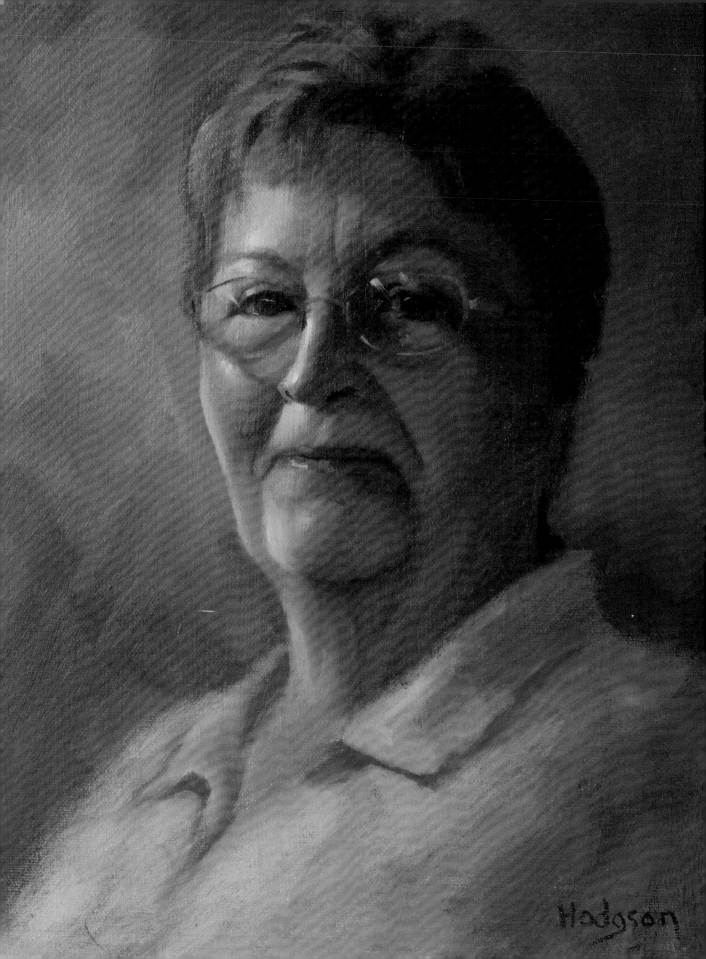

Hodgson

Minnie O'Conner

Family Is My Focus

Born June 19, 1933; raised in St. Paul, Alberta

At the time, you think leaving is the thing to do but when you get Outside, it's different. Everything out there was an effort. John missed the camaraderie of his barbershop. Whitehorse has so much to offer—we have a beautiful city, the people are friendlier and I could not live out of the mountains.

—Minnie

Minnie's condo is cozy with family memorabilia and crocheted doilies on the chair arms. In the attached living room sits a glass-fronted hutch displaying a twelve-place setting of Ireland's signature four-leaf clover chinaware: Belleek cups and saucers, dinner plates, tea pot, sugar bowl and creamer. It represents a treasure to anyone of Irish descent.

Minnie is the first of eight children to a Dutch family who farmed "on the bald prairie in southern Alberta." They homesteaded near St. Paul, "a small Anglo settlement, where we were treated as outsiders." The schoolchildren were so hostile the nuns dismissed the Dutch and Ukrainian children a half hour early so they could walk home without getting beat up. Minnie says, "Those were rough years for us. It shapes you." Despite this, Minnie married a charming Irishman, John, when she was eighteen.

Minnie and John started out farming but she says, "I wouldn't wish that on anybody. If you didn't grow it, make it, or sew it, you didn't have it. We never had cash. We had one pair of sheets that I washed and put back on the bed."

John decided to take a barber's course and soon after a brother living in Whitehorse phoned to say there was a job opening. John came up, looked it over and called Minnie. "I can make eighty dollars a week." And Minnie thought, "Wow. What I can't do with eighty dollars a week!"

They came to the Yukon December 1, 1956. It was humble beginnings; they rented a one-bedroom house in the Kay McDonald area between where the S.S. *Klondike* is now and Robert Service Way. "We had four children and two boarders, all in that one-bedroom house. It was lots of work. We didn't have a flush toilet, only a biffy." They also had water delivery but it was never enough with that many in the house so her husband carried pails of water from the river. In spring, they rented a bigger house and kept boarders for eight years.

The town was a frontier. "Main Street was dirt, mud, and rocks, and these big logs where you'd pull up in front of stores. Wood smoke was everywhere—everybody had a wood stove of some kind. There was not much for shopping but there was enough. I remember buying my first big order of food for the winter; it came to forty dollars and it was a lot of groceries. We had very little choice compared to today."

With a salary, Minnie says, "It was the first time we had an extra dollar, so we could shop. We relied on Eaton's and Sear's catalogues. We ordered kids' clothes in the spring and fall and all our Christmas shopping too." John eventually opened his own barbershop.

In June 1964 they moved to Vancouver to buy a barbershop. But the deal fell through and by the first of December, they decided to come back—by car—with seven kids and a houseplant. Minnie recalls, "Just outside Mile 101, the thermometer read 58 below zero. We arrived in Whitehorse on the nineteenth of December. The White Pass shipping container with all our belongings arrived on the twenty-first and the men from White Pass helped us set up house on Christmas Eve. It was 40 below when they unloaded the container. Thanks to them, we got to celebrate Christmas with our household around us."

It was that kind of spirit that kept them in the Yukon. They and their children prospered. John passed away in 1997.

These days Minnie keeps busy. Watching baseball is her number one hobby but she also crochets, knits, does canning and makes jam. She says, "I bake thirteen loaves of bread and hand it out to my kids. They get excited about my cinnamon buns, which I take out to them when they go camping." She travels to Alberta to visit family but with seventeen grandchildren and four great-grandchildren—and growing—her Yukon family is her focus.

"If there's ever a catastrophe, my kids say they'll come to my house because I've got enough food for us all; I like to see a full freezer and a lot of jars on the shelf."

Maggie *Holt*

Making a Go of It

Born February 4, 1953, in Home Hill, Queensland, Australia

I was travelling on an around-the-world ticket and my friends convinced me to come and see "The Yukon, God's Country" first. I never made it any farther.

—Maggie

Maggie welcomes me at her Marsh Lake home just as her partner, Barry, leaves to walk their two dogs. The original log cabin is intact but an addition has transformed it into an elegant, luxurious home with high ceilings, huge windows overlooking the lake and décor right out of a magazine. Barry's the builder and Maggie's the decorator. Together they have built and brought a new level of style not only to this home, but also to all their joint ventures.

Both Australians, Maggie was born in Queensland and Barry in Tasmania. They never knew each other in Australia but you might say, because of their Yukon connections, they had a relationship before they even met.

In 1971 Maggie connected with a Canadian girl on a cruise and recalls, "We were standing on the docks saying goodbye and we decided instead to share an apartment in Sydney." She laughs. "Then a bunch of her girlfriends from the Yukon came over and we all travelled around Australia—five girls in a car and tent for six months—stopping to work in Tasmania to pick apples and oranges and hops. The girls from the Yukon always talked about Barry so we looked up his family."

Her Yukon friends returned north and told Barry about their new Aussie friend Maggie.

She continued working and bought an around-the-world ticket in 1972. Her destination was England, but the girls convinced her to come to "the Yukon, God's country" first. She never made it any farther; she and Barry immediately became an item. She says, "He talked me into staying. He even sold my plane ticket on Trader Time, the local radio program, to make sure I didn't leave."

Maggie worked in his various businesses: he built houses and she did the interior design, he had a tax services agency where she filed the returns, and he owned a trailer park where she collected rents and managed a grocery store.

Barry's business interests were eclectic. He invested in Atlantis Submarines, a tourism company offering submarine rides in the Caribbean. Always expanding, in 1984, they persuaded him to travel around the world selecting dive sites. Maggie went along with him to the Cayman Islands, where they recruited her to set up the retail outlets and reservations systems. She remembers, "Our first office was a cash register in a tent but we grew to five sites in the Caribbean, three in Hawaii and one in Guam." A perfectionist, Maggie grew with each challenge.

She eventually settled in Hawaii but in 1986 Barry was drawn back to Whitehorse. He had a dream: to convert the YMCA into the High Country Inn. Over the next ten years, "Barry kept showing up. I never really got on with setting up my life separate from him. He was always there." In 1996 he asked Maggie to help and she agreed to come back to the Yukon for three months, but she says, "When I was leaving, he asked me to make a go of it on a personal and business level." She smiles. "I said okay."

They devoted themselves completely to the High Country Inn, turning it into one of the Yukon's flagship hotels. It was demanding, and over time it wore Maggie down. By 2005, she knew something was wrong. "I went to the doctors over and over and over but they didn't pick up anything."

Barry had turned down a purchase offer but by November 2006, Maggie's health had deteriorated and she told him, "I can't do it anymore; you need to call those guys up and ask them to buy the hotel." Barry did and they said yes. Just after, Maggie was diagnosed with stage-four colon cancer. Her first reaction was denial. "I couldn't bring myself to tell Barry—I didn't know how to tell him—but when I had to go in for surgery, I did."

Maggie says, "My biggest accomplishment was beating that cancer and Barry was right there with me." She moved to Vancouver and says firmly, "It was my full-time job to get well and there was nothing to distract me from getting that job done." Maggie is clear of cancer since 2007.

Maggie and Barry now split their time between homes in the Yukon and California. She says the cancer changed her life. "I was never one to be able to take; I would always give. I had to learn how to accept. I had to learn how to say no. I learned to respect my body. I learned to listen. And most of all, I learned to forgive."

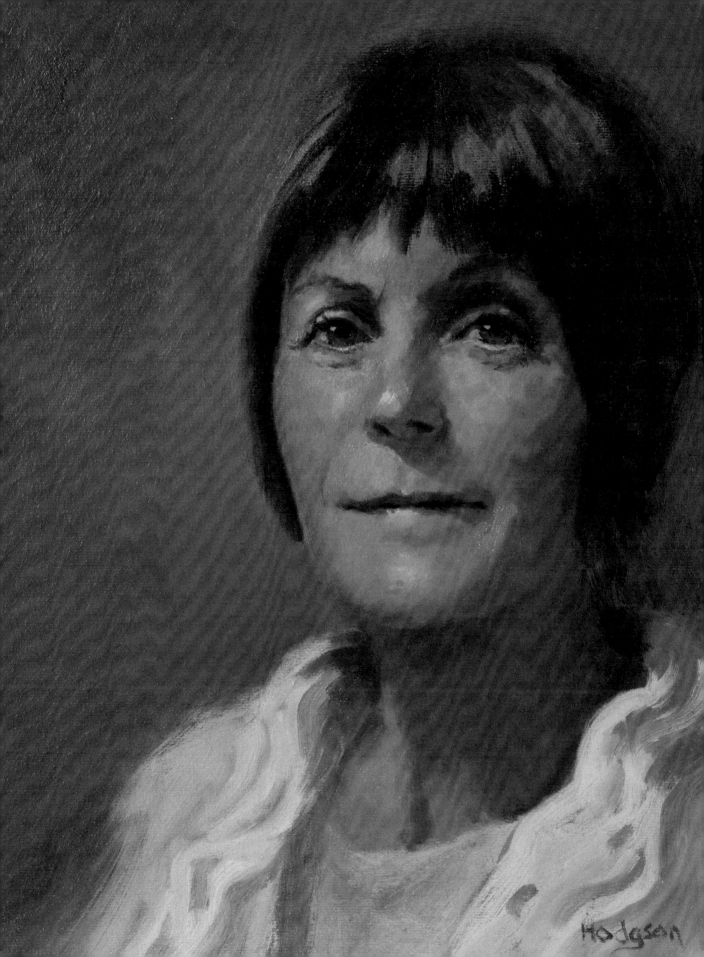

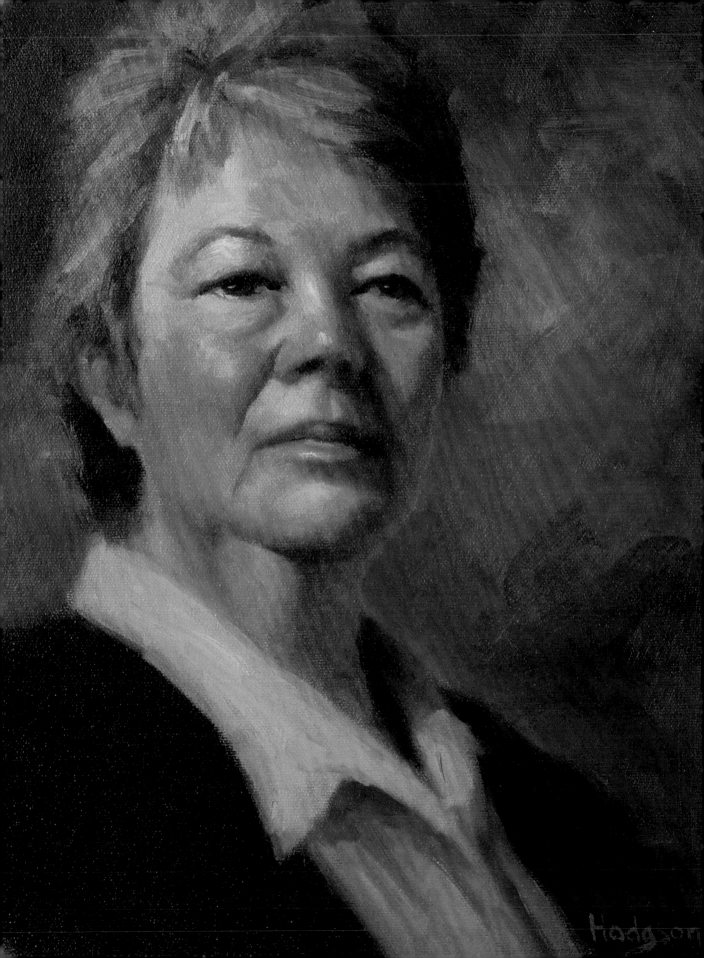

Carol *Pettigrew* (Carpenter)

The Underlying Impact of Story

Born April 14, 1948, in Calgary, Alberta

I brought along my sewing when I went to the First Nations communities, where I developed a very quick rapport with other sewers. I had no idea that in their culture, sewers are known to be resourceful and tenacious and to have a respect for traditions and standards and qualities. All these things that speak to personality and character— I was being accepted on that basis.

—Carol

Sitting at my kitchen table, Carol drapes a luminous green scarf over my arm. "It's made from Japanese kimono silk. Look at the way it captures light!" Eyes rising from the scarf, she sits straight and settles into herself with a calm assurance. As the first born in an era when child care was not available, Carol lived with her Ukrainian grandparents in Mundare, Alberta, until she was five. Her Baba instilled in her a passion for textiles and at a very early age, teachers also noted Carol's writing abilities. Carol philosophically unifies them. "The biggest theme of my life is the underlying impact of story and how it plays out in our lives."

Carol wanted to be a journalist but her father disapproved so she became a teacher. But she rebelled by marrying "the most shocking choice I could find, under the conviction that I could save him from himself." Seven years later, after her daughter was born, she left the marriage.

Searching for new adventure, Carol applied for a teaching position in the Yukon. She taught for two years and wanted out of the classroom but not the Yukon. "I had no idea that I could be so completely taken in by a landscape. I was hooked. My whole purpose in coming north had been to make a grubstake to buy an orchard in the Okanagan but when I drove back after just two years it seemed crowded to me. Already the wide-open spaces had gotten to be part of me. I came back north quite happily."

She worked for the Yukon Native Language Centre training speakers of nine First Nations languages to teach their language in the classroom. When she went out to their communities, she brought along her sewing projects and was accepted quickly. "We connected on a very traditional ground, which was much more powerful than I realized at the time." Over the years, Carol decided, "If I care about my work, I will work my way out of this job. I developed a method whereby a Master Teacher could train other speakers of her language and when we had trained enough First Nations people who could take over, I was ready to move on."

Her next adventure was with "the most amazing person I've ever been attached to," her late husband, John Ostashek. She says, "He showed me how a person is committed in their lives to things that matter to them." They shared a deep passion for the wilderness and business but she says, "He expected me to step up and apply my own skills and abilities in our business."

One goal they shared in their big game hunting business was to be booked two years in advance. So Carol challenged John to allocate 10 percent of the budget toward advertising. He shot back, "All right, Smarty, I'll give you 10 percent and if you get us booked two years in advance you can have 10 percent every year." Carol sent their hunters a postcard saying "We hope you had a great hunt and a safe trip home and please send us your photographs." She smiles. "And to a man, they did. I wrote a newsletter with photos and stories of their hunts and they copied it and sent it to all their friends." She laughs. "Within a matter of months, we were booked *three* years in advance and I got a permanent budget for advertising. It worked like a dream."

When they sold their business in 1991, Carol wrote in earnest and John entered politics, becoming the Yukon's premier. Carol published about ten stories in literary journals but her interest in textiles won out; she opened a quilt shop with a business partner. Shortly after retiring from politics, John was dignosed with cancer. Carol sold the shop to her partner and cared for John until he died in 2007; she says it has taken years to get her feet back under herself.

Carol runs the silk between her fingers and smiles. "Now that I've found my grounding again, I spend time with my grandchildren and connect with people who share the things that matter to me: the textiles, the writing." Looking neither forwards nor backwards, she's just ready to accept the next part of the narrative.

Ellen Margrethe *Davignon* (Porsild)

Tongue Hinged on Both Sides

Born October 22, 1937, in Dawson City, Yukon

My tongue is hinged on both sides. I love to tell stories.

—Ellen

Ellen ushers me to her kitchen table and we talk as rhubarb pies bake in the oven. Renowned for her humorous and insightful writing that chronicled life on the Alaska Highway, Ellen loves to tell stories.

In 1929 Ellen's father, a Dane who grew up in Greenland, was hired to build corrals out on the Mackenzie Delta in anticipation of five thousand reindeer being herded there from Alaska's Bering Sea. One year later Ellen's mother travelled from Denmark to Aklavik, where they married; they lived in a cabin forty miles downriver. Two of Ellen's four siblings were born in Aklavik but one died in infancy.

Later the family moved to the Dawson City area where her father trapped, mined and worked the dredges. Ellen says, "My mother was extraordinary. Whatever he wanted to do she just said, 'Okay, Bubi. Let's go!'"

After the Alaska Highway was built, Ellen's father "got the idea to build a highway lodge." The summer of 1947, the whole family tore down an old army camp and by October they opened a restaurant, the beginnings of what would become Johnson's Crossing Lodge. "We had three tables and six chairs for guests. Mom was working on a four-burner kitchen stove. She served her customers just the way she served her family: very homey." She says, "Americans were flocking up the highway to see the last frontier. Our lodge was pretty basic but people never complained. It was part of the frontier."

As a teenager Ellen longed to leave Johnson's Crossing. When she was seventeen, she met Phil Davignon and they were soon an item. Shortly after, he started working in their tire shop. Ellen says, "I married Phil because he said he was going to take me away to Alberta." But it didn't turn out that way. They stayed on, helping her parents, and eventually Phil talked Ellen into taking over the lodge. She sighs. "We bought it in 1965 and we stayed until 1992." Ellen and Phil had five children who "grew up knowing every facet of the business," but wanted no part of owning it as adults.

By the seventies, tourists had changed: they either stayed in their motor homes or demanded more than frontier standards. "Accommodation," Ellen says, "was the worst part of the business. I have nightmares still about the lodge." Finally, in 1978, they closed the lodge and reopened as a bakeshop and campground business. Ellen says, "I didn't work any less hard. I was up at three in the morning, had a little nap around noon and went back at it until around nine o'clock at night." They operated only during tourist season and Ellen loved it. "I baked seven tons of flour in a season; I had about a dozen specialties that I baked. Those thirteen years were great. It was a happy time for all of us."

In 1965 Ellen began writing "The Teslin News" for the *Whitehorse Star* but stopped "to have another baby and I never got back to it." Ten months later, when the *Yukon News* called, Ellen submitted a sample column "about life on the highway." She called it "Lives of Quiet Desperation." She smiles. "My first column was about the bolt that cost four dollars and by the time it got here, it cost four hundred." Her best source of inspiration was Phil. "Everything that Phil ever did to make me mad, I'd find something funny about it and write about it. One year we won a trip to Hawaii but Phil wouldn't go. Oh, it gave me a great column." Ellen also published *The Cinnamon Mine,* a book about growing up on the highway; she sold over seven thousand copies. She beams. "It was the best souvenir item I ever sold through the bake shop."

In 1992 Ellen and Phil sold the business and moved to Whitehorse. Ellen finally got to travel—without Phil, who stayed close to home and died of cancer in 2002. She doesn't miss the business but misses Johnson's Crossing itself and especially the interaction with customers. Her fondest memory of that time is "when my kids were older and had their kids and we had Christmases together. Everybody stayed for up to six days. One Boxing Day, my husband and son-in-law went down to the river and came back with a whole mess of grayling."

These days, Ellen and her brother are writing a book about their parents and she spends lots of time with children and grandchildren. Taking a deep breath, she pushes her chair back from the table and laughs. "Now, I'd better get those pies out of the oven before they burn to a crisp!"

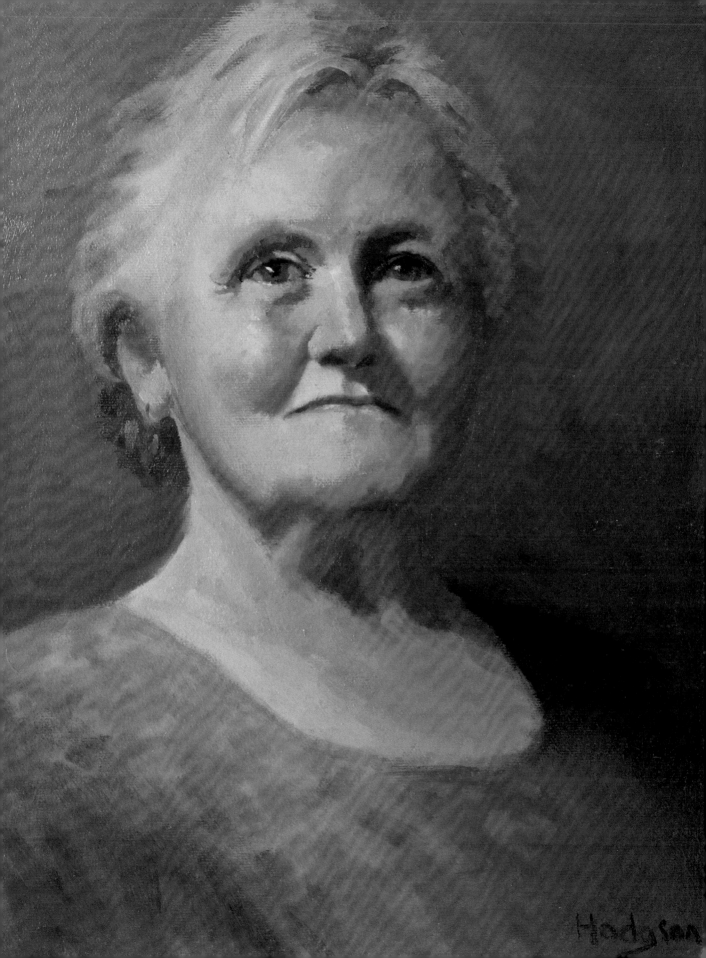

Supporters

We would like to recognize the following individuals, businesses and agencies as Supporters of
Remarkable Yukon Women:

Bertrand Lacroix

CorLine Management Services

Yukon Legislative Assembly Speaker
and Members

The Yukon Foundation contributed the Roy Minter Fund
toward the production of *Remarkable Yukon Women*.

YUKON FOUNDATION